ODE TO TRAVEL

Ode to Travel

Patrick Trefz

Introductions by **Christian Beamish, David Kinch & Jim Denevan**

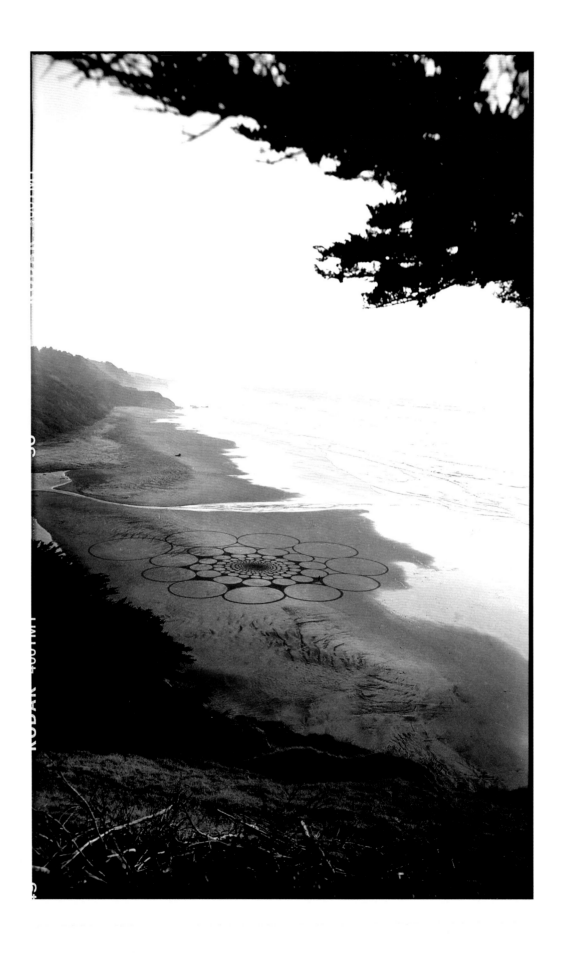

WHAT ARE WE HUNGRY FOR

What are we hungry for? Whatever might sustain. In the construction or the fashioning of our days, what to include and what to keep out. In choosing ingredients, what mystery and physical fact goes in the pot?

A recipe, literal or metaphorical, is married to its source. Patrick Trefz' journey starts out from the pot, a measuring of surprising courses.

The (his) Sims Road house, accessed on high, past living redwood and oak, a long table set. Feasts for friends, recipes warmed by a forest's fire, ingredients gathered in sunlight and storm. Glasses, steps, bowls. Dripping, evidence.

Discovery comes from a desire to know.

Going beyond one's usual pathways, away from preconceived notions, a fresh outlook—and the travel notebook fills. Colors, shapes, tastes, and feelings cohere.

Travel brings insight and knowing, along with a degree of humility and an immersion in mysteries, a dance of perspective among moving definitions and changing shape as we see and feel and taste a different perspective.

You can't know until you've been there, it is said.

Digging deeper, layer upon layer exposed, and you still don't know. The rewards of travel turn out to be knowing less while discovering more.

In the Arabian desert, head thrown back and looking into the night, stars reveal. A new friend provides an explanation of the celestial. What the sky looks like from here: a perspective that simultaneously suggests the universal and the particular.

An *Ode to Travel* gives substance to distance, arranges one position among the many and the specific.

Patrick Trefz is hungry. He's making this. Ingredients given heat. Portioned, shared. Dishes, napkin pressed against lips; is that enough?

You have never had food this good, you will never eat this well, never ever, as long as you live.

GOAT HEADS PILED ON THE FLOOR

Patrick Trefz was well situated for a career in photography from his father Detlef, a studio photographer for *Vogue* in the 1970s and 80s. Gifted a sturdy camera, a Minolta SR-T 101, by his dad, Trefz spent long hours as a teen absorbed in creating his own still-life sets. Visits to Detlef in Paris—observing the precise set-ups and lighting techniques, the interactions with stylists and editors—made Trefz aware of the attention to detail and the professionalism of a working photographer. Bringing these impressions home to Dusseldorf, Germany, Trefz worked in his school's darkroom, learned the intricacies of the Minolta, and further honed his skills in a studio apprenticeship.

But for a youth more interested in graffiti and skateboarding, studio work felt stifling. So Trefz took his SR-T 101 and hit the road. His first trip was to Tunisia in 1986, traveling there when he was fifteen. Trefz said he dressed for work; a button-down shirt tucked into khakis, belt cinched tight. He laughs describing the outfit, amused by the seriousness of his younger self juxtaposed against wilder days that would follow. Yet for 35 years, from the streets of Europe to far-flung destinations across the globe, Trefz has maintained his focus and respect for the work.

Of equal importance to Trefz' work ethic and technical mastery of photography, is his harder-to-define aesthetic sensibility. Where many surf photographs are bright and color-saturated, curated to sell a dream, Trefz often works in darker tones. An oceanscape in Basque country with forest-shrouded mountains becomes, quite literally, a different world from the palm fronds and bikinis of others' depictions. Something of the studio photographer's exacting eye characterizes a Trefz composition: the elements are neatly framed, attention given to the structure of a scene, a certain formality achieved even in spontaneous action.

Trefz' surf films offer glimpses of a grittier reality. In the aptly titled film Idiosyncrasies, with the splendor of Hawaii as a backdrop, surfboard shaper and builder Lance Ebert cruises his neighborhood while a voiceover of a conversation with a local lady provides a snippet of regional accents. The scene comes off humorously, even as their chat suggests something of the struggles and the idiosyncratic isolation that accompany life in remote and insular communities.

Alongside his celebrated surf photography and filmmaking, Trefz also chronicles regional cuisine—bridging worlds through cooking, small farms, and the sea. His visual and narrative skills come together powerfully in his Oscar-qualified documentary, *Man in the Field*, about artist and farm-to-table innovator and chef, Jim Denevan. Trefz films the spectacular settings of Denevan's gatherings on farms, in orchards, or on beaches (spoiler alert: the end seats get swamped by the shore pound when the tide maxes out). There are also scenes of Denevan's fantastic land art: gigantic sand drawings on beaches and desert plains visible from space.

Food is the essence of *Man in the Field* and food is a central element in Ode to Travel as well. Trefz' immersion in the cuisines of the regions he has visited is reflected in his own cooking and in the pages of this book. The recipes are organic, immediate, and in the fullest sense of the word, nourishing. Trefz' travels in the Basque country in particular have made a lasting impression on him. His home in the Santa Cruz mountains has a similar feeling as might be found outside Zarautz—fog-shrouded forests looming over a cold sea. As he cooks on an open fire, thick cuts of beef soaked in oil and salted, one half expects shepherds to emerge from the woods with an extra skin of wine. And it is not surprising that for the past 25 years, Trefz has made his home in Santa Cruz, California, where organic and regenerative agriculture play a fundamental role in the community.

Yet Santa Cruz is also home to a rowdy, uniquely American surf culture where Trefz gives as good as he gets in a rough-and-tumble scene. Still, he carries an old-world understanding of style and lineage that makes the cruder and even naive aspects of American life seem more laughable than lamentable. In person and in his photographs, Trefz can catch people off guard: the overly earnest neophyte catches a wisecrack, a page turn reveals a pile of severed goats' heads piled on the floor. Ode to Travel lives up to its title—it is travel with an edge, as travel ought to be—where the unexpected and the sensuous are revealed by a willingness to explore.

Christian Beamish

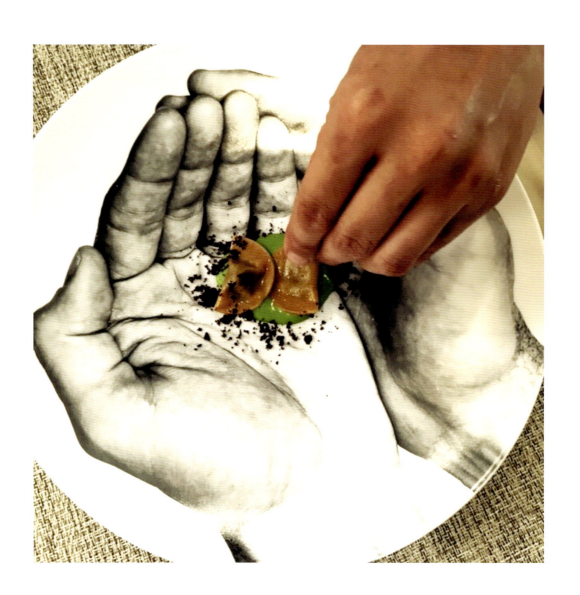

NATURAL INTUITION

I first met Patrick in 2005 when he came to eat at Manresa, my restaurant in Los Gatos, California, just inland from Santa Cruz where we both live. I was familiar with Patrick's photographic work and his influence on the surfing community, mostly through his photographs. His reputation preceded him and I was quick to introduce myself to him when he visited the restaurant. We quickly learned that we shared a common passion for food as well as surfing, and we hit it off immediately.

Surfers are a tribe and a nomadic one. Patrick and I share that in spades. I first got into cooking because I felt that cooking afforded me an opportunity to see the world. I loved the physical act of cooking but I also felt a wanderlust and wanted to embrace the challenge of something new: A new environment. A new combination of flavors. A new sensation.

Patrick's work as a photographer embodies this. I think that is one of the deep-rooted, real connections that Patrick and I have. Patrick thinks very much out of the box. I loved that he often shot in black and white and seemed to embrace a sense of movement and motion, a flow of currents, and a deeper sense of the culture that is surfing. Most surfers travel and focus only on the waves, spending time only in the water oblivious to their surroundings. Patrick dives into the culture of the places he visits while in search of waves. He knows how to capture the spirit of the people by immersing himself with the locals, the land, and the coastline; the traditions, and the food. It shows in his photos.

Patrick's work comes from his head and heart, and his ability to capture the world, whether in film, writing, or his photography—or his cooking. Patrick, I found out, had been accepted into the community of local food purveyors. We ended up cooking together a few times at his house in the hills. He is a very good cook, natural and intuitive—the best kind—not following recipes but going with his instincts. He tasted and seasoned food properly, not afraid to take risks in his search for flavor.

Our cooking together was the start of our relationship for over twenty years now; our friendship has grown, full of grace and generosity. Patrick has gifted me a couple of pieces of his artwork, some that I've hung in Manresa. His art is moving and captures something meaningful that in a small way enriches my life, through art, beauty, and friendship.

INTRODUCTION

It all started in the spring of 2020, a time when I would usually pack my bags to escape the windy Pacific coast around Santa Cruz, California—where the ocean goes severely lackluster once the winter swell season is over. I'd leave home for trips all over the world for good waves, filmmaking projects, and photography assignments, traveling to places like Mexico or Chile. I'd visit family all over Europe, surf the Atlantic Ocean, and share great food and wine with old and new friends.

But this spring was different; it was the spring of 2020. The COVID-19 pandemic was sweeping across the globe. I wasn't going to travel anywhere. As for so many of us, these first few months were simply a lockdown at home. I was going stir-crazy! To not lose my mind, I started a vegetable garden with my neighbors. At least we knew that if the world would go upside down, we'd have carrots, lettuce, tomatoes, and artichokes to chew on. That, combined with a newly found daily sunrise yoga practice, helped me tremendously. I was able to keep my mind and body together.

It was between self-care and having all the time in the world; there were no other pressing matters, no deadlines, no travels, no nada. Simultaneously, starting the garden and spending time with my neighbors got me deeply into cooking; cooking gave me a sense of purpose. I was inspired to chop and create using the vegetables in the garden.

I'd dig through the books and magazines that were sitting on my shelf, some I hadn't looked at in years: from Marcella Hazan's *Essentials of Italian Classic Cooking*, Reinhard Wolf's 8x10 Japanese food studies, Irving Penn's *Still Life*, back issues from the now defunct Scandinavian experimental gourmet magazine *FOOL*, *The Zuni Cafe Cookbook* to David Kinch's *Manresa: An Edible Reflection* and Ernest Hemingway's *A Movable Feast* and *A Really Big Lunch* by Jim Harrison. And both *How to Cook a Wolf* by MFK Fisher and *An Everlasting Meal* by Tamar Adler were food for thought (no pun intended).

Later that summer, the perfect storm brewed up right on top of us, in the midst of the bone-dry summer drought. It's normal to not have rain in California for 4 or 5 months. But on August 16, 2020, a tropical weather system hit us in the middle of the night and unleashed a fury of lightning and thunder with eleven thousand bolts hitting the ground in the greater Bay Area—with high winds but very little rain—resulting in hundreds of fires across Northern California. Later dubbed the CZU Lightning Complex fires, these small fires combined into a wildfire that would eventually burn out of control for 37 days across San Francisco, San Mateo, and Santa Cruz counties. The CZU fire would become one of the largest and most destructive wildfires in California's history.

After days of burning, on the north coast between Pescadero and Davenport, the fire came barreling through the Santa Cruz mountains, encroaching on the town center, with visibility going down to 100 feet. About midday, our zone got a mandatory evacuation order. My barn/studio/home was located only a few miles away from the giant flames, so it was clear: we had to bail. We jammed up Highway One to stay with my good friend Doctor John in the coastal town of Mendocino where it was fire-free and safe. But we weren't there yet! All of NorCal was on fire. We were jamming up the highway and had just turned on to the 101. Suddenly, close to Healdsburg, the sky turned dark and a giant fire barrel engulfed us: I was shooting through, pedal to the metal, desperate to find an exit from the flames. It seemed like Armageddon had found us…but we arrived safely. Safely, with just the bare minimum that we had been able to grab—cat and dog, a few hard drives, passport, a couple of clothing items.

I had left my large collection of analog photographs in the metal filing cabinets behind. I had not looked at that body of work in a few years as I was busy focusing on new projects. As I left it all behind, I was thinking, "Well, if it burns down then it will be time for a reset." After 10 days the evacuation ban was lifted and we were able to return to my ash-covered studio. Luckily, everything was still there. Hundreds of homes got burned to the ground by the fires—911 in Santa Cruz alone—and a lot of my artist friends lost their homes, studios, work. It was devastating.

As the fires were brought under control and the COVID-19 pandemic continued, I fell into a slight depression during the rainy dark winter months. The news reported evacuations again, this time due to massive landslides, triggered by torrential downpours hitting the burned-out forest slopes.

. . . .

Not being able to travel to see family and friends for an extended, involuntary period was a life-changing experience for me, like it was for so many people across the globe. My yearning and lust for travel was seemingly unbearable.

As the world softly opened up a bit several months into the crisis, I started to connect with my purveyor friends from the weekly farmers market in downtown Santa Cruz over a pint or two at the local bar. We'd hang out talking about life, food, travel, and recipes as it was all in front of our noses. Jeff Larky, now retired, an early pioneering organic farmer at Route One Farms, Hans Haveman, the sustainable fishmonger from H&H Fresh Fish, and Joe Schirmer from Dirty Girl Produce were among the Wednesday afternoon regulars. It was inspiring to listen to their travel stories and the food that they had experienced—and led to new adventures.

Jeff helped me to mastermind and dig a Samoan Umu (page 189). He had sailed from California to Polynesia years ago and had experienced firsthand how it is done. I did a stage/worked for trade at H&H Fresh Fish, Hans and Heidi's gourmet seafood shop in Santa Cruz Harbor. I fileted, cracked, and chopped up vast amounts of fish, seafood, and vegetables to create dishes like lomi-lomi salmon, crab salad, ahi poke, kimchi squid, octopus salad, bouillabaisse, roasted sardines, sesame seaweed salad, ceviche, and lox schmear. I grilled, steamed, and baked whole fish like salmon, halibut, sablefish, and tuna.

Eventually, on January 1, 2021, in an attempt to channel positive New Year's resolutions, I started digging into my old files, traveling through my photographs and memories. As I was working through the different countries I've visited, looking at decades of work over the light table, I realized what beautiful material was there. Those files from years of

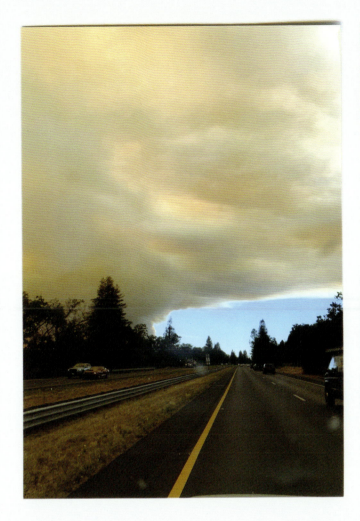
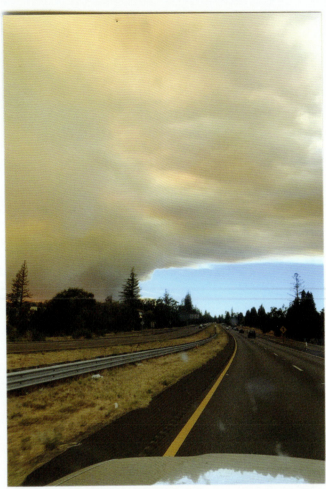

traveling had a forgotten magic energy to them: the old emulsions, the offbeat colors, the light leaks, my eye that was always looking for the path less traveled. I hadn't realized it but even though my barn had not burned down, it was time for a new start. A different start.

I immediately contacted my publisher and pitched them the idea for *Ode to Travel*. I had always loved to travel. In a way, travel has been the inspiration for my photography; my love and need to travel is at least partially responsible for my commitment to capturing images as a way to interact with and understand culture.

My earliest traveling days had begun at age 15 when I worked as a dishwasher at the Deutsche Bank cleaning thousands of plates after lunch. One day, I bought myself a ticket to Tunisia. Armed with an old Minolta SR-T 101 and 30 rolls of expired Agfa slide film, for three weeks I explored all aspects of Tunisia like my life depended on it. I look back and I suppose it did. I have made my life exploring and engaging with places and people.

I was tromping along through the 110-degree desert heat in long pants and button-up shirt, taking taxis, trains, and buses. I crisscrossed the country with an insatiable appetite to go deep into the back alleys of this ancient culture. The souks received my biggest attention, piled up herbs and spices, huge loads of watermelons, and halal goat heads with a hole between the eyes. Men dressed in traditional Kaftans, hanging out, drinking tea, and smoking water pipes.

A few years later, I bought a van with a friend of mine from the San Francisco Bay Area—an old 64 Dodge—and we drove it down the California coast through Mexico down to Central America and ended up in Costa Rica. It was definitely an adventure—full of joy and horror—as we had some very close calls with sharks, narcos, crocs, soldiers, a night in a military prison, a typhoon, and other crazy stuff.

Throughout my life, I've worked on and off in kitchen environments, first as a stoned dishwasher then ambitiously climbing up to the cold kitchen and then into the curious heat of cooking as a sous chef. The work became a source of income that allowed me to travel around the world. It also gave me the liberty to work on my art/photo/film interests.

Flying by the seat of my pants I somehow secured a full-time staff photographer position at *Surfer* magazine. My timing was right as the Half Moon Bay big wave spot "Mavericks" received a lot of attention globally—I'd caught a ride out on my friends' boat to take photos of the surf and surfers. That led to a cover shot, followed by a wide variety of assignments.

As time went on, I was fortunate enough to choose where I wanted to go and I traveled all over the world on the magazine's dime. Besides getting the required surf action shots, what was most interesting to me was to capture the cultural side of things; that was the original point of traveling.

The world offers endless opportunities for exploration and discovery, which can serve as inspiration for anyone looking to broaden their horizons. From a small Japanese dish "Chawan Mushi" to a Gaucho style grilled whole lamb Chilean, the diverse cultures of our planet offer a plethora of culinary experiences. This is the driving motto behind my thinking & inspiration on what to cook.

When creating dishes for my book, I drew inspiration from the people & places I encountered, letting my emotions guide me towards recreating their flavors in my own way. It was almost like sleepwalking, as my subconcious took over to create dishes that spoke to the terrior of the regions I visited...

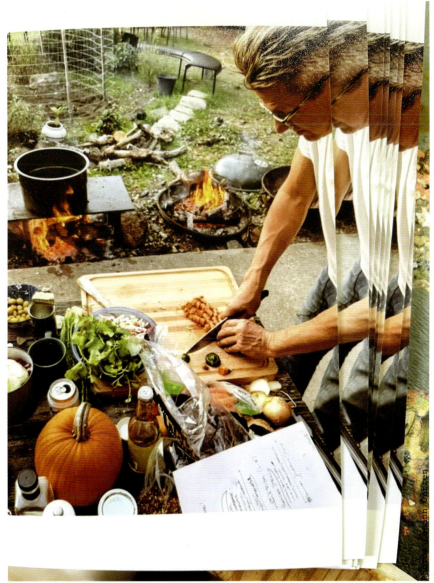

Photo: Leeann Curren

Table of Contents

This book is a collection of my favorite photos & thoughts from my ~~far~~ travels over the years — for each country I have included a recipe that inspired me, including personal notes, — I have left a space for you to leave any of yours, too.

enjoy!!

~~ARGENTINA~~ 16
AUSTRALIA 22
~~AZORES~~ 28
BASQUE COUNTRY 34
~~BRAZIL~~ 48
~~CABO VERDE~~ 54
CANADA 60
Chile 66
~~CHINA~~ 72
78 Costa Rica
~~EASTER ISLANDS~~ 84
~~el salvador~~ 90
FRANCE 94
~~GALAPAGOS~~ 100
106 GERMANY
Greece 112
GUATEMALA 118
~~HONG KONG~~ 124
130 iReland
134 ITALY
JAPAN 140
Maldives 146
152 Mexico New Zealand 160
166 NICARAGUA NORWAY 172
178 Portugal SAMOA 184 ~~Scotland~~ 190
196 ~~Switzerland~~ TAHITI 202
208 THAILAND Tunisia 212
USA: ALASKA 218 CALIFORNIA 224 HAWAII 230 NEW JERSEY 234 NEW YORK 238

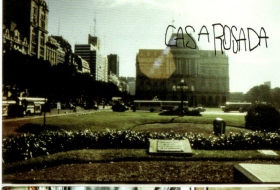

CASA ROSADA

Dream of a coup d'etat
Hipolito Yrigoyen

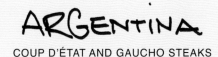

ARGENTINA
COUP D'ÉTAT AND GAUCHO STEAKS

In Buenos Aires, after a heavy milanesa steak dinner and a few glasses of Mendoza Malbec, I woke up alternately cold and sweaty throughout the night, shifting between nightmares. The narrow courtyard outside my hotel room amplified the echoing sounds of the street: cars honking, trams rattling by, people talking and shouting, maybe a wailing police car siren, the thump of cumbia from a nightclub.

A sliver of light streamed through the only window in the room, and in the midst of my hallucination, I imagined the sound of marching footsteps echoing through the narrow courtyard. In a state of paranoia, I imagined the return of a military regime. A raid of death squads from the Dirty Wars under dim streetlights. Another coup d'état tearing through the seams of the city—through the Plaza de Mayo where mothers protested for the children they lost to six years of dictatorship,[1] through parks where men pass around maté at dawn, through the Casa Rosada where dictator Juan Perón and his wife, Eva, delivered speeches beneath the palace's Italianate porticos.

With Perón came political turmoil, then his exile, then years of unstable civilian governments—and then his second wife, Isabel, rose to power. A cycle of military dictatorship ensued. Jorge Videla overthrew Perón. Roberto Eduardo Viola overthrew Videla. Leopoldo Galtieri overthrew Viola. Galtieri's military junta collapsed in 1983, and Argentina worked to restore democracy.[2] And now, in my nightmares, I fear one of them has returned.

But years had passed, and the next morning, I woke up to a clear blue sky, no evidence of the kidnappings and warfare I'd dreamed of.

Pulling a large surfboard bag, I walked to the Retiro railway station at the northeast end of the city, past cake and pastry shops selling medialunas and empanadas and the smells of barbecued beef rising from backyards. A third-class ticket took me on a freezing, unheated, thirty-hour train ride southwest to Bariloche, a city at the foothills of the Andes and the southern shores of Nahuel Huapi Lake. Unprepared for the cold after my time in the tropics and armed with only a backpack full of alpaca fleece sweaters from a distant friend, I hoped to find work in a ski resort and to spend the winter playing in the snow. I'd migrate west in the spring to fulfill my longtime dream to surf the Chilean coast. The train churned along the tracks, through the endless expanse of the frozen Pampas' grassy steppes and prairies, small towns and ranches slinking away into the fertile lowlands. I spent the cold hours alone with a group of Mapuche, huddled up in ponchos and blankets, the Indigenous people who once roamed freely across the Pampas and into Patagonia. They hunted rheas and guanacos, wild versions of the more familiar South American llama until the Argentinian government confiscated Indigenous lands and consolidated its territory in the 1800s.[3]

Centuries after Spanish colonizers herded cattle on ships and brought them over to South America's vast plains, a new class of Argentinians emerged. The gaucho, a mestizo European Indigenous migratory horseman adept at cattle work roamed the frontiers of Argentina, Uruguay, and the Rio Grande do Sul in Brazil in a hunt for hides. The gaucho's food was steak from the wild cows they chased on Spanish horses. At first, the upper classes cast them as vagabonds and outcasts forsaken to an unruly life riding across the plains. But the export of cattle hides became a profitable commercial enterprise and as estates expanded across the Pampas, landowners attempted to tie down and control the wandering gaucho.[4]

After the Argentine War of Independence, Argentinians reimagined the gaucho as an iconic symbol of freedom and Argentine national tradition. Displaced rural workers rallied behind the gaucho, a rugged frontiersman. European immigrants adopted gaucho imagery—their flat boinas or berets, their fogones or firepits, and foot-stomping chacareras, the folkloric dance—in their anxiety to assimilate. At a time when Argentina's elite exalted their European roots, gauchos garnered attention for their non-white, Indigenous ancestry.[5] The way gauchos would slow-roast cuts of beef over fires for an asado—a colossal, giant barbeque—soon became a sacred social event and an emblem of national identity.[6]

Thirty hours after my journey began, the train sailed into San Carlos de Bariloche, a rural town of glittering lakes, snow-capped mountains, Swiss Alpine architecture, and small chocolate shops. The Mapuche Mapudungu language had named this place Vuriloche, or "people from behind the mountain."[7] The Poya, an Indigenous Tehuelche people, traveled from the Andes through forested slopes, marshy meadows, and distant glaciers, keeping the trail to Bariloche secret from Spanish priests.[8]

And now, I had found the cold I had been searching for.

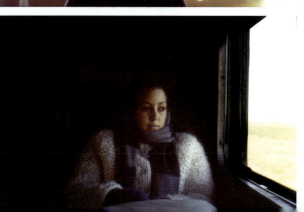

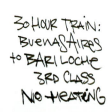

30 HOUR TRAIN:
BUENAS AIRES
to BARILOCHE
3RD CLASS
NO HEATING

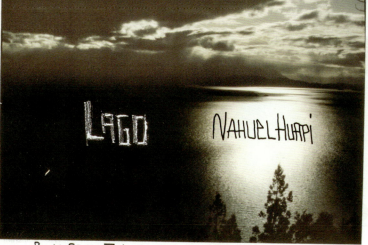

People from behind the mountain
NAHUEL: Jaguar
HUAPI: Island
MAPUCHE — JAGUAR ISLAND

The name Bariloche came from the Mapudungun word meaning - 'Vuriloche' - People from behind the mountains. the Poya people used the Vuriloche Pass to cross the mountains, keeping it secret from the Spanish Priests.

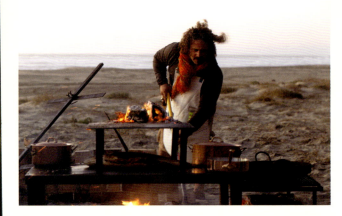

BIFE GAUCHO

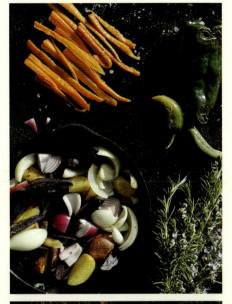

CHIMICHURRI SAUCE

- 1 cup fresh parsley leaves
- 1/2 teaspoon chopped fresh rosemary
- 4 garlic cloves, minced
- 1/2 teaspoon dried oregano
- 1 teaspoon red pepper flakes
- 1/2 teaspoon salt
- 1 cup white wine vinegar
- 1 cup olive oil

SERVINGS: 4

Finely chop the parsley, rosemary, and garlic by hand.

In a large bowl, combine the parsley, rosemary, garlic, oregano, red pepper flakes, and salt. Mix until well combined.

Add the white wine vinegar and mix again.

Slowly pour in the olive oil while continuously stirring until the sauce is well combined.

Cover the bowl and refrigerate the sauce until it is ready to use.

GAUCHO STEAKS

- 4 Tomahawk ribeye steaks (a ribeye cut with at least five inches of rib bone left intact)
- coarse salt to taste
- 2 garlic cloves, minced

Remove steaks from the refrigerator and let them sit until they are at room temperature—about 30 minutes to an hour. Meanwhile, preheat the grill to high heat.

Generously season the steaks with salt.

Place the steaks on the grill and brown on high heat for about 3 to 5 minutes on each side for medium-rare 135°F. Or shorten the grill time for 'bleu' (French for Blue), 115° to 125°F—eat at your own risk!

Remove the steaks from the heat and slice them into strips.

Serve steaks with chimichurri sauce on the side.

Pair with roasted potatoes and vegetables like carrots, peppers, or onions.

The leftover bones can be used for an excellent soup stock.

NOTES

CHEF'S NOTES

Pairing this Gaucho steak with an Argentine Malbec wine is a beautiful thing! I recommend a bottle of Catena Malbec from Mendoza which is situated in the foothills of the Andes

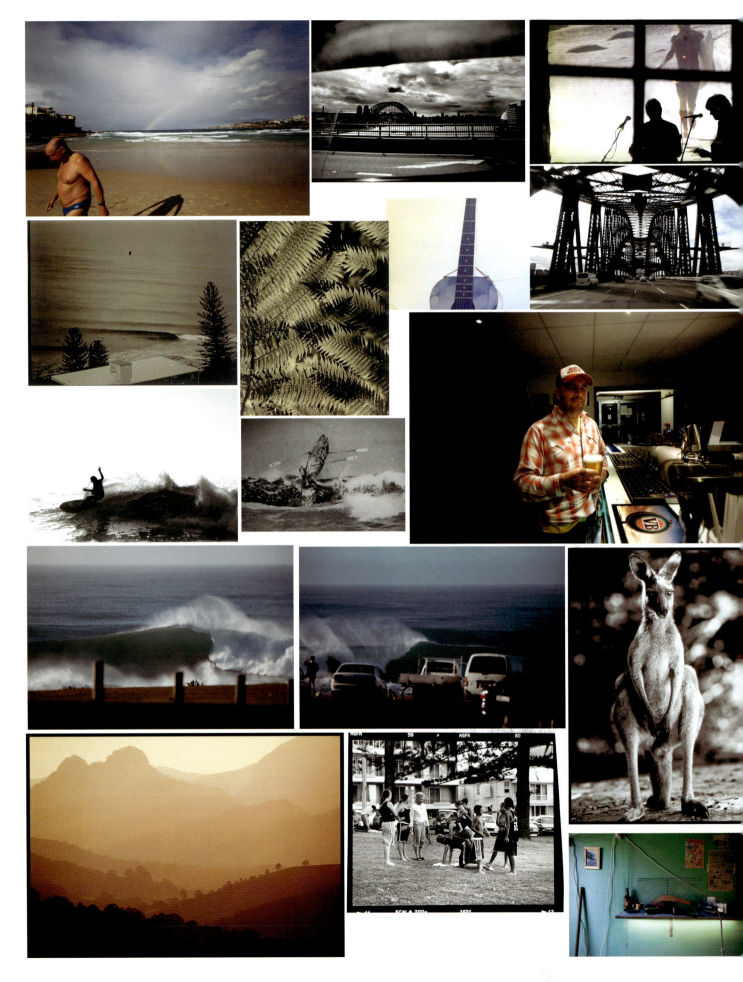

PUB BRAWLS & COLD HOT DOGS

Days on the road in this nation of rust-red soil and nights fueled by Victoria Bitters and gin & tonics taught me that a "real home," as Bruce Chatwin says, "is not a house, but the Road."[1] Before joining my friend, Andrew, his partner, Michelle, and their kids, Bella and Gus, in New South Wales, I imagined days of endless surf. I imagined riding the southerly swells that spill over and crack on shallow right-hand sandbars along the Gold Coast. But when I arrived on his remote farm, Andrew—a musician, filmmaker, writer, and photographer, who surfs and crafts pizzas with as much skill as he does art—convinced me to join his band on tour, filming their live shows. We would wake early, stuff instruments and gear into Andrew's minivan, and wind through the hilly subtropical canopies and flat river plains of Queensland, and through the endless beaches and bushlands of New South Wales. Each night, we returned late to his family, tired, but ready to repeat the journey once the sun rose.

The farm overlooked Mount Warning or Wollumbin in the Bundjalung language. I remember how the moon hung over its jagged peak—the relic of a warrior's spear that once pierced a giant bird, according to some Aboriginal legends. And for some, warriors in battle with each other cause the lightning and thunder that often strikes the mountain.[2] Considered one of the most sacred sites for ceremonies and initiation rituals, the Bundjalung peoples ask visitors to refrain from trekking the mountain out of respect. Some say a songline—a walking path, a dreaming track—stretches through this verdant, volcanic caldera; from the Bunya Mountains, a peak engulfed in ancient pines, to the sharp rhyolite daggers of the Nimbin Rocks.[3]

Long before Europeans colonized this arid terrain, around 500 Indigenous Nations inhabited Australia. In over 250 distinct languages, each married to a particular area of land, Aboriginal peoples told stories of their totemic ancestors—a natural object, plant, or animal that members of a clan or family inherit as their spiritual emblem. These ancestors traversed the continent, marking routes to the land and sky, between places, Creation events, and ceremonial sites. Like the nerves and sinews that bind a body beneath the skin, songlines linked these corridors of knowledge, burgeoning with stories of birth and survival.[4]

Song, dance, story, and mythology become ingrained in the landscape. The elders or the trained Aboriginal peoples will sing the landscape to guide each other across the deserts of Australia's interior.[5] Songlines spread throughout the lands of different Aboriginal groups, but the melodic contours shaping these ancient paths bridge any barriers language might pose.[6]

With colonization came imported sheep and cattle that trampled edible plants and fouled water holes. The colonizers and their livestock—unlikely instruments of genocide—depleted staples of native food, like the murnong, or yam daisy, in Victoria.[7] European encroachment presented Aboriginal peoples with a limited set of choices: displacement, starvation, or assimilation. Assimilation meant survival but also ushered in the end of traditional hunting and gathering in the name of so-called civilization.[8]

In the 1980s, a growing gourmet movement revived interest in Aboriginal peoples' foodways.[9] Restaurants in Australia's glittering urban centers began to offer distinctive, modern takes on native bush foods: seared pepperberry kangaroo filets, finger limes in Michelin-starred kitchens, smoked magpie geese, and green ant cheesecakes.[10] The humble pie, however—an echo of medieval Britain—defines Australia. With its solid, straight-sided crust, and flaky pastry lid, the steak and kidney pie provided settlers with a sturdy, protein-packed meal. The crust doubles as a cooking vessel and container, its pastry originally tough and inedible but able to preserve meat for up to a year.[11]

I had my fair share of what seemed like year-old pies on the road with Andrew and the band, stale pastries oozing with congealed mystery meats that did no justice to the classic Aussie dish. After endless days on tour, how could I not become one with the landscape of bowling alleys, old country pubs, community halls, and clubhouses where my friend's band played? What memories and myths could I glean from witnessing a few rough pub brawls, from stomaching cold hot dogs and day-old pies? I learned to accept the unpredictability of travel, to see a country through the eyes of a close friend, and to understand the complexities of a land embedded in ancient Aboriginal songs.

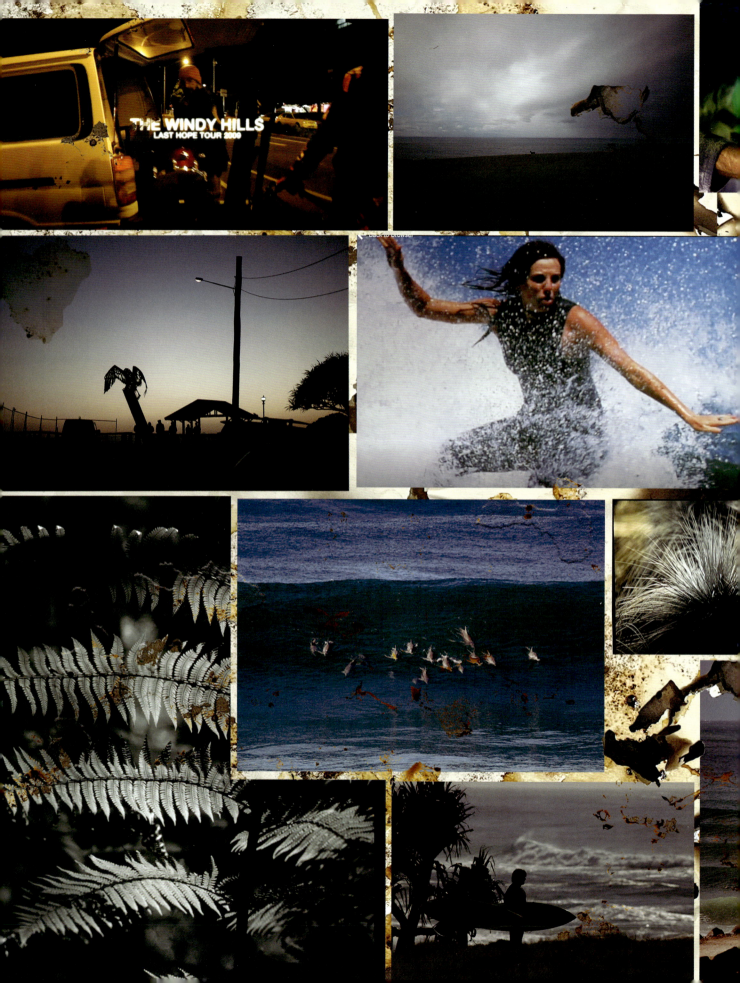

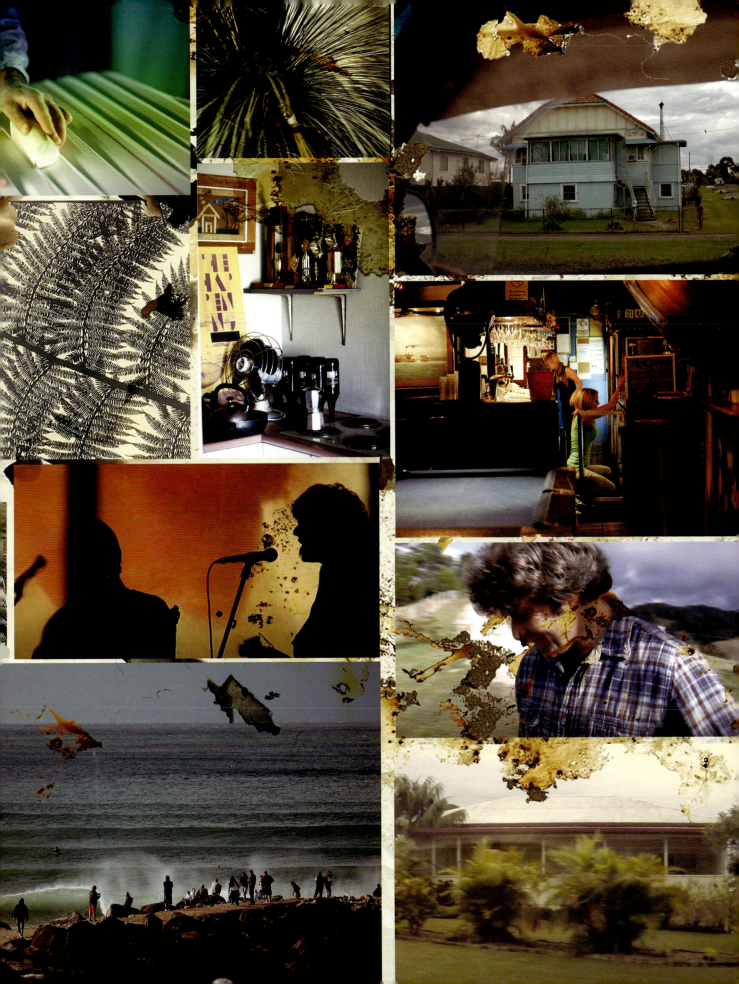

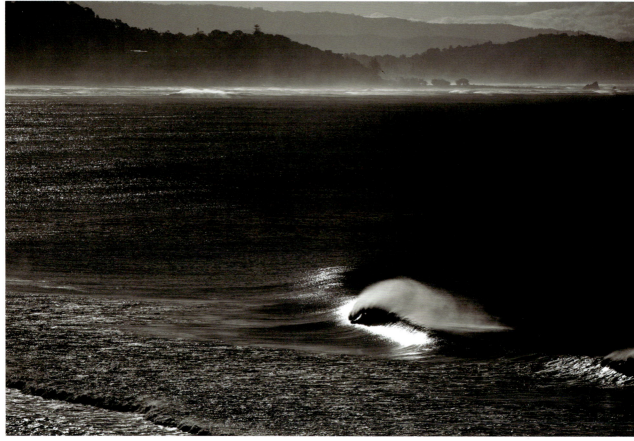

Jalapeño Pasta

The Italian migration population of the world refers to the millions of people of Italian descent who have left Italy and settled in other countries throughout the world. Italian migration has been happening for centuries, with large waves occurring during the late 19th and early 20th centuries as well as after World War II. Italian migrants have made significant contributions to the countries they have settled in, including Argentina, Australia, Brazil, Canada, and the United States, among many others. They shared their recipes with the world, from pasta, pizza, gelato, and more, with Italian cuisine becoming a global sensation.

Initially, when I worked as a dishwasher at Olio, I learned this recipe from Chef Roman, who started an underground lunch project at his Italian import wine & olive oil shop in Germany to attract customers. All he served was jalapeño pasta, a recipe that he discovered in the south of Italy, that is very oily, spicy, and delicious. Since its humble beginnings, Olio has become one of the most popular fine-dining spots in Dusseldorf.

- extra virgin olive oil
- 5 garlic cloves
- 3 jalapeños
- 4 or 5 fresh plum tomatoes or a 28 ounce can of Italian-style plum tomatoes
- 1 bay leaf
- salt to taste
- 3 whole black peppercorns
- 10.6 oz of chicken broth or veggie stock
- 1 pound box of penne

SERVINGS: 4

CHEF'S NOTES

WITH ITS SPICY & CRISPY ELEMENTS OF JALAPEÑO & GARLIC, THIS DISH TRANSPORTS ME TO NORTH AFRICA.

PAIR WITH MINT TEA

This is an ode to the Italian migration population of the world. One of my best memories is cooking this dish for my good friends in Australia, who are vegetarians. Andrew Kidman is Australian, and his partner Michele Lockwood hails from New York City, where she grew up around her Italian family. Michele's grandmother was a great Italian cook. She came from Italy by boat to New York with her ten children and settled in Brooklyn. We harvested the garlic, jalapeños, and tomatoes from Andrew's garden, where he grows them from seed.

Part 1: The Sauce Thinly slice two cloves of garlic. In a pan with olive oil about an inch deep, slowly sauté the garlic. Add 2 jalapeños cut in half lengthwise, leaving the seeds, to the pan.

Once the garlic becomes slightly golden, add 4 or 5 sun-ripened whole plum tomatoes; if tomatoes are not in season, add a can of Italian-style plum tomatoes. Add the bay leaf, salt, and a few whole black peppercorns.

Add your chicken or veggie stock, and simmer for about 2 to 3 hours with the lid tightly on. The fresh tomatoes should only be cooked for about 45 minutes to an hour, check consistency and make sure it doesn't burn.

Part 2: The Jalapeños Dice the third jalapeño about 1/2 inch thick. Pour about an inch and a half of olive oil into a medium-sized pan to make sure the jalapeños are generously covered. Sauté the diced jalapeño on medium heat until almost crispy—be careful not to burn the pepper!

Add 3 cloves of garlic, cut thinly crosswise, to the pan. Turn the heat down and slowly infuse the oil with the garlic and jalapeños.

Part 3: The Pasta Timing here is crucial! Boil water and cook your pasta, using the directions on the box.

Chop up a generous amount of flat parsley and set aside. As the pasta is cooking, fill a large jar with the tomato sauce and chopped parsley.

Immediately toss the hot olive oil/jalapeño/garlic mix on top of the tomato/parsley mixture and start stirring.

Rinse and serve pasta on a plate. Pour over the pasta and serve right away while the dish is hot.

NOTES

A VOLCANIC ARCHIPELAGO

The rugged tips of nine underwater mountains rupture the North Atlantic Ocean, two-thirds of the way from New York to Lisbon. The Açores, a volcanic archipelago, rise into a swirling mist and straddle the Eurasian, North American, and African tectonic plates.

The islands' early inhabitants likened the ceaseless, violent volcanic eruptions that decimated their villages to the wrath of angry gods—penance for the sins they brought with them.[1] Like the Earth's arrhythmic heartbeat, maybe the constant ripple of tremors across the islands—27,000 within only a few months in 2022 after decades of silence—signals a cycle of destruction and rebuilding, year after year.

Ancient poets like Homer and Horace sang of the Fortunate Isles in the Western Ocean, an earthly paradise for those pure enough to enter the Elysian Fields following three reincarnations.[2] Following Plato, the lost remains of Atlantis could have been found in the hot springs, towering peaks, and lush, fertile soils of the Açores.[3]

No people or animals populated these tiny atolls of black lava until 15th-century Portuguese explorers first docked their caravels and other small sailing vessels along the shores of Santa Maria and São Miguel—or so people say. But recent studies have unearthed evidence of agriculture and livestock up to 700 years prior to Portuguese presence—perhaps a vestige of the Vikings' nautical abilities.[4]

When Flemish settlers arrived on the island of Faial in the late 15th century, they dried, powdered, and fermented woad, extracting a deep blue dye. Portuguese fleets returned from India, fusing local foods with cinnamon, nutmeg, allspice, and pepper. During the Spanish occupation, fleets docked in Faial's ports, where they unloaded galleons flooded with South American gold and Caribbean spices.[5] And in 1939, the first Boeing 314 Clipper four-engine seaplane brought Americans to Horta's port.[6]

One late autumn, my friend Greg and I reached Horta, a port town in Faial. A city of sailors steeped in the traditions of past generations, Horta has become a quick stopover for seafarers and yachtsmen. The people of Earth's continents converge on this tiny speck of lava-rich land in the middle of the Atlantic.

We ventured away from the colorful yachts bobbing in Horta's marina and sailed between the islands by ferry. Across the archipelago, cliffs collapse into a steep coast, vast craters bubble and boil, and boundless thickets of pastel hydrangeas line seaside roads and crown abandoned Baroque churches like the Earth sealing the scars of its past.

On a remote stretch of one of the outer islands, we searched for a place to stay the night in a small village with ivy-covered stone houses. With no hotels in sight, a family opened their doors to us, and the father shared moonshine so potent you could run a moped on it. In the kitchen, I could smell the kale, kidney beans, and smoked chouriço sausage simmering in a pot of sopa de couve.

We hired a farmer in town to take us to a wave we'd spotted from way up above. Armed with rubber boots, a pack of cigarettes, and a machete, he sliced through dense brambles to unveil a forgotten goat path. Only one wrong step on this almost vertical cliff could lead to our deaths. After a couple of hours, we made it—only to find the wave blown out by the afternoon trades. The next day the swell had died and the spot was nonexistent.

The sea that surrounds these islands shapes the homemade, heart-warming local cuisine. The ocean ushers in garlicky stewed octopus, grilled lapas smeared in musky olive oil, lemon, and parsley, and plates oozing with piles of pastéis de bacalhau, codfish balls made from potatoes, dried cod, onion, and parsley. Fajãs, the flat forelands formed from ancient lava, plunge into the ocean below. The fertility of these fajãs favored agriculture, and settlers once grew yams, maize, tarot, greens, garlic, and figs. Abandoned after successive waves of earthquakes, the overgrown fajãs exist as a reminder of the fleeting nature of human settlement.

Pork has become a prized staple on the island. Every Christmas, families revel in a celebration that spans several days. A pig would be slaughtered and cleaned on the first day, then hung from the ceiling as a symbol of joy and prosperity. Cows also graze in lush green pastures, and as with pigs, Azoreans waste no part of the animal. Tender tripe stewed with white beans and sausage. Chouriço à bombeiro, or the "fireman's sausage" doused with aguardiente, a potent distilled spirit, and then set ablaze. Rissóis de carne, deep-fried turnovers stuffed with a spicy beef mixture.

We head into town, where a fish market offers eel, barnacles, limpets, and clams. And no other place in town embodies Horta's sailing tradition like Peter's Café Sport. For more than eight decades, this family bar has represented a cultural landmark as important as the Caldeira crater or the ruins of a church destroyed in the 1998 earthquake. A hearty dinner of Whale Soup—a beef and vegetable stew—was incomplete without Peter's house gin. Peter's Gin do Mar, infused with passionfruit liquor, became popular with the workers from British telegraph cable companies who made landfall in Horta more than one hundred years ago.

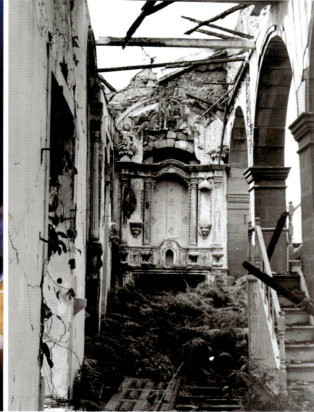

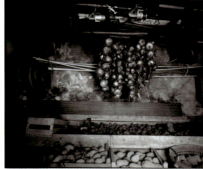
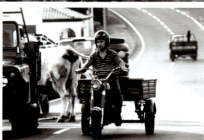

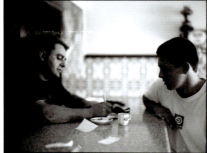
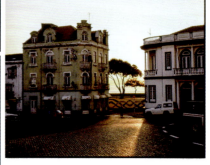

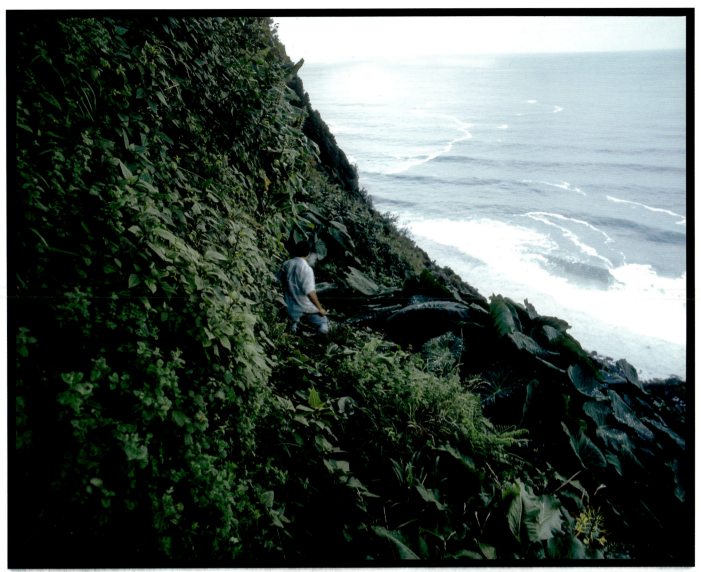

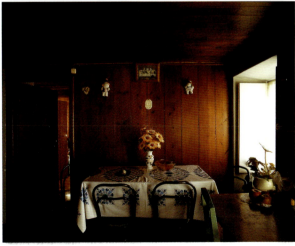

OUTER ATLANTIC ATLANTIS

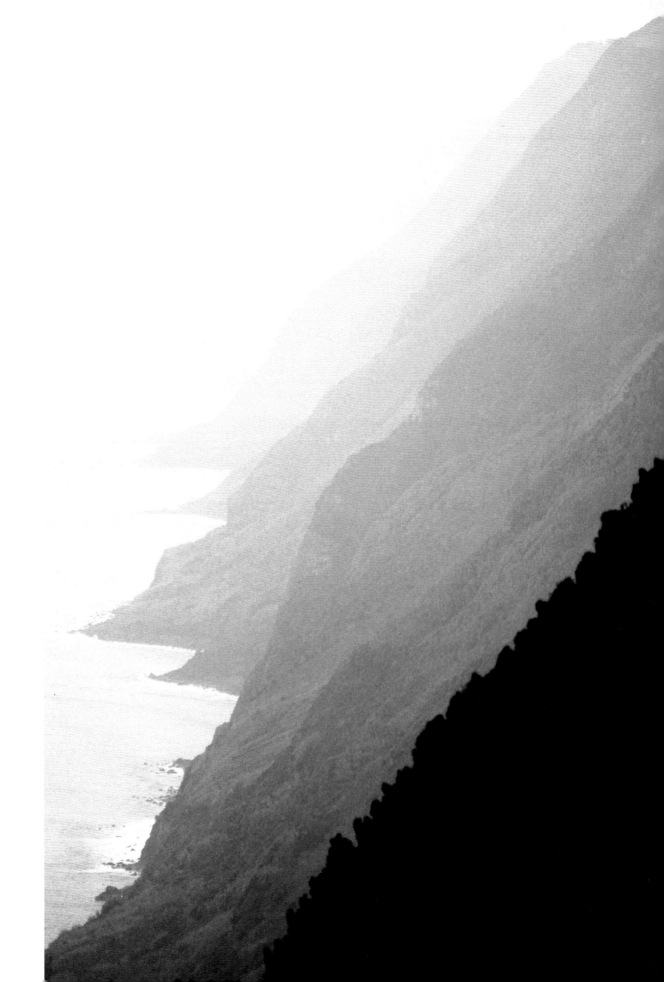

Sopa De Couve

Kale soup has its roots in the traditional cuisine of the Azorean people, who relied heavily on agriculture and livestock for sustenance. The fertile volcanic soil of the islands allowed for the cultivation of various crops. Kale, or couve, is a staple vegetable in the Azorean diet due to its hardiness and ability to thrive in the region's climate. Enjoy your delicious and hearty sopa de couve from the Azores, made with kale and chorizo, a cured sausage made with pork and spices local to the Iberian Peninsula.

- 2 tablespoons olive oil
- 3/4 pound chorizo sausage, sliced
- 1 large onion, chopped
- 2 garlic cloves, minced
- 2 medium potatoes, peeled and diced
- 4 cups chicken or vegetable broth
- 1 14.5 ounce can diced tomatoes (alternatively, 4 to 5 fresh diced tomatoes)
- 1 teaspoon dried thyme
- 2 15 ounce cans northern beans or other white beans
- 1 large bunch of kale, chopped
- salt and pepper to taste

SERVINGS: 4

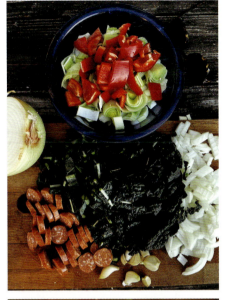

Heat olive oil over medium heat in a large pot.

Add the sliced chorizo and cook until brown.

Then add chopped onion and garlic and sauté until the onions are translucent.

Add diced potatoes and stir until they are completely coated with the oil.

Pour in broth, tomatoes, and thyme. Bring the mixture to a boil.

Add the two cans of beans to the mixture and stir.

Bring the pot of soup to a boil, then reduce to a simmer for about 20 minutes.

Add the kale and stir in until slightly wilted and al dente. Serve warm.

Notes

CHEF'S NOTES

After a long day in the steep cliffsides, farmers reheat to a big bowl of soup, which gets washed down w/ the moonshine that we were served. Cured right in the cave cellar underneath their home.

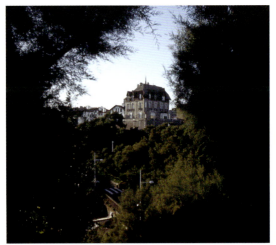
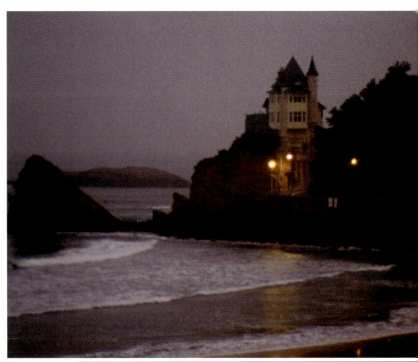

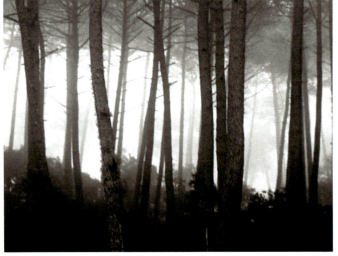
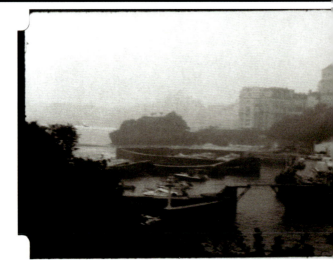

BASQUE COUNTRY NORTH

THE SUN ALSO RISES

Euskal Herria stretches across more than 90 miles of the Atlantic coast, from Bilbao to Bayonne, a fortified city and the capital of the French Basque Country. The Pays Basque spreads throughout three French provinces: Labourd, Lower Navarre, and Soule. Verdant valleys and hills morph into the rugged base of the Pyrenees. White farmhouses with red-trimmed roofs nestle between French oaks, holly hedges, hazel shrubs, and black elderberry trees.

Biarritz—less than an hour's drive from the Spanish border—is a city of grand villas, the sweetest surf spots, turreted châteaus, and chic eateries that bloom and perfume the air. Seaside cafés serve tender French mussels bathed in an herb vinaigrette, thinly sliced pieces of cured jambon de Bayonne, and soft ewe's milk cheese. Napoleon III and his wife, Eugénie de Montijo, reshaped this once-modest fishing village into a fashionable resort town in the 19th century.

Their palace brought prestige to the town, pulling the world's elite like a magnet into this Basque coastal gem. Frank Sinatra and Coco Chanel may have scooped briny fines de claire or sipped a chilled white wine by the pool of the Hôtel du Palais. Jean Cocteau strode down Biarritz's golden beaches at sunset. Ernest Hemingway meditated on discomfort in the things that should be most simple and heart-warming: dancing, liquor, fishing, friendship.

In the winter, rain shrouds the cliffs that pierce the Bay of Biscay. In the summer, a throng of tourists flock to Biarritz's beaches to lounge beneath brightly colored parasols. And surfers search for the perfect waves in La Côte des Basques like screenwriter Peter Viertel and producer Richard Zanuck behind the scenes of *The Sun Also Rises* in 1956.

That summer of 1956, the first surfboard appeared in Biarritz—birthing the surf scene in Europe—imported from California and smuggled across the Spanish border into France as Franco's regime intensified.[1] Viertel left his board with Joël de Rosnay, who pioneered the first French surf club and became one of the best surfers of his generation.[2] Surf culture soon spread to Gipuzkoa and Bizkaia in Spain, where Iñaki Arteche crafted his first board, and in 1964, Iñaki and his brother, Javier, first rode the waves of San Sebastián's crystal-clear La Concha beach.[3]

Biarritz, the birthplace of European surf, soon became home to Basque pros like Lee-Ann Curren, born into a legacy of French Basque surfers. Lee-Ann's mother, Marie-Pascale Delanne, vice-champion of France and Europe, pioneered women's surfing. Her father, American Tom Curren, a three-time world champion surfer, has become a living legend. Together, they established a lineage of surf royalty, taming waves along the moody Biarritz coastline.

In a white villa overlooking a famous surf break near Biarritz, on the Lapurdi coast, American surrealist Man Ray shot *Emak-Bakia* in 1927. Infused with rayographs, double exposure, soft focus, and ambiguous features, the short film also features a shot on a single plane showing the hilly terrain of isolated farmhouses. Spanish filmmaker Oskar Alegria later embarked on a quest to find Man Ray's mythical house, walking and wandering around the Basque shoreline. *Emak-Bakia* means "leave me alone" in Basque but it can also mean "give peace." And perhaps this is exactly what the French Basque Country did for those who stepped foot across its rugged seascape and lush slopes.

A refuge for Hemingway's characters from the guilt of Pamplona's raucous Fiesta de San Fermín. A hideout for ETA at the height of its activity in the 20th century. A place for sharing the passion of becoming one with nature among seasoned Californian surfers and Basques in the Bay of Biscay. A pilgrimage site for those in search of peace and solace.

My good friend, Sancho Rodriguez, is originally from Irun, an old Roman town that sits a stone's throw away from the old border that once divided the French and the Spanish Basque country. During the height of the pandemic, Sancho had ample time and energy to jump into something new. At the time, it was forbidden to set foot on the beach or go surfing in the waters of the Atlantic—neither on the French side nor on the Spanish side. So, Sancho catapulted his energy inland where, with the help of internet maps, he scoured out old forgotten vineyards from the early 1900s that were long, long forgotten; he drove out there and started tiling those fields, just by himself, camping for a few days, his only helper a small rototiller. Sancho slept in his tent, channeling memories from early surf discoveries he made in the 1990s, from Desert Point to Grajagan, Uluwatu—and to the empty days at his beloved Mundaka in the Bay of Biscay. This was a new chapter in his life; now with a partner and two kids, he put his adventurous spirit into something that could support his young family! I remember the first time he called me to tell me about this new venture; he was very fired up and excited about it, sheer stoke! Sancho started selling the wine under the *Manin y sus muchachos* label, a collective. Manin is the name of Sancho's vine pruning mentor, an old Portuguese man who he met when he was a kid, going up to visit the family's vineyard in Rioja.

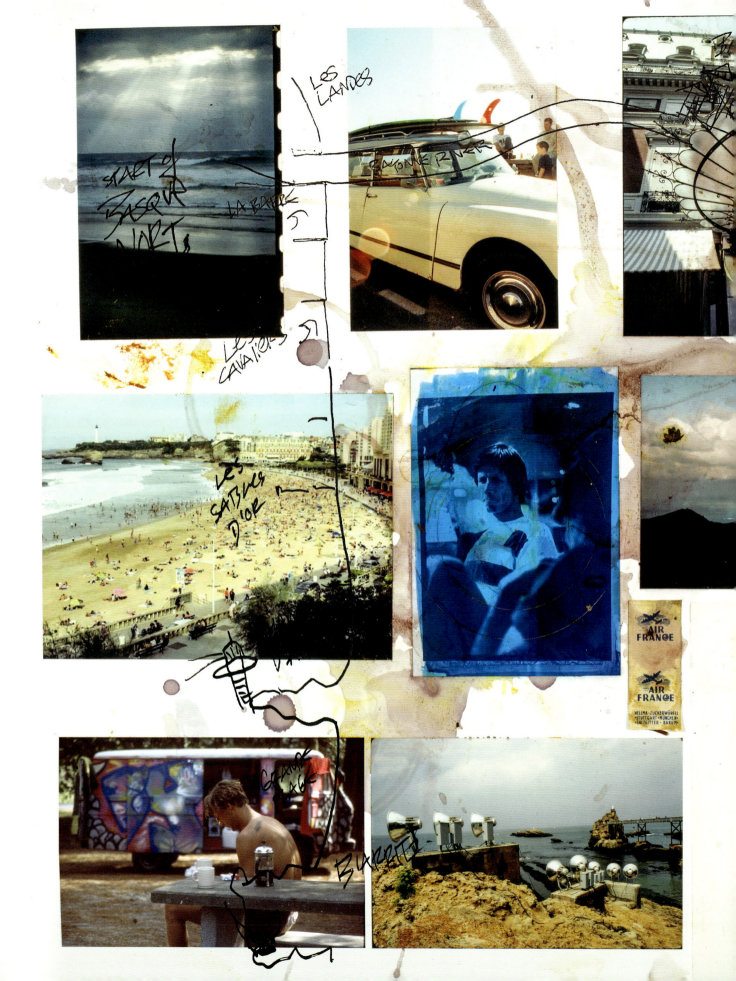

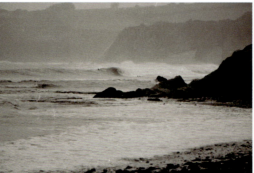

Moules Basquaise

Moules Basquaise is a popular seafood dish from the Basque region of France. It typically consists of mussels cooked in a sauce made with tomatoes, onions, garlic, peppers, ham, and white wine. Often, a pinch of piment d'espelette—a moderately spicy red pepper introduced to the Basque region in the 16th century and now a designated product of the northern Basque region—adds just the right amount of heat. If it's available, please use it!

- 3 tablespoons extra virgin olive oil
- 1 onion, finely chopped
- 2 large pointed red peppers, sliced
- 2 garlic cloves, sliced
- 8 cherry tomatoes
- 2.5 ounces cured ham, chopped into small chunks
- 2 cups dry white wine
- 3 pounds mussels, cleaned and debearded
- salt and pepper to taste
- 1 pinch of red chili powder (piment d'espelette, if available)
- 1 bunch fresh flat-leaf parsley, roughly chopped
- baguette or other crusty bread

SERVINGS: 4

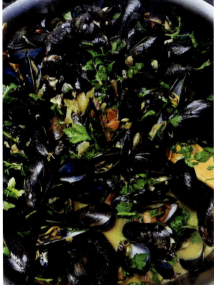

Begin by heating olive oil in a wide pan, large enough to hold all the ingredients, over medium heat. Add onions and peppers and cook until they begin to soften. Then add in garlic. Add tomatoes and the ham to the mixture and cook thoroughly. You can tell when it's ready when the tomatoes are beginning to blister and the ham is beginning to glaze.

Once the sauce is ready, pour wine over the mixture and crank up the heat. Bring to a boil.

Add mussels, cover with a lid, and bring the liquid down to a simmer. Cook for about 5 minutes until all of the mussels have opened. If any mussels do not open, discard them.

Season with salt and black pepper to taste, adding just a pinch of red chili powder.

Serve in bowls, garnished with chopped fresh parsley.

Enjoy your moules Basquaise with crusty bread and a glass of white wine; the best wine to pair with this dish from the terroir: a Manin Clarete Nuevo Antiguo 2019.

CHEF'S NOTES

Pair with a wine from the terroir: my friend Santxo Rodriguez, (brother of) has been resurrecting defunct vineyards in the Basque Zone some as old as 40 years. ~~2019 was the~~ MANIN Clarete Nuevo Antiguo 2019

NOTES

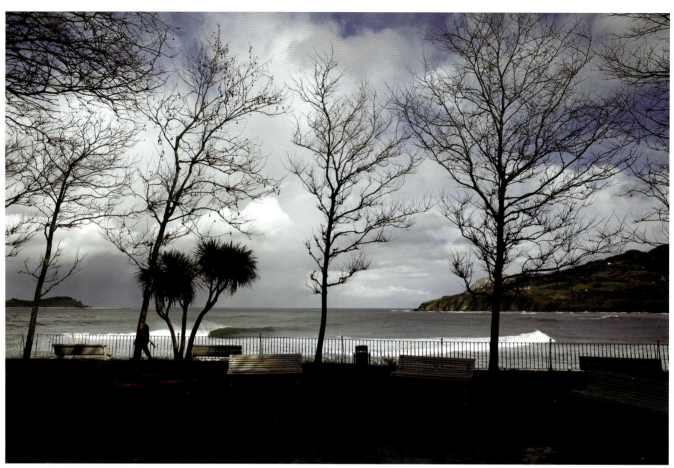

DANCING WITH TXULETA BONES

The first time I arrived in Donostia-San Sebastián, a short, beefy man held me at knifepoint and demanded my wallet. Those were the days before Bilbao became Guggenheim-ed, before world-class institutions shielded in swooping metal sheets like rainbow fish scales reshaped an industrial city on its deathbed. Those were the days before San Sebastián's seaside pintxo bars earned Michelin stars, from Arzak's innovative tasting menus to the ever-evolving Mugaritz in the riverside town of Rentería. These changes, despite their challenges, brought more visitors with a shared passion for Basque food, landscapes, and culture.

Those were the days when factories nearing abandonment still spewed clouds of smoke. In the mid-19th century, across the Spanish Basque provinces of Bizkaia and Gipuzkoa, modern blast furnaces smelted iron ore.[1] To the north of Bizkaia and Gipuzkoa, the Álava province clung to its green foothills and valleys until the 1950s, when steel mills and factories razed tracts of the agricultural heartland.[2]

The demand for Basque steel ignited with the outbreak of World War I, powering the weapons, ships, and tanks that tore through Europe. But with the transformation of Basque steel as a world standard also arose a new economic class of workers, their repression and exploitation, and the birth of the Basque nationalist movement.

In 1937, a year into the Spanish Civil War—a war of class and religion, of dictatorship and democracy—the fascist general Francisco Franco enlisted Nazi support and strafed and bombed the Biscayne town of Gernika. Picasso immortalized the horrors in Guernica, an international symbol of civilian casualty.[3] Picasso's interpretation of both Franco's dictatorship and the attack on the Basque town of Guernica only set the stage for the struggles that would ensue.

Those were the days when Euskadi Ta Askatasuna, or ETA, the armed Basque separatist group still besieged the Spanish Basque Country's mountain villages, pine forests, and decaying industrial fortresses. Since the end of the 19th century, Euskara neared obsolescence, as schools stigmatized the Basque native tongue. Franco's dictatorship banned Euskara from public life—an attempt at linguistic and cultural genocide.[4]

The political conflict that engulfed the region's dark, rocky coastline lasted beyond Franco's regime. In its four-decade campaign for a sovereign Basque state, ETA first tried to derail trains transporting key politicians, then planted bombs in airports, car parks, bank headquarters, police barracks, and southern beach resorts.[5]

But not even a knife to my throat on my first trip to Euskadi could stop me from returning. I returned for the powerful Atlantic and its consistent year-round swells. I returned for the vine-ripened tomatoes and mushrooms displayed in woven baskets and wooden crates, the buckets of gnarled goose barnacles. I returned for the steaming cups of bone broth from a small café with a sign announcing salda badago! We have broth!

I returned for the people, who invited me to their homes where we drank deep red Riojas into the night, as if the practice of crafting Remelluri's Gran Reserva had never been in danger of dying out.[6] I returned for friends like Sancho, who drove around with a hunk of txuleta on his gearbox on a cold and rainy autumn day to help the meat reach room temperature to remain red and juicy on the inside. I remember one evening at Sancho's family home in Irun, one of the oldest houses among the hilltops, where xirimiri—a light, constant drizzle—fell as we flipped thick cuts of txuleta over the living room's fireplace. We sat at a long table, the patriarch Don Jaime at the helm, along with a group of friends, Peta, Borja, Xabi, Inigo, Mikel, Iñaki, and others, enjoying the festive time.

One night, Sancho, the founding director of "Savage Cinema," the Action Sports category at the San Sebastián International Film Festival, invited all of the filmmakers for a txuleta steak dinner. I was taken with the idea to collect all of the leftover bones from people's plates. I stuffed these gargantuan bones into a plastic doggie bag. After the dinner, we arrived at San Telmo, a 16th-century convent turned museum, for a VIP film festival party. In the cloakroom, the attendants rejected my coat. They had sniffed out my cherished treasure. I couldn't leave my bag of bones behind, so I spent the night dancing with the bag, a rich, meaty smell following me across the dancefloor. But the sacrifice was worth it. Over the next two days, using a simple electric coil stove back at our apartment, I channeled my energy into crafting a broth that I shared with friends, keeping us warm and nourished for days and days. ¡Salda badago!

In these moments, I thought of how, despite decades of violence, Franco couldn't uproot ancestral traditions of winemaking, shipbuilding, and fishing. Basque musician Mikel Laboa sings about a bird whose wings couldn't be clipped in Txoria Txori; throughout the years I returned to Euskadi, I understood what he meant.

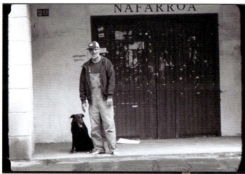

Pasaia is a town and municipality located in the province of Gipuzkoa in the Basque Autonomous Community of Northern Spain. It is a fishing community, commercial port and the birthplace of the famous Admiral "Blas de Lezo".

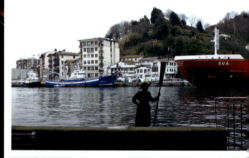
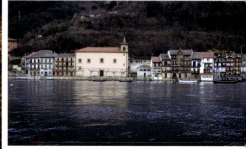

SALDA BADAGO

Salda badago, the Basque name for clear beef broth, directly translates to "we got broth." While traveling through Basque country, I spotted signs for this at taverns and somehow interpreted this as a gesture to say, "Welcome to this place, sit with us, and drink an inexpensive hot-tasty broth to warm up your soul and feel comfortable here with us." Speaking with friends from Basque country, they say that in a world of pure capitalism, where all the food, drinks, etc., are becoming more and more expensive, salda remains something affordable and working class, and offers little profit to the boss of the restaurant—but it is still being served all over Basque country.

- 7 pounds of beef bones
- 2 large yellow onions, diced
- 1 bunch of celery, roughly chopped
- 1 horse carrot (or about 1 pound of smaller carrots), cut into smaller pieces
- 1 head of garlic, broken into cloves, skins removed
- 2 bunches parsley stems (mince the parsley leaves and use to garnish the finished soup)
- 1 bunch thyme
- 10 bay leaves
- 8 peppercorns
- enough cold water to cover all ingredients

SERVINGS: 4

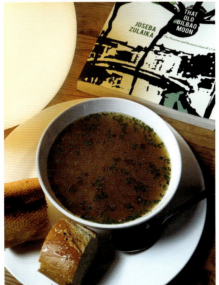

Begin by rinsing all the meat and vegetables in cold water. Pat dry.

Roast the beef bones in a large pan at 350°F in the oven for 45 minutes.

Add onions, celery, carrots, and garlic to the beef bones and stir; continue roasting for an additional 20 minutes.

Empty the entire pan (including the fat) into a large stock pot. Add parsley stems, thyme, bay leaves, and peppercorns. Then fill the stock pot with cold water, covering all the ingredients.

Boil the mixture until the liquid is reduced by 2/3. Depending on the size of your stock pot, this may take several hours or even overnight. If it is overnight, reduce the heat to a slow simmer.

Remove bones, parsley stems, and thyme from the broth. Strain liquid and discard solids.

Chill broth overnight or until a thin fat layer forms on top of the liquid. Then remove the fat layer and discard.

Serve steaming hot with a garnish of minced parsley. Add a raw egg if you like. Some crusty bread on the side is mandatory!

Recommended soup slurping literature: Ernest Hemingway's *The Sun Also Rises* or, as pictured, Joseba Zulaika's memoir and history book, *That Old Bilbao Moon*.

CHEF'S NOTES

When I first saw the sign "Salda Badago" displayed in Basque taverns, I thought it was a "you are welcome" greeting. But it means 'we got broth', an invitation to fuel up on this inexpensive working class superfood

FEIJOADA

I first expected Brazil to look like this: a tropical paradise, where strolling beach vendors served skewered shrimp, and beautiful bikini and speedo-clad people sipped caipirinhas in the sweltering heat while "The Girl from Ipanema" crooned from a radio. As I walked along the frozen, wintry sidewalks of central Europe and passed travel agencies advertising this land, I imagined myself basking in the glow of a golden sunset melting behind Rio de Janeiro's Sugarloaf Mountain. But when Alma Surf magazine's print publication invited me to São Paulo in the dead of winter, I saw Brazil as this: overcast and chilly, where Oscar Niemeyer's sleek concrete façades and elegant domes curved around posh luxury stores, and squatters made their homes in the remains of half-burned skyscrapers covered in the angular, rune-like graffiti of pixação.[1]

Over twenty-two million people extend across São Paulo's metropolitan area, the biggest and richest of Brazil's cities. A terrain of shopping malls, hotels, cultural centers, and the world's best restaurants spell out visions of modernity. Industrial suburbs have consumed the valleys and foothills surrounding the city, so the wealthy retreat to high-rises and guarded compounds. Niemeyer's architecture aimed to inspire a future that would bridge the stark divides of class, intertwining progressive politics with courageous, free-form edges and radical urban planning.[2]

But the wealth that flows from the city's banks escapes the hands of millions. Precarious, informal housing and cosmetic and chemical factories swallow the lower parts of the alluvial land lining three riverbanks—the Tietê, the Pinheiros, and the Tamanduateí.[3] My local friends advised me not to walk around the city alone. As scenes from the 2007 documentary Manda Bala—Send a Bullet—surfaced, I valued my ears enough to steer clear of any potential danger and heeded my friends' warnings. But I never felt unsafe. I felt the warmth and gentleness between people, even in this giant metropolis.

São Paulo's foodscape amplifies the city's contradictions, yielding to a mix of modernist, gourmet cooking with echoes of traditional Brazilian ingredients. Nestled in the chic Jardins neighborhood, chef Alex Atala placed Brazil on the map of world cuisine with polished reinventions of indigenous ingredients. Amazonia pirarucu fish with açaí berry. Farofa mille-feuille. Heart of palm fettuccine.[4] The gourmet establishments that glitter from São Paulo's posh neighborhoods can't overshadow the contributions of the working class and a global flux of immigrants, who created the wealth of this city. Late into the night, pastelarias sell deep-fried, heart-of-palm or mozzarella-filled pastries adapted from Chinese spring rolls.[5] Temakerias, the fast food sushi restaurants unique to Brazil, craft hand-rolled pieces of mango, kiwi, and garlic chives fried in butter.[6]

The deep scars of slavery run through Brazil's national dish, feijoada, a black bean stew traditionally brewed with the cheapest cuts of meat: pig's ear, jowl, feet, and tail, sometimes beef tongue. Food historians may disagree on the true origins of this meal, but popular storytelling recounts how enslaved people from the African continent would salvage the meat refuse from the kitchens of their cruel Portuguese masters.[7] Surviving the violence on 19th-century sugarcane plantations, Afro-Brazilians used native black beans and the aromatic heat of dendê oil to coax a rich flavor, texture, and sustenance from the most undesirable leftovers.[8]

Feijoada climbed its way up the social ladder and soon reached even the most expensive tables of the 20th century. Today, cured carne seca or smoked pork spareribs might also simmer beside sautéed collard greens or kale, orange slices, and a sprinkle of farofa—toasted cassava flour. Across all classes, a dish as warm as the pagoda that pulses through São Paulo's streets must be shared with friends or family on a weekend afternoon.

In Rio de Janeiro, southeast of São Paulo, I finally felt the warmth and the music pulsing. A decade had passed since my first visit. I returned to Brazil to welcome a new year with a dear friend, an actress, healer, and artist born in this seaside city teeming with life. In this hot, heavy summer, the city seemed to palpitate. Children scurried between narrow alleyways, escaping the summer's steamy downpours. Beachfront bars thumped throughout the night. I sensed a poetic beauty in the way nature swallowed this sprawling city. Some cities with millions and millions of people can make you feel isolated, but in Rio, there was a kindness and softness to how people moved through this chaotic space together.

And on New Year's Eve, we donned our white clothes and swarmed the beaches in celebration of Iemanjá, the goddess of the sea, a central orixá, or spirit, of the Candomblé religion.[9] Groups of women in billowing white dresses formed circles as they danced and sang, undulating like sea foam at the crest of churning waves. They made offerings of sweet rice and coconut puddings, jewelry, perfumes, and flowers to Iemanjá.

In that moment, we asked for peace and spiritual purification, but in this country of stark contrasts, political tensions boiled and broke out days later in Brasília. Only a week after Luiz Inácio Lula da Silva's inauguration, the threat of a coup shook the nation's capital.[10] But for now, a return to democracy looms on the horizon.

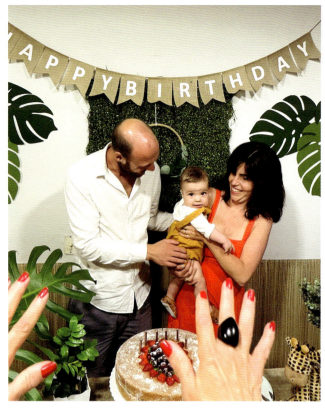

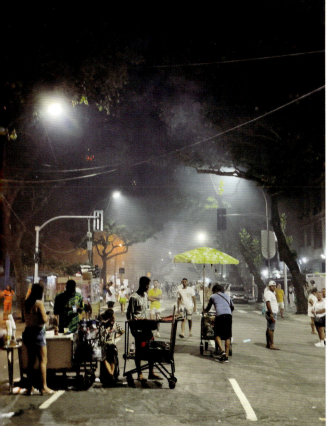
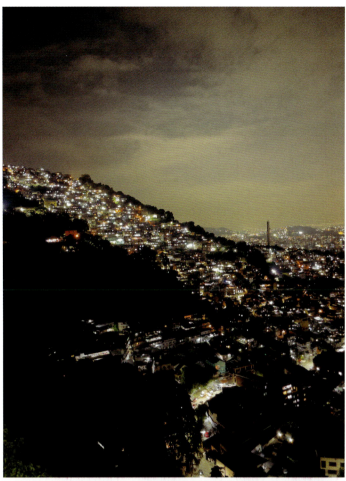

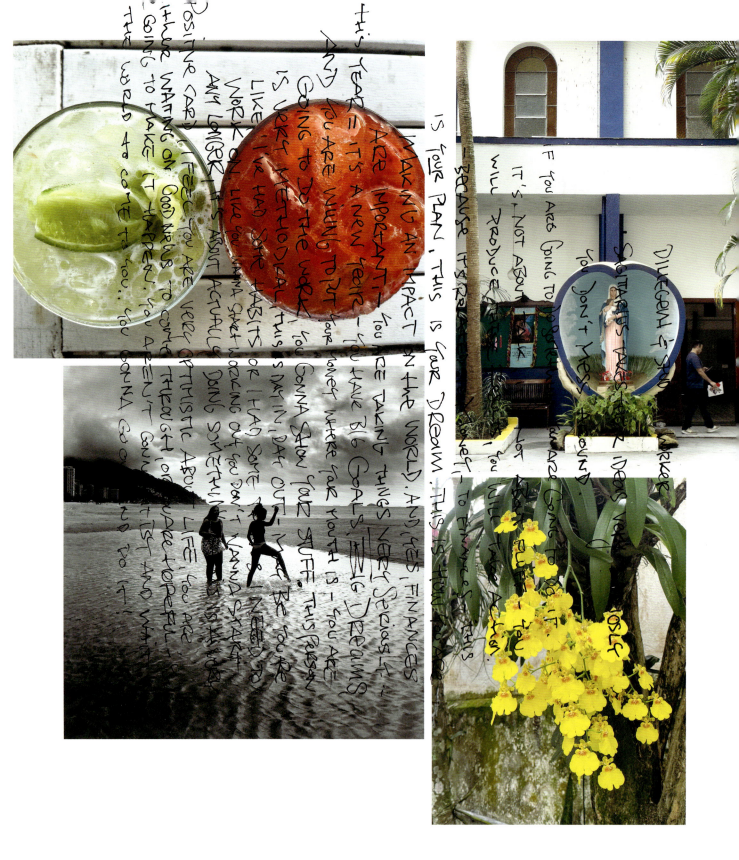

Feijoada

The best of all world cuisines in one pot! Feijoada is a black bean and pork stew that is often served with farofa—toasted cassava flour—sprinkled on top or on the side. I have always been a huge fan of this big hearty stew as it combines different meats, hence why I cook these meats on the griddle first, and then dump it all in together. But obviously, that's personal preference!

- 1 pound dry black beans
- 4 ounces slab bacon
- 1 tablespoon olive oil
- 1 pound pork ribs, cut into individual ribs
- 2 Mexican chorizo sausages, sliced
- 1 smoked sausage (I recommend linguiça or kielbasa), sliced
- 1 large onion, chopped
- 4 garlic cloves, minced
- 3 tomatoes, chopped
- 1 teaspoon sea salt
- 1 teaspoon ground black pepper
- 3 bay leaves

Servings: 4

In a large bowl with water, soak the beans overnight.

With the rind removed, dice the bacon. Add it with oil to a large soup pot over medium heat and cook until crisp.

Take the bacon from the pan and set aside on a plate; use the same pan to brown the ribs.

On a griddle, cook the sliced chorizo thoroughly—and drain the grease before continuing.

Cook the sliced smoked sausages on the griddle.

Set ribs and sausages aside after cooking.

Sauté the onions and garlic in the oil that remains in the large soup pot on medium-high heat until soft—about 5 minutes. Then add tomatoes and cook for another few minutes.

Drain and rinse the soaked beans. Add the beans, along with everything else—the bacon, the pork ribs, the chorizo, the smoked sausage—to the soup pot.

Cook for 2.5 hours or until the beans are soft.

Serve with white rice! And farofa if you have it!

 NOTES

CHEF'S NOTES

PAIR W/. A SPARKLING RED LIKE 'RIO SOL ROUGE' TO CUT THROUGH THIS SAVORY & FATTY DISH. ALTERNATIVES ARE A ROSE TXAKOLI 'ZUDUGARAI', OR AN ALSATIAN RIESLING SERVE WELL CHILLED!

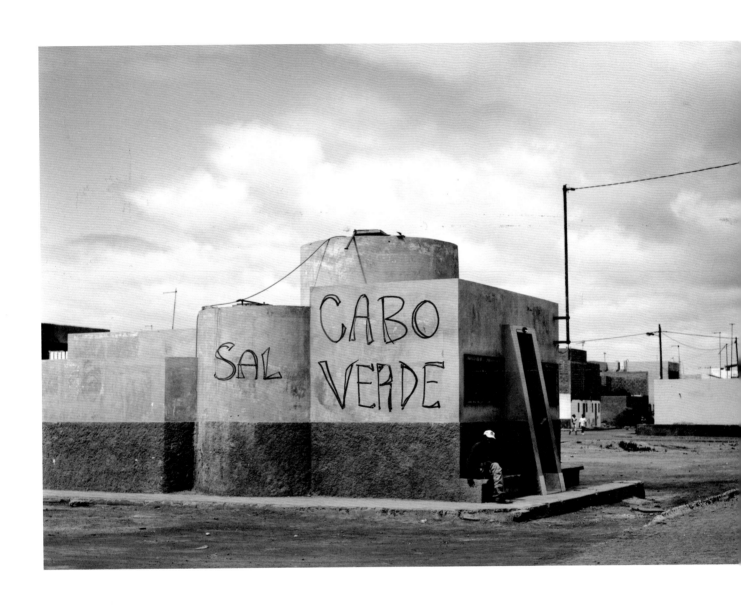

MORNA, FUNANA & BATUKU

Aquamarine waters hug Santa Maria's long, half-moon shores on the island of Sal. Open-air bars draped in soft lights bump funaná music into the night. European tourists escape the harsh winters, oiled up, splayed out on fine-sand beaches, aluminum reflectors propped up against themselves to achieve an orange, blistered bronze tan. In the past, Saharan sandstorms have surged westward, clouding the red deserts and beaches in a layer of dust—which I just barely escaped alive one year. But Cape Verde, an archipelago of ten islands in the Atlantic, eludes simple narratives as either a balmy, sun-soaked paradise or a place steeped solely in the violent history of slavery.

Roughly 400 miles off the coast of Dakar, the wealth that fueled Brazilian sugar plantations, Spanish and Portuguese colonies, and the industrialized, power-hungry economies of the United States and Britain began here.[1] Some historians say the Portuguese, who crashed upon Cape Verde's shores in 1456, found the islands completely uninhabited.[2] Oral history and mythological origin stories of the archipelago say otherwise, tracing a lineage of early settlement to Arab and African fishermen. In a quest to catalyze Portugal's colonial empire, Cape Verde became a place where Europeans traded enslaved people from western Africa as commodities.[3]

Plantations on São Tiago and Fogo produced sugar and cotton for shipment to Portugal and grog, a sugarcane liquor, and panos, cotton textiles, for trade across Africa. The sooty cone of Pico do Fogo juts through the clouds, dispersing mineral-rich soil ripe for farming. On these islands, plantations and gardens became experimental stations for growing crops like corn, hot peppers, pumpkins, and cassava from the Americas and sugar, bananas, mangos, and papayas from Asia. Cape Verde's waters teem with fish, as the two streams of the Canary Current swirl through the archipelago and nurture some of the richest marine life in the world. Yet for centuries, Portuguese colonial officials forbade Cape Verdeans from owning fishing vessels in efforts to forbid enslaved Africans from becoming fugitives.[4]

Those working the land became exploited, and so did the archipelago's fragile ecosystems. For several years, droughts plagued the islands. Fishing, restricted to the shores along the few coves, reefs, and shoal waters, hardly provided inhabitants enough to survive.

In Santiago, the first place of colonial settlement and the largest island of the archipelago, hamlets cling to the crests of mountain ranges where self-emancipated people fled from slavery. The 20th century brought a fight for independence from Portugal that rocked the arid hills and plateaus of Cape Verde. The agricultural engineer, writer, and revolutionary, Amílcar Cabral— known by the nom de guerre Abel Djassi—helped pioneer independence from brutal colonial rule.[5]

Never a place entrenched in their colonial past, Cape Verdeans have always reinvented their own realities, ensuring that their culture and heritage continue to be free from the binds of their colonial past, unwilling to simply be a marker of imperialism, gathering dust in the memories of the past. The soul of Cape Verde lies in the Crioulo language, in the song and dance of morna, funaná, and batuku—primarily a women's dance, an expression of pain and resistance once banned under Portuguese rule.[6] Tales of longing, suffering, and resilience unfurl in legendary Cesária Évora's warm vocals and the lyricism of her mornas and coladeiras. She meditates on her homeland, a small and cherished cradle of love and nostalgia.[7]

The stolen labor, knowledge, and skills of formerly enslaved people lives on, as women from West Africa passed down methods of food preparation and uses of medicinal plants.[8] Nestled in the craters of Cape Verde's highest peak, Pico do Fogo, cobbled roads weave between hamlets of lava-block houses. Coffee farms, vineyards, and fruit trees still encircle the volcano's black slopes. Fishing thrives on the islands, in seas, rivers, creeks, and lagoons, and infuses traditional cuisine with fresh tautog, cod, bluefish, or sea bass. Caldo de Peixe, a classical Cape Verdean fish soup, calls to mind the Portuguese influence with a tomato-based herbed broth. A fresh saltwater fish, scaled, gutted, and cleaned simmers in the broth with sautéed onions, sweet potatoes, and maybe a pinch of saffron.

This merging of Portuguese and West African culinary traditions and techniques reveals residues of colonial power. At the same time, these traditions assert an identity of resistance against that power, in recognition of history's material legacy. Cape Verdean poet David Hopffer Almada sings of the heroism of his people, who "stubbornly cover with green the parched and arid land," who "create gardens on volcanic ashes," and "turn desert winds into the sweetly delicious breezes of beautiful tropical night."[9]

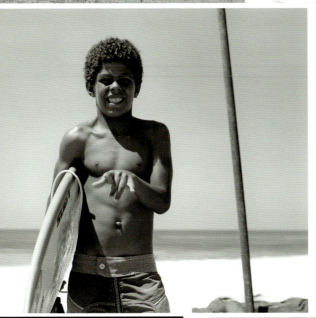
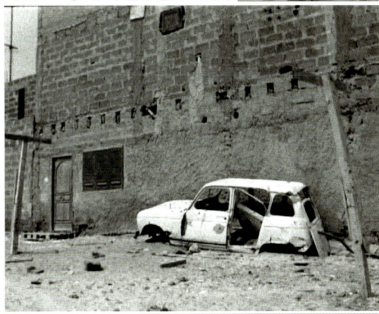

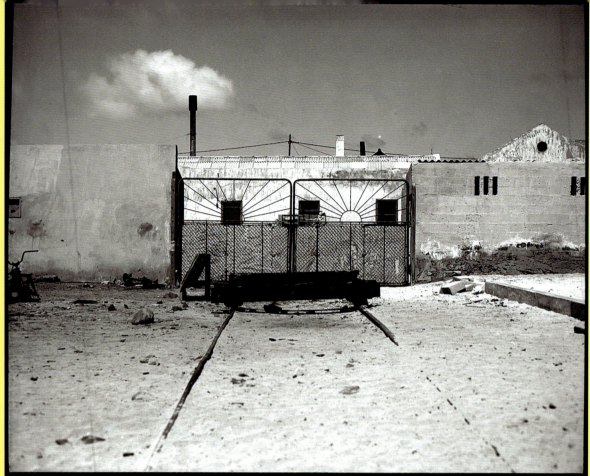

cachupa

- 2 cups dried corn
- 2 cups dry black beans
- 2 tablespoons olive oil
- 1 small yellow onion, chopped
- 2 garlic cloves minced
- 1 red bell pepper, chopped
- 1 green bell pepper, chopped
- 1 small butternut squash, peeled and diced
- 1 sweet potato, peeled and diced
- 2 tomatoes, diced
- salt and pepper to taste
- 3 cups cooked rice, for serving
- chopped cilantro for garnish

SERVINGS: 4

Soak the dried corn overnight in water.

Drain the soaked corn and add the corn and the beans to a large pot with enough water to cover. Bring to a boil and then reduce the heat and simmer for about 30 minutes or until the corn and beans are tender.

In another pot, heat the olive oil over medium heat. Add the onion and garlic and sauté for a few minutes until softened.

Add the red and green bell peppers, butternut squash, and sweet potato. Sauté for a few minutes until the vegetables start to soften.

Add the diced tomatoes and enough water to cover the vegetables. Bring to a boil and then reduce the heat and simmer for about 20 minutes, or until the vegetables are tender.

Add the vegetable mixture to the pot with the cooked corn and black beans. Mix well and season with salt and pepper to taste.

Simmer for another 10 to 15 minutes to allow the flavors to meld together.

Serve hot over rice with chopped cilantro for garnish.

CHEF'S NOTES

PAIR WITH FRUIT JUICE "SUCOS DE FRUTA" OR CAFE FRUIT, ON THE SOUTHERN TIP OF SAL, MAKES AN INCREDIBLE ORANGE, PINEAPPLE, PAPAYA & GINGER DRINK!

NOTES

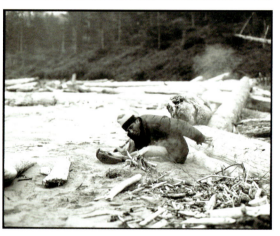

BRITISH COLUMBIA

Hovering on the far edge of a continent lies a land of twisting fjords and rocky bays cloaked in fog and mist. A ferry from Port Angeles, Washington took me to a small harbor town in British Columbia, a place that seemed easy to disappear into for days, months, eternities, lost in a tangle of cedar, fir, and hemlock. As the Vietnam War festered and boiled, draft dodgers and military deserters fled into these thick coastal forests, finding solitude away from the horrors of war. They built primitive homes along glimmering waterways, where sockeye salmon spawned and slid like clots of blood up rivers and creeks.[1]

The way to Port Renfrew was overcast and drowsy. Vancouver's skyline glittered in the distance at the base of the North Shore Mountains, their sharp-pointed peaks carving into the clouds. In Vancouver, different corners of the world collided, revealing a confluence of cultures in a plate of steaming pork buns, sizzling Korean barbecue, and perfect rolls of cherry-wood-smoked salmon sushi. Here, everything was still. Endless stretches of beach led into endless, veiny tributaries fringed with tall grass, where chinook or coho or sockeye shimmered in the water by our feet, which we followed until we reached endless meadows. I could have been on another planet. But I was very much on earth, grounded in the ancestral lands of the Kwakwaka'wakw, the Nootka, and the Coastal Salish.

For the Kwakwaka'wakw peoples, a group that stretches across seventeen distinct nations along Vancouver Island and the mainland, salmon is sacred. Upon the first salmon run at the dawn of summer, they separate the fish's head, bones, and entrails from its flesh, then wrap it in a cedar mat. Once they are returned to their birthplace in the water, the salmon, believed to be immortal, can continue its life cycle.[2]

In these far western reaches of Canada, where thimbleberries and bunchberries bloom between dense canopies of subalpine fir and spruce trees, the Kwakwaka'wakw peoples are not the only ones to revere this fish. The Coast Salish First Nations also threw salmon bones back into the river, with special care given to the fish's head bone.[3]

The ways of preparing this sacred fish are as numerous as their immortal lives. Think of chinook salmon, dried in the cold wind for several days, silvery skins glinting in the afternoon sun. A salmon's pinkish flesh, dried and dipped in oil, served in clam shells. Think of coho and sockeye roasted over a fire with tongs, or white chinook salmon slit open at the throat, its head pushed back, belly split open and cleaned, filets stored in a smokehouse. Or the fatty fish pierced through with a stick crafted from red cedar, hung over a smoke rack, crisped over a fire of alder wood.[4] Sometimes, the fattier morsels of meat might be cut into long, slender strips, laid in the sun to dry. Buttery, strong but sweet sockeye salmon simmers in a communal soup.[5]

The colonization during the late 1800s may have decimated traditional fishing grounds, while Aboriginal weirs are blamed for the ongoing depletion of the salmon.[6] We may take for granted the return of salmon each year, blessing our bellies for eternity as they pass through an endless cycle of birth, death, and resurrection.[7] But without the water that brings about their rebirth and migration through these streams, we now find lifeless fish floating dead in the shallow, warming water of a creek that should be deeper. The droughts of a changing climate have reached this swath of land too, but for as long as the water runs, the sacred fish will continue to breathe life into future generations.[8]

Indigenous Salmon & Mussels Mushrooms

One of the traditional recipes from the Canadian province of British Columbia features salmon and mussels, showcasing the province's abundant seafood. It's a simple yet flavorful dish that is perfect for special occasions or a cozy night in. The combination of the tender salmon filets and the briny mussels is a match made in heaven, and the garlic and white wine broth adds a delicious depth of flavor. This recipe is a great way to enjoy the flavors of British Columbia and is sure to impress your dinner guests.

- 2 tablespoons of olive oil
- 2 garlic cloves, minced
- 2 pounds fresh mussels, scrubbed and debearded
- 1/2 cup dry white wine
- 1/2 cup chicken or vegetable broth
- 1 pound fresh salmon filets, cut into four portions
- 1/4 cup chopped fresh parsley
- salt and pepper to taste

SERVINGS: 4

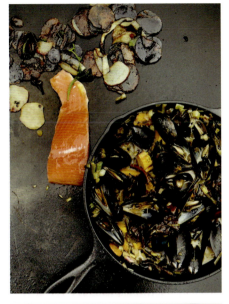

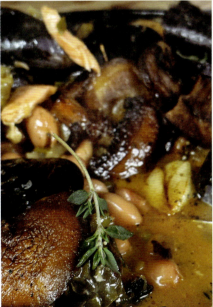

Preheat the oven to 375°F.

In a large ovenproof skillet, heat the olive oil over medium heat. Add the minced garlic and sauté for about a minute, or until fragrant.

Add the fresh mussels to the skillet and stir to coat them with the garlic and olive oil. Pour in the white wine and chicken or vegetable broth, then cover the skillet with a lid and simmer for about 5 to 7 minutes, or until the mussels open up.

Remove the lid and use tongs or a slotted spoon to transfer the cooked mussels to a large serving dish, discarding any mussels that did not open.

Season the salmon filets with salt and pepper, then place them in the skillet with the remaining broth and garlic mixture.

Transfer the skillet to the oven and bake for about 10–12 minutes, or until the salmon is cooked through.

Remove the skillet from the oven and carefully transfer the cooked salmon filets to the serving dish with the mussels.

Pour the remaining broth and garlic mixture over the salmon and mussels, then sprinkle with chopped parsley.

Serve hot with crusty bread.

CHEF'S NOTES
For the ultimate Canadian forage fishing & hunting experience, contact local captain, hunter, surfer Raph Bruwiler. Tell him I sent you.

NOTES

A LONG PETAL OF SEA, WINE AND SNOW

From Argentina, I intended to set out—with surfboards at the ready—for Chile, where I dreamed of chasing swells down the Southern Hemisphere. Back in Bariloche, a lack of snow and tourists had dashed my hopes of a job at a ski resort that season. For several weeks, I lugged my surfboards from bus to taxi to plane to train and preoccupied my mind with visions of the iconic left-hand point break in Punta de Lobos. But in Chile, I then found myself penniless. When I reached Santiago, I had to sell my boards to some local surfer kids to pay for the long haul back to Europe.

More than a decade passed until finally, my dreams of surfing Chile's central coast came true. In Santiago, Alfredo Escobar, a fellow photographer friend who published the influential Chilean surf magazine, Marejada, greeted me at the airport. The Andes' snow-capped peaks surrounded a city of high-rises and working-class brick dwellings. Gleaming glass skyscrapers, million-dollar residential condos, luxury boutiques, and fine-dining venues tumbled out across Santiago's upper-class suburbs. Tall pines and palm trees framed wide, clean avenues, hiding a darker underbelly. Decades ago, the higher echelons of Chilean society galvanized support for General Augusto Pinochet's brutal military dictatorship—seventeen dark years set alight with the 1973 coup against democratically-elected Salvador Allende.[1] And the US CIA's hand in the downfall of the country's early democracy rippled across the country.[2]

Chile, "a long petal of sea, wine and snow," as poet Pablo Neruda once described, may have come to terms with its past and looks out to possible futures.[3] In some of Santiago's most prestigious dining spots, internationally-trained chefs offer sensory experiences, shattering the myth that Chilean cuisine can't be haute. Some chic, low-lit bistros offer echoes of Indigenous Mapuche and Aymara ingredients and cooking techniques, with steaming plates of horse ham cooked on hot stones with hazelnuts. Or cancato, a buttery corvina, salmon, or flounder baked with cheese, tomato, and onion from the stormy island of Chiloé. Some establishments offer lamb with luche, the tendrils of sea lettuce often associated with coastal Mapuche peoples and a lower social class.[4]

The flavors of daily Mapuche and Aymara foods remain most popular in homes, roadside restaurants, and fluorescent-lit market stalls. As I walked the streets, the smell of charquicán, a hearty meat, pumpkin, corn, and potato stew originally made from dried and salted llama mix, simmering in large pots. The Mapuche, who defended their lands from the Spanish and remained independent of colonial control for nearly 300 years, crafted mote con huesillos, a honey-hued, nectar-like drink of rehydrated dried peaches, husked wheat, and a touch of cinnamon.[5] And at almost every corner, vendors sell the Chilean version of Latin America's empanadas de pino, this time filled with chopped onion, diced meat, hard-boiled egg, and raisins.

In my friend Alfredo's apartment, I met the then young, shy Ramón Navarro, a fisherman's son and Chilean big wave surfer with a penchant for preserving his homeland's striking coast. Ramón would be my key to the long peeling waves of Punta de Lobos that slipped my grasp years ago. We drove several hours, down Chile's center, past vineyards producing the country's prized wines and endless matorral—evergreen shrublands—that gave way to sandy coves and rocky headlands and miles of pine forest. I could imagine huasos, skilled horsemen similar to the Argentinian gaucho, galloping toward mountain ranges, cloaked in chamantos, the patterned wool ponchos. They began as bandits, helping uproot Spanish royalists. Somewhere across the fields, golden clouds of dust must have billowed from the beating hooves of their horses.[6] But huasos soon settled down as farmers and cattle workers.

Further south of us, sheep grazed and guanacos galloped across undulated steppes, and pitch-black condors swooped across the skies. The Chilean Patagonia birthed one key dish that has since made its way into the weekend barbecues of friends and family throughout the country: cordero al palo or asado al palo. The name describes precisely what cooking this dish involves: lamb, either quartered or halved or splayed out like a spatchcocked chicken, is put on a long metal spindle. The spindled lamb rotates evenly over a fire between two forked spikes driven into the ground. Rubbed down with warm water, salt, and garlic, rivulets of lamb fat bubble to the surface over the course of roasting for several hours.[7] Once complete, pebre, an aromatic sauce of coriander, chopped onion, olive oil, garlic, and ground or puréed spicy aji peppers season the meat. Catalan engineers and masons first created pebre when they first arrived in Chile, building fluvial channels, river walls, and bridges to halt flooding of the Mapocho River.[8] A smooth, velvety wine or a couple of tart Pisco Sours provide the perfect way to end a night.

We stayed with Ramón's family in Pichilemu, a small, quiet beach town and the original home of Promaucae peoples, an Indigenous Mapuche tribal group.[9] Ramón's parents greeted me with the hospitality and kindness they would an old friend, although we'd only just met. I awoke early one morning to the sound of someone splitting wood with an ax. As I unswaddled myself from a thick layer of blankets, the frigid air pricked my skin. I managed to find my way into the kitchen, where I helped Ramón start the wood-fired stove. Beyond the house, huge rocks like ancient sculptures pierced the sea. The cold Humboldt current ushers in fresh sea bass, centolla Chilena—the southern king crab—and lush mollusks served in creamy stews or slathered in fatty cheeses. That morning, Ramón stirred scrambled eggs with a local German-style cheese over the fire. Slowly, slowly, we began to feel a warmth spread through our bones again.

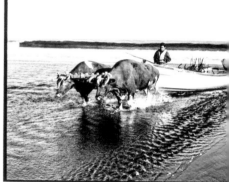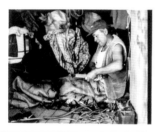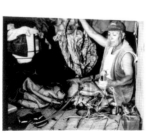

HOY

DESAYUNO
ALMUERZO
- CAZUELA DE VACUNO
- CAZUELA DE CERDO
- CAZUELA DE AVE
- CADILLO DE PESCADO
- PESCADO FRITO
- PAILA MARINA
- MAVISCALES
- POROTO
- TALLARINES

WHOLE LAMB

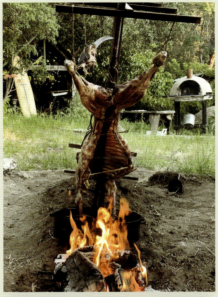

Preparing a whole lamb Chilean-style requires a lot of preparation and time, but the result is a delicious and memorable dish that's perfect for sharing with friends and family. Enjoy your delicious Chilean-style whole lamb cooked over an outdoor fire with some urchin empanadas on the side!

- one whole lamb, about 30 pounds cleaned and prepared; ask your butcher to do this for you
- olive oil
- sea salt
- fresh lemons

Servings: 8

Start by preparing the lamb: rub it down with olive oil and season it generously with salt, making sure to coat it thoroughly on all sides.

Heat up a large grill or build a fire pit, making sure the flames have died down and the coals are glowing hot. Place the lamb on the grill or in the fire pit, making sure to secure it well so that it doesn't fall off.

Cook the lamb slowly, turning it occasionally to ensure that it cooks evenly on all sides. You'll want to cook it for several hours until the meat is tender and falls off the bone. That might take 5 to 6 hours.

As the lamb cooks, baste it occasionally with olive oil to keep it moist and add flavor.

About halfway through the cooking process—two and a half hours—squeeze fresh lemon juice over the lamb to add a bright, citrusy flavor.

Once the lamb is fully cooked, remove it from the grill or fire pit and let it rest for about 10 minutes before carving and serving. Serve the lamb with a variety of side dishes, such as roasted vegetables, fresh bread, or a green salad.

CHEF'S NOTES

PAIRED WITH A MAGNUM BOTTLE OF SPOTTSWOODE 2003 CABERNET SAUVIGNON THAT CHEF KINCH SHOWED UP WITH, the pairing could HAVE NOT BEEN ANY BETTER!

 NOTES

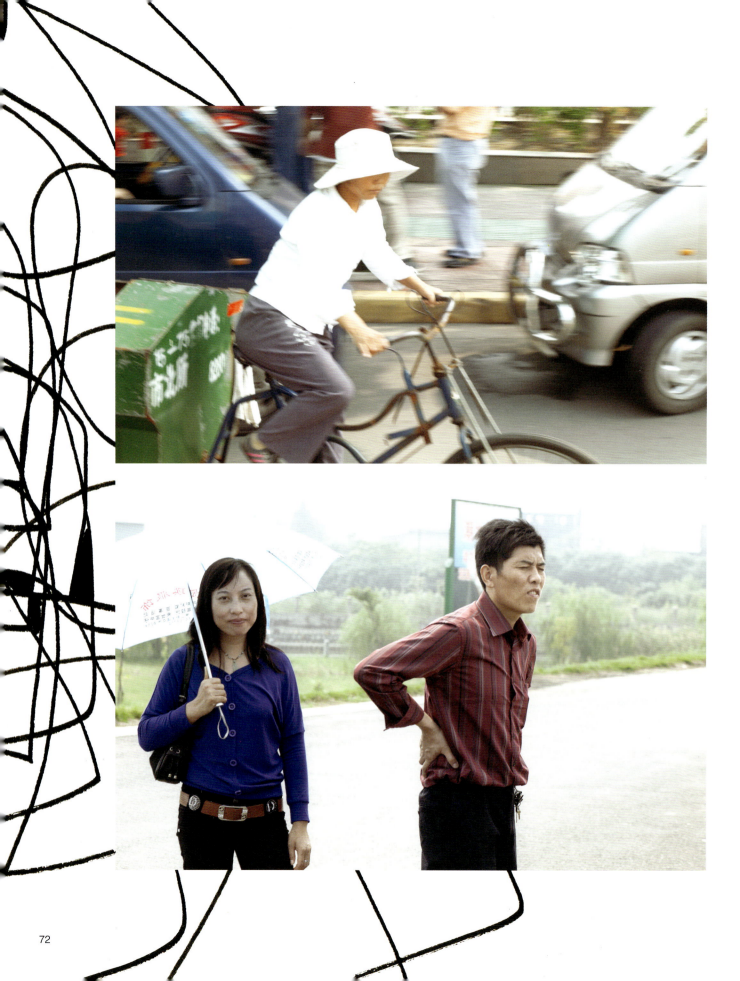

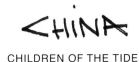

CHINA

CHILDREN OF THE TIDE

At the mouth of the Qiantang River, the Silver Dragon awakens, spiraling and crashing toward Hangzhou Bay. In the wake of a new or full moon, gravity triggers the world's largest tidal bore. The wave's murky waters climb the delta up to 8 feet high for over 25 miles and submerge the land around its fortified banks. In the fall, the Silver Dragon reaches the peak of its power, and for centuries, crowds have gathered on the eighteenth day of the eighth month in the Chinese calendar to bask in the glory of nature's violent swells.[1]

Surfers converge from the far corners of the world to barrel through the tidal bore. Unlike any ocean wave, the Silver Dragon shapeshifts. Sometimes, its face slopes and a surfer can cut across. Other times, the wave breaks into a wall almost two stories tall.[2] Today, a backdrop of factory smokestacks and high-rise buildings frame the bay, and surfers navigate an obstacle course of boats and piers and cement pilings.

But in the days of the Song Dynasty, from AD 960 to 1279, the Emperor first commissioned rituals on the tidal bore in celebration of the Mid-Autumn Festival. Polynesian cave paintings of the 12th-century mark Indigenous Pacific islanders as the pioneers of surfing. In the Song Dynasty, which reigned over an expanse of eastern China, expert watermen—short-haired and tattooed—would paddle toward the rushing waves, performing tricks on pieces of wood, canoes, and sailboats, or dancing with the frothy water. Statues depict Buddhas surfing on carps, a sacred fish, and stories of the era speak of the "Children of the Tide." To please the Emperor and pacify the Dragon King's raging soul, the Children of the Tide would offer their bodies to the wave and perform acrobatics for the festival crowds.[3]

The Chinese may not have been the first to surf, but the Song Dynasty may have provided the earliest documentation of the sport's existence. Known for its prized blue porcelain, classical opera, and delicate landscape paintings, the Song Dynasty crafted restaurants specialized in the regional cuisines of its vast empire.[4] Szechuan restaurants served dishes with tongue-numbing doses of pungent chili peppers. Along the Imperial Way, noodle shops bustled well into the night. Taverns dished out steaming plates of coastal shrimp and saltwater fish.[5] And just as early surfers would ride the Qiantang River to entertain the Song Emperor, imperial kitchens created lavish menus in worship of the royal class.

The Song Dynasty fell to Genghis Khan's grandson, Kublai Khan, who became Emperor of the Yuan Dynasty, a division of the Mongol Empire. Under this dynasty in 1330, a royal dietary physician named Hu Sihui recorded one of Beijing's most iconic dishes: Peking duck.[6] The former Chinese capital of Nanjing in the eastern province of Jiangsu boasts of the dish's birthplace, although the name Peking refers to an old spelling of Beijing.[7]

Roasted duck may have graced the tables of China's Southern and Northern dynasties between AD 420 and 589, but these thin pieces of tender, roasted duck meat, served with sliced spring onion, cucumber, and sweet bean sauce, have garnered contemporary international acclaim. A steamed, crepe-like Mandarin pancake sometimes envelops the meat. Slathered in a syrupy sugar and sesame oil sauce, the crisp, roasted duck skin earns a lacquered glow.

From dynasty to dynasty, centuries of imperial kitchens cooked this sweet, rich bird with majestic and lengthy preparations. Hu Sihui's original recipe called for duck roasted in the depths of a sheep's stomach, but today, two methods suffice: cooked in a closed oven or hung in an open one, a way of cooking that emerged in the late 19th century. Some Beijing restaurants may roast the ducks slowly in closed ovens, sorghum stalks fueling their fire. Others might hang them on hooks over an open flame kindled of date, peach, or pearwood.[8]

What began as traditions to impress the aristocracy, or appease the god of water and weather, soon became some of the world's greatest phenomena—surfing a monstrous tidal bore and dining like ancient emperors on a succulent, white-feathered bird.

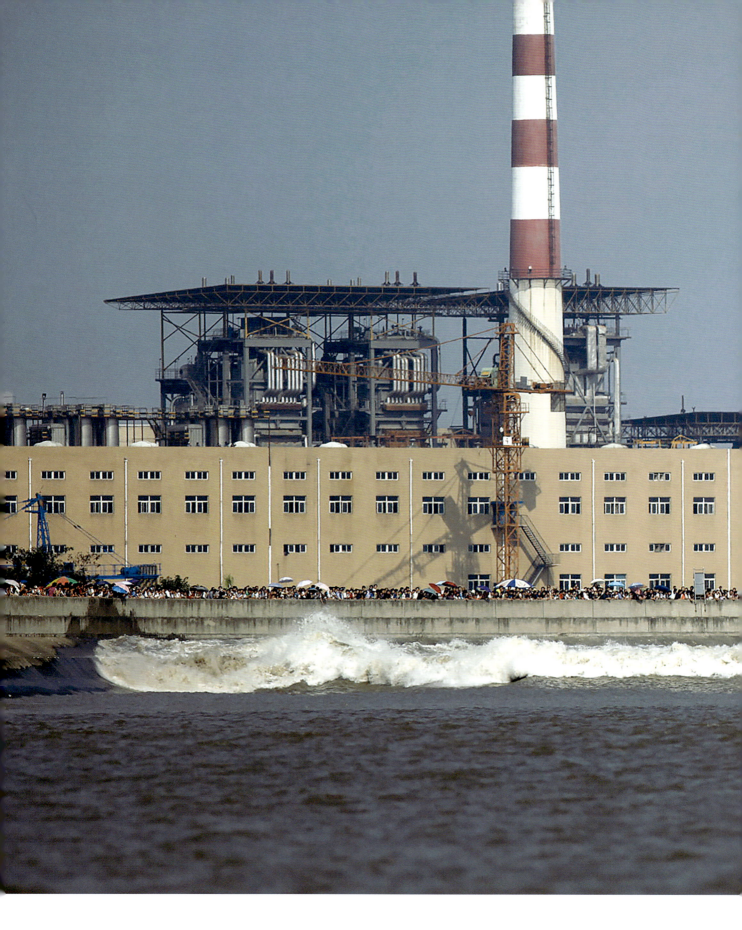

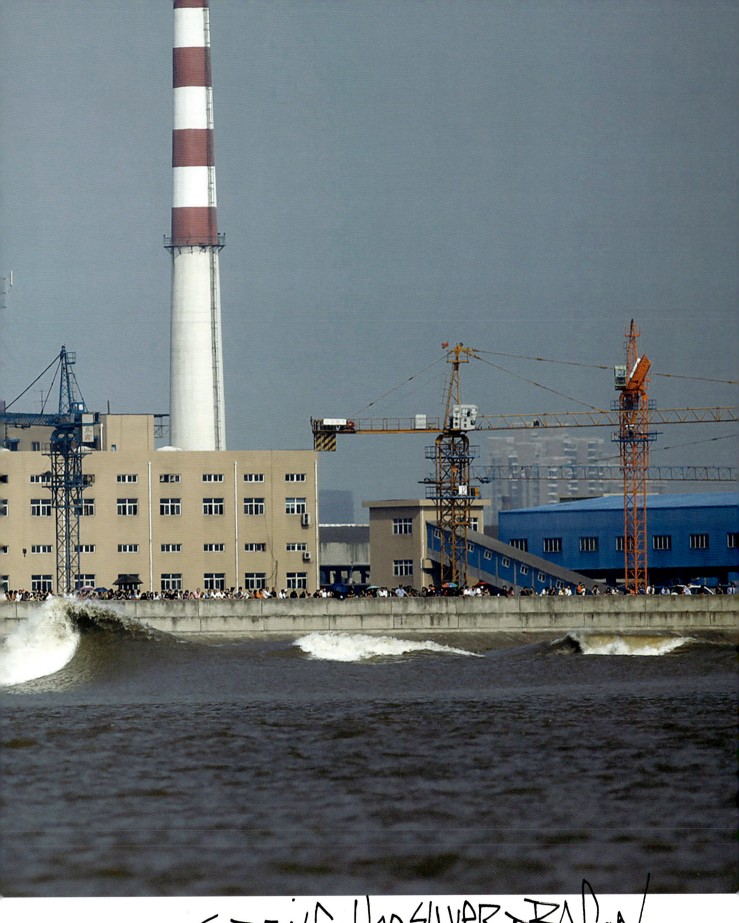

SURFING the SILVER DRAGON

~~Deconstructed Peking Duck~~

- 1 whole duck (around 5.5 pounds)
- 1 tablespoon honey
- 1 tablespoon white vinegar
- 2 tablespoons Chinese five-spice powder
- 2 tablespoons fine sea salt
- 1 tablespoon whole Sichuan peppercorns
- 1 tablespoon Shaoxing wine
- 2 tablespoons sesame oil
- 4 to 6 whole dried red chili peppers
- 4 bok choi
- 1/4 cup hot sauce
- finely sliced spring onions and
- thinly sliced cucumber garnish to serve
- plum sauce

Servings: 4

Clean the duck thoroughly and remove any innards. Pat dry with paper towels.

In a small saucepan, mix together the honey and white vinegar. Warm up on low heat until it becomes liquid. Brush the mixture onto the duck, making sure it is coated evenly.

In another small bowl, mix together the Chinese five-spice powder, salt, and ground Sichuan peppercorns. Rub the mixture all over the duck, inside and out.

Place the duck on a rack in a roasting pan, breast side up. Leave it in the fridge to dry overnight, uncovered.

Preheat the oven to 425°F. Brush the duck with Shaoxing wine and place it in the oven for 15 minutes.

Reduce the temperature to 350°F and continue roasting for another 45 minutes to an hour, until the duck skin is golden brown and crispy.

Remove the duck from the oven and let it cool for a few minutes. While it is still warm, carve the duck into medium-thick slices. Use a sharp knife to slice off the skin in thin pieces.

Sizzle the pieces of duck with a dash of sesame oil in a hot cast iron pan or on top of a hotplate with the dried red chili peppers and bok choi; drizzle with hot sauce. Serve with a side of plum sauce to balance out the spice and fat. A great finger food and a visual surprise!

CHEF'S NOTES

IN ORDER TO CUT DOWN ON THE 27 HOUR COOKING PROCESS, ONE CAN BUY A FULLY ROASTED DUCK IN ANY CHINATOWN AROUND THE GLOBE.

NOTES

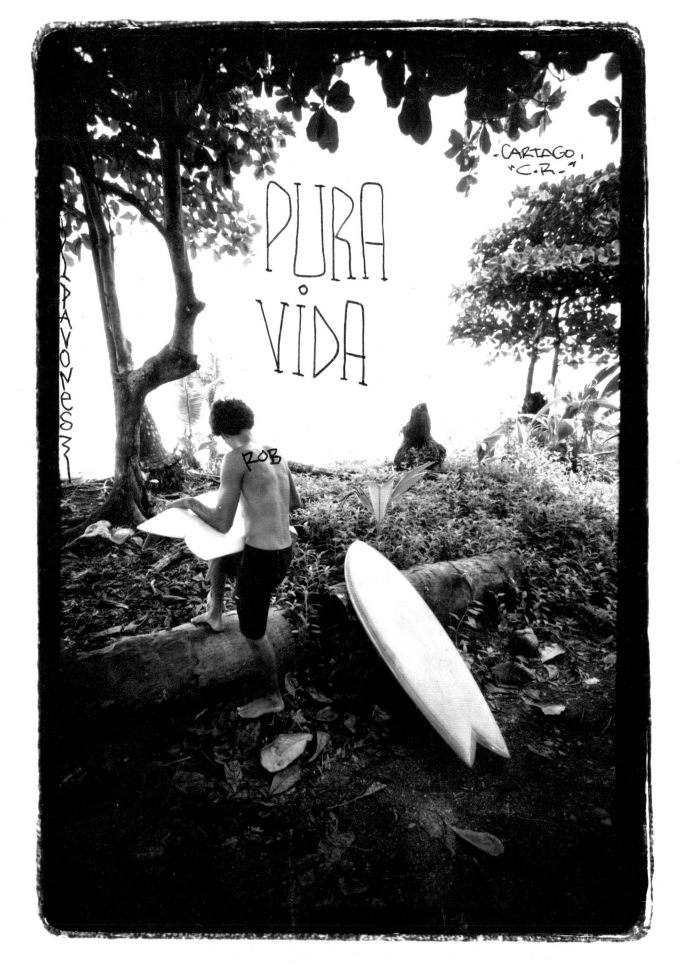

A COUNTRY WITH NO MILITARY

On a dark and rainy night in the late 1980s, a couple of friends and I landed in San José, Costa Rica. The air was warm and muggy. We had just escaped the miserable, frigid winters of central Europe and arrived in a country with no military. A country that shifts from the verdant, volcanic hillsides of the Cordillera Central to the dry tropical desert of Guanacaste across a land only slightly larger than Denmark. A country where people say pura vida as a greeting, a farewell, a thank you—or a daily toast to a pure and simple way of life.

While neighboring Central American countries faced conflict and United States-backed counterinsurgencies,[1] former World Bank official Juan Bazo called Costa Rica "the land of the happy medium."[2] Within the next decade, this myth would propel a booming tourism industry. Surfers, hippies, and conservationists from around the world flocked to Tamarindo, a wave-rich and once-remote retreat along the northern Pacific coast.

I was among those preparing to ride the waves as well in the warm tropical water of the Pacific. I had just surfed the cold and rugged coastlines of the Basque region in the dark and rainy month of late November. Winter Solstice in central Europe translates into a 9 o'clock sunrise, 18 hours of darkness… consider yourself lucky if you see the sun at all, as the low-pressure systems stack up, barreling down the outer Atlantic to slam into the Bay of Biscay.

And this is how I lived for some time after arriving in Costa Rica: hopping from beach to beach, hitchhiking or hauling boards on local chicken buses, and paddling through lukewarm waters with local Tico surfers who navigated the punchy, hollow barrels with ease.

From Quepos, once a sleepy port town and shipping center of the United Fruit Company,[3] I caught a ride to Tamarindo with a pair of Berliner Lufthansa airline flight attendants in their rental car. When I arrived, Tamarindo was a humid, sparsely populated fishing village in the province of Guanacaste, with long stretches of white sand beach, four hotels, and hardly any other foreigners in sight. Each person I met shared their favorite surf spots and places to go. The stereotypes seemed true about this pura vida spirit. I spent my days riding the clean, crisp offshore waves and stopping to eat a quick casado at a soda—the small and simple family dinners embedded within every corner of Costa Rica—on a blistering hot afternoon.

Since then, Tamarindo has expanded and, piece by piece, investment corporations and international hotel developers dedicated to mass tourism and the real estate business have chipped away at its shores.[4] In 1994, Bruce Brown's Endless Summer II, the sequel to the seminal surfing documentary, put Costa Rica on the map as an iconic tourist hotspot. But even now to this day, there are still tons of hidden spots off the beaten path that go unridden daily, away from the luxury resorts and air-conditioned boutiques of Jacó or Tamarindo.

In the years following my first trip, I have returned to the country a few more times. On my second visit, I stayed for five months and made a humble living painting signs for different businesses along the coast and taking people out to free dive on a nearby island. I lived from a tent, survived on rice and beans, maybe a freshly caught snapper or langosta, and climbed trees for papayas, coconuts, and mangos. It was too easy to romanticize this simple, idyllic life.

Beneath Costa Rica's offshore wind-sculpted peaks, lush cloud forests, and humid coastal lowlands, Spanish colonizers imagined a land swelling with gold. At the dawn of the 16th century, King Ferdinand dispatched Diego de Nicuesa to seize control of what would later become Costa Rica. But in this "rich coast," the colonizers only starved in the sweltering heat. In defense of their lives and lands, independent Indigenous groups burned their own crops rather than feed the invaders.[5]

Now, 2.4 percent of Costa Ricans identify with eight of the country's Indigenous groups: the Bribrí, Brunka, Bröran, Cabécar, Chorotega, Huetar, Maleku, and Ngäbe.[6] While a surge in export monoculture has decimated ecosystems and Costa Rican towns and cities glisten with the grease of American fast food chains, indigenous crops remain staples in Costa Rican foodways. This includes corn crops like tortillas and tamales but also a diversity of beans.

Costa Rican researchers have argued that formerly enslaved people's foodways inform contemporary Afro-Costa Rican cuisine and Costa Rican cuisine in general.[7] Since 1789, Spanish colonizers cultivated rice in small quantities, but at the time, maize reigned supreme. One theory proposes that in the mid to late 1800s, rice and beans arrived as a popular food in Costa Rica through enslaved African peoples moving through the Caribbean region mixing rice with the indigenous bean crops.[8] The American South has Hoppin' John. Spanish-speaking islands like Cuba have moros y cristianos, or Moors and Christians. Former French colonies have pois et riz. And Nicaragua, which borders Costa Rica to the north, shares gallo pinto as its national dish. Along the rain-drenched Caribbean shoreline of Puerto Viejo, restaurants and street vendors also sell heaping plates of rice and beans infused with coconut milk.

And in Costa Rica, we have gallo pinto. Although eating Costa Rica's national dish, gallo pinto—spotted rooster—is a daily ritual, the origins of this popular breakfast food are disputed and remain shrouded in mystery. In a geographic region where rice and beans dominate everyday diets, it can be difficult to determine the origins of Costa Rica's gallo pinto. Speculation around the dish's name suggests the colorful mixture of rice and beans reminded someone of a rooster's speckled feathers.

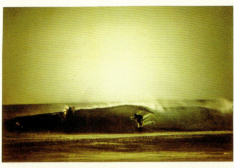

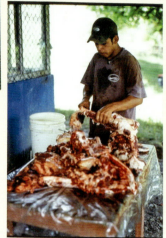

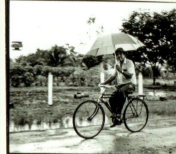

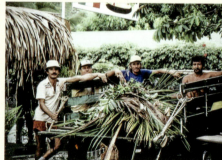

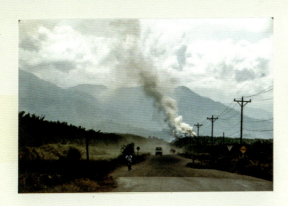
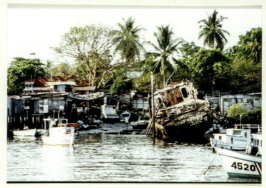

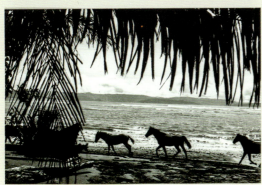

ROCA
BRUJA

GALLO PINTO

When I lived in Costa Rica, I always made my black beans from scratch; I still prefer that method as it has more depth and a silky texture. Cooking black beans is easy, inexpensive, and they taste so good! Salsa Lizano is a thin brown slightly sweet sauce that is the pride of Costa Rica; created in 1920, it is made of puréed vegetables, warm spices like cumin, mustard, and turmeric, and a hint of both peppers and sugar. It's available in specialty stores and also widely sold on the Internet.

- 8 cups dry black beans
- 2 tablespoons olive oil
- 1 small yellow onion, chopped
- 2 garlic cloves, minced
- 1 red bell pepper, chopped
- 1 tablespoon cumin seed
- 1 tablespoon dried oregano
- 3 cups cooked rice
- 2 eggs, for each individual serving
- 1/4 cup (60 ml) Salsa Lizano
- 1/4 cup (4 g) fresh cilantro, chopped

Servings: 8

Rinse the black beans under cold water and remove any debris or stones. Soak the beans overnight in a large bowl with enough water to cover them.

In a large pot, heat the vegetable oil over medium heat. Add the onion, garlic, and red bell pepper. Sauté until the vegetables are softened and fragrant, about 5 minutes.

Add the soaked and drained black beans to the pot. Stir in the cumin and oregano. Mix well to coat the beans and vegetables with the spices.

Add water, ensuring it covers the beans by at least an inch. Bring the mixture to a boil over high heat, then reduce the heat to low and simmer partially covered for about 1 to 1 1/2 hours or until the beans are tender.

Gently stir in cooked rice and cook until heated through and most of the liquid is absorbed—about 3 to 5 minutes.

For each individual serving, fry up a couple of eggs in coconut or palm oil, flipping them just once over easy.

Stir in chopped cilantro, season to taste with Salsa Lizano (if available but any mild hot sauce will do) and serve with a fried egg on top!

Leftover rice and beans can be kept in the refrigerator and used for about a week.

 NOTES

VINAGRE CHILERA

ESCABECHE TICO

CARROTS
RED BELL PEPPERS
WHITE ONIONS
CUCUMBER
GARLIC
WHITE VINEGAR
TABASCO SAUCE

CHEF'S NOTES

Listen to Costarican folklore musician Aristides Baltonado to get into the groove whilst cooking this soulful classic.

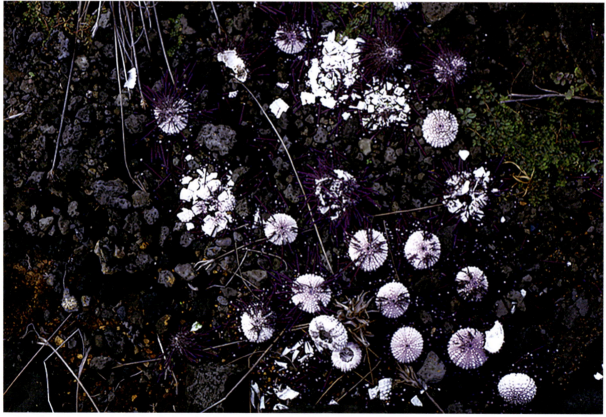

EASTER ISLAND

RAPA NUI

Between the sea and the edge of Mataveri International Airport's single runway, local teens lay on the grass to gaze at 747s hurtling through the sky to land on the short stretch of asphalt, nearly grazing their chests. The planes descend over the people, landing after soaring over a desolate ocean more than 2000 miles off the coast of Chile into a rugged land whipped by perennial winds—making it the most remote place on earth.

On one of my first days in Rapa Nui, I watched the island's most dangerous spectacle from a distance. For the weeks that followed, totemic moai carved from volcanic stone loomed over all of us. Some stood with their backs to the sea, looking out over the land, and others stared beyond the lava flows and rocky coves, remembering an ancestral journey.

I walked between winds that howled and violent waves that lashed against the same shores the Polynesians washed up on in canoes and catamarans. They filled their diets with plump, fresh fish: Pacific chub known as nanue, fished from shallow reefs exposed to surge; yellowfin tuna or kahi ave ave; and a spiny lobster called ura—now rare, overfished as a tourist's dish of choice.[1] In tide pools, on exposed reef flats, and in rocks submerged in the wave-swept surge zone, deep purple urchins rule the clear seas.[2] The urchins, with movable spines, burrow between the caverns of rocks they latch onto, their hostile frames belie soft, delicate organs.

In Rano Raraku, a verdant volcanic crater and quarry, artisans carved ten-meter-high moai into the rock, then detached and transported the statues, embedding them in the fields and hills across the island. Some say this crater of consolidated ash is the birthplace of the island's more than 1,000 moai. Here, hundreds and hundreds of moai remain—some with paternal, godly features chiseled to completion, petroglyphs tattooed on their fungus-spotted backs, and others left unfinished, buried to their shoulders or still embedded within the rock.[3]

The quarry's freshwater source, coupled with the act of quarrying, may have fed Rano Raraku's soils, which became rich in clay from weathered volcanic bedrock, perhaps the richest on the island.[4] Here, banana, taro, and sweet potatoes sprouted from unusually fertile soils. And to some researchers, the ancient Rapanuian carvers left upright moai on this land for a specific reason: they may have believed the monoliths capable of producing agricultural fertility, and thus, critical food supplies for a population grasping onto the final fruits of rapidly worn-out and eroding soils.[5] Did Rapa Nui's original inhabitants ravage forests and usher in the island's lush but treeless landscape? Did they strap their sacred moai stone statues to tree trunks and drag them on the ground? Or did they roll these stoic, all-knowing representations of the island's ancestral kings on sleds over felled trees?[6] With trees fallen, leaving behind only fertile carpets of long grass, did this lack of wood lead to fewer boats, and less boats to crumbled fisheries?[7] No one has answered these questions with certainty.

The ancient traditions of Rapa Nui islanders exist in conflict with the illegal, industrial fishing vessels of the modern century.[8] While commercial fishing vessels cram through every corner of the world's oceans, the ancestors of the island protected prime areas from over-fishing. During some seasons, tapus or fishing bans, blanket surrounding waters fringed with sandy beaches, allowing populations to grow and migrate.[9] And a tapu might have been placed upon someone's death, as their soul needed a path through the sea to pass from the ocean to the heavens, the sky turning the bright orange of a scooped-out sea urchin.[10]

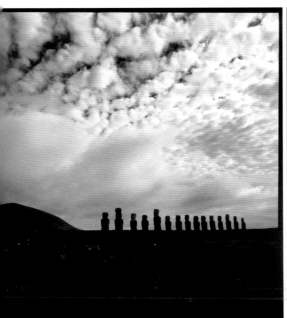

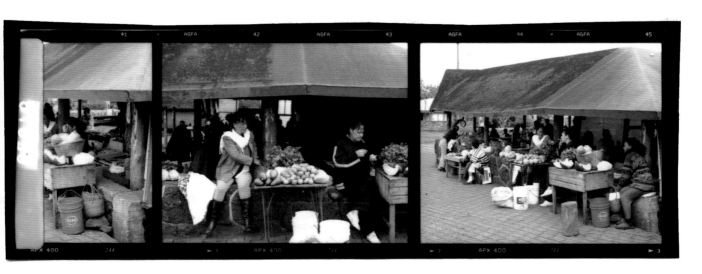

RAPA NUI

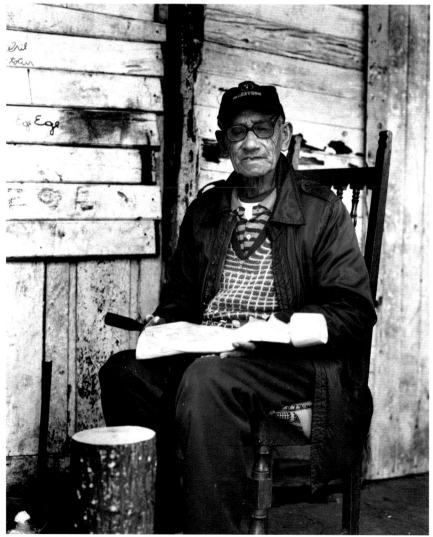

Urchin Risotto

- 1/2 to 3/4 cup fresh sea urchin roe
- 1/4 cup olive oil
- 1 medium yellow onion, finely chopped
- salt and freshly crushed white peppercorns, to taste
- 1 cup arborio rice
- 1/2 cup white wine
- 4 to 5 cups chicken or fish stock

SERVINGS: 4

Carefully clean off all the spines and grit from the sea urchin roe. Set aside.

Sauté the onions in olive oil until they soften and start to turn golden; lightly season with salt and freshly crushed white peppercorns.

Stir in rice and completely coat in oil. Cook, stirring occasionally, for about 1 minute.

Add wine and stir until it is almost all absorbed.

Add 1/2 cup of the stock and cook over moderate heat, stirring constantly, until the stock is almost absorbed.

Continue adding stock, 1/2 cup at a time, stirring as it's being absorbed until risotto is the consistency you desire. The risotto should be moist and creamy, not stiff or dry. It takes about 18 to 20 minutes for the rice to cook properly.

Place urchin on top of the risotto and serve alongside a whole cooked fish.

NOTES

CHEF'S NOTES

Sea urchins are abundant in vitamin C & A plus a great source of minerals, fiber & proteins. It's also high in Omega 3-fatty acids

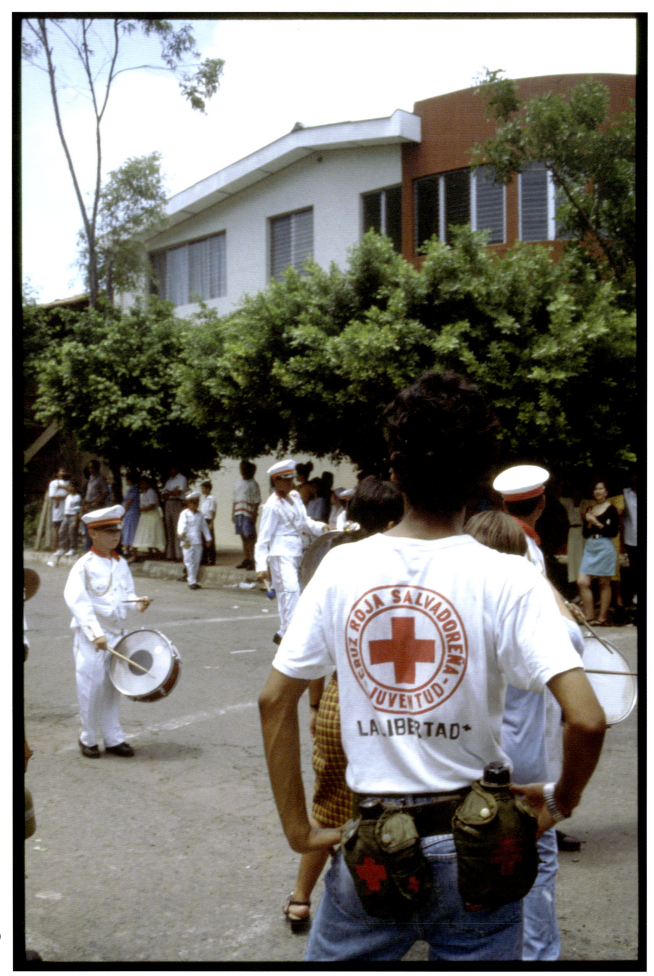

EL SALVADOR

PUNTA ROCA

El Salvador, one of the most densely populated places on earth, had barely resurfaced from the rubble of a twelve-year civil war when we heard news of the Pan-American Highway's reopening. The war claimed more than 75,000 civilian lives but determined not to let terror define the Central American nation we'd heard so much about, we drove our 1968 Dodge van into La Libertad. Paved roads collapsed into dirt and rock, and we traveled through deep, green valleys and gorges that plummeted into rivers below.

From Guatemala, we reached La Libertad, a weekend getaway for the crowds of the capital, San Salvador. We were anxious to surf the long walls of Punta Roca, El Salvador's main surf spot and, sure enough, ten-foot Southern Hemisphere swells greeted us upon arrival. In the 1970s, surf pioneers Craig Peterson and Kevin Naughton found the right-hand point breaks of this rugged port town.[1]

We followed in their footsteps. We navigated the rocky shoreline and climbed boulders, past the oceanfront cemetery where machete-wielding bandits hid, waiting to steal watches or surfboards—or so we were told. Poverty haunted the corners of the country. The ghosts of a US-funded war lingered; President Reagan had poured billions of dollars into the pockets of military dictators and conservative forces blocking reform.[2]

The story of colonization's brutal campaign to eliminate Indigenous culture loomed over Latin America. In El Salvador, Pipil and Lenca leaders led surprise attacks against the Spanish but nothing could deter the dispossession that would set in throughout the centuries. An oligarchy of fourteen Spanish families built sprawling coffee plantations, squeezing Indigenous Salvadorans and the working class from their ancestral lands.[3]

In Juayúa, Nahuizalco, Izalco, and Tacuba, Indigenous residents rose in resistance, armed with pickaxes, shovels, and machetes to hold onto their heritage.[4] The rebellion that ensued fueled a massacre in response; the Lenca and Cacaopera were forced to abandon their languages and, in exchange, avoid genocide and their deaths at the hands of the government. The Nahuat Pipil language hangs by a thread.[5]

Later in town, I crossed paths with one of the machete men—the men who waited, hidden, to rob a clueless gringo at the graveyard point. The bottom of my only pair of surf shorts had begun to tear, so I brought them to what I thought was a seamstress shop. But I soon learned the seamstress shop was an upholstery shop and that the man with the machete worked there. He'd glued and stitched a thick, rough piece of carpet to the back of my trunks—not the delicate mending I'd imagined—but I knew these shorts would last a lifetime.

We fueled our days on the water with pupusas topped with curtido, a lightly fermented cabbage relish, and a tangy tomato salsa. We ate these thick, stuffed, skillet-cooked corn tortillas three times a day—the cheapest meal we could find to survive on our shoestring budget. Roadside vendors rolled balls of dough between their hands, a remnant of the Pipils who first farmed, hunted, and fished in El Salvador.[6]

In the lush lowlands of the wide Lempa River Valley, woven between the cities of La Libertad and Ahuachapán, the Nahuat Pipil, the Lenca, and Cacaopera molded maize into tamales. They palmed dough into hefty tortillas and fermented the ubiquitous crop into fiery chicha.[7] With no crops wasted, the pulverized seeds of squash and pumpkins became alguashte, a seasoning for fresh-cut mangos, pineapples, and crunchy jícama.[8]

Buried beneath the ashes of volcanic eruption, archaeologists unearthed pupusas preserved as they were being cooked almost 2000 years ago near La Libertad. Before colonization, Pipils filled the original, half-moon-shaped pupusas with squash, chopped loroco flower buds, fungi, and herbs like the leafy, green chilipín. In the late 16th century, Spaniards began to pack pupusas with chicharrón—a shredded, spiced, pork—and chicken.[9]

One stormy day in La Libertad, an Australian friend and I waded into the murky, dark water. The debris of torrential downpours over the past few days surged around us. As we sat on our boards and waited for a wave, I felt the pull of a strange current beneath us. A shark, I thought. When I told my friend of my first instinct, he replied, in typical Aussie fashion, "Nah, there's no sharks here, mate!" La Libertad's warm waters allegedly lacked sharks, but within seconds, a kid closer to the surf point began to scream. He'd fallen from his boogie board into the jaws of a giant shark. We'd tried to pull the kid out of the blood-hued waters and onto the rocks, but it was too late.

Some places hold the weight of their past like a sack of stones tied to our ankles. But pain and suffering are not the given of any place. Decades have passed, presidents have come and gone, some languages have been lost, and others are rising once again, passed down from the tongues of El Salvador's Indigenous ancestors. The smells of ripening rose apples, dried chilaca chili peppers, and a tropical breeze brings new visitors, and perhaps the hope for a brighter future. Orchids, bougainvillea, and ivory izote flowers crown San Salvador's Quezaltepeque volcano. The Torogoz, a brown and turquoise-tinged motmot bird, sings off in the distance.

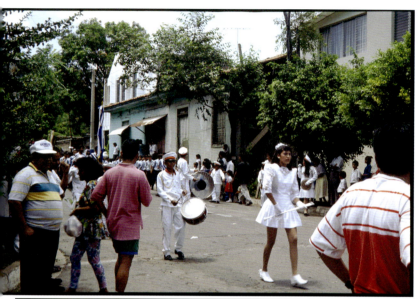
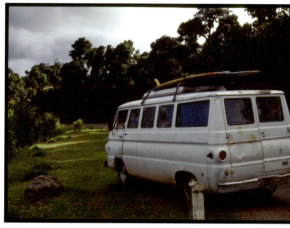
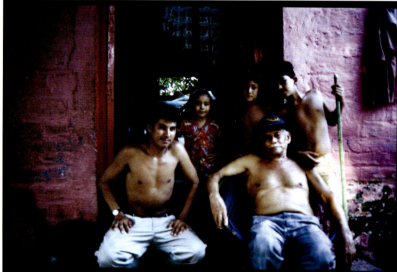

PUPUSAS

Pupusas are a traditional Salvadoran dish that consists of thick, handmade corn tortillas filled with various ingredients, such as cheese, beans, or meat. Pupusas are served with curtido—a lightly fermented cabbage, carrot, and onion slaw.

CURTIDO

- 1 small cabbage, finely shredded
- 1 large carrot, grated
- 1 medium tomato, finely chopped
- 1 small red onion, thinly sliced
- 1/2 cup white vinegar
- 1/4 cup water
- 1 teaspoon finely chopped fresh oregano
- 1 teaspoon sea salt
- 1/4 teaspoon black pepper
- 1/4 teaspoon red pepper flakes

In a large bowl, combine the cabbage, carrot, tomato, and red onion.

In a separate small bowl, mix together the white vinegar, water, dried oregano, salt, black pepper, and red pepper flakes.

Pour the vinegar mixture over the cabbage mixture and toss well to combine. Make sure the cabbage is evenly coated with the dressing.

Cover the bowl with plastic wrap or a lid and refrigerate for at least 2 hours, or overnight if possible. This will allow the flavors to meld together and the cabbage to soften slightly.

Before serving, give the curtido a good stir. Taste and adjust the seasoning if needed.

CHEF'S NOTES: the Curtido is what makes this dish. The kraut & the vinegar gives it a perfect balance to the cheese and corn cakes

CHEESE-AND-BEAN PUPUSAS

- 1 cup shredded mozzarella cheese
- 1/2 cup refried beans
- 2 cups masa harina (corn flour)
- 1 1/2 cups warm water
- 1/2 teaspoon salt
- 1/4 cup vegetable oil

Servings: 6

In a bowl, mix together the shredded mozzarella cheese and refried beans (if using).

In a separate, large mixing bowl, combine the masa harina, warm water, and salt. Mix well until you have a smooth, pliable dough. Let the dough rest for 10 to 15 minutes.

Divide the dough into 8 to 10 equal-sized balls. Flatten each ball with the palm of your hand to create a disk-shaped tortilla.

Spoon a tablespoon of the cheese-and-bean mixture into the center of each tortilla.

Carefully fold the edges of the tortilla up and over the filling, pinching the dough together to seal the pupusa closed.

Flatten the pupusa gently between your palms to create a thick, round cake.

Heat a skillet or griddle over medium-high heat and add the vegetable oil.

Cook the pupusas for 2 to 3 minutes on each side or until golden brown and crispy.

Serve the pupusas hot with curtido.

NOTES

CAMPING SAUVAGE

The epicenter of Roman Gaul, Nîmes remains as a testament to what seems like the luxuries of Roman rule. Julius Caesar launched bloody campaigns, conquering Gaul between 58 and 51 BC. As a strategic location between Italy and Spain, Emperor Augustus soon Romanized the region. Palaces, bathhouses, temples, walled cities, aqueducts, and paved roads reaching into far-flung, former Roman provinces crumble along the countryside as relics of a dead empire.[1]

Biannual bullfights still rage behind the near-perfectly preserved arches of the city's stone amphitheater, and sometimes, reenactments of ancient gladiator battles collide around its arena.[2] Emperor Augustus' armies settled here after their victories in Egypt—a retirement home away from the chaos of Rome. Romans baked the first flatbread known as focaccia, or fougasse in French, in Provençal kitchens. And grapes, apples, pomegranates, and preserved fruits adorned the tables of Roman Gaul's elite.[3]

Just outside of Nîmes, the Pont du Gard—part bridge, part aqueduct—reminds visitors and residents alike of the grandeur of a long-lost empire. Here, my family and I had traveled through the garrigue scrublands in our rickety Land Cruiser sans trailer. Traveling on a shoestring budget, we'd spent many trips "camping sauvage" at the riverbed below the aqueduct. Much before an onslaught of international tour buses began to cart hundreds and hundreds of tourists to the site, people would set up camps and caravans and motorhomes in the wild, on public or private lands, in the open, or hidden far behind the brush. I'd wake up in my little tent and set my fishing lure to cast in the river. I'd hear my mother making coffee in the camper. To cool off from the intense summer heat, we'd plunge into the Gardon River's clear blue-green waters. Construction of the aqueduct began at the source of the Alzon River in the town of Uzès, originally Ucetia or Eutica in Latin. Nothing but the forces of gravity-fueled the fountains and baths of Nîmes with millions and millions of liters of fresh spring water.[4]

Decades later, I'd return to the region, slicing through the countryside on the TGV bullet train, traveling at a speed of 320 km/h, 200 miles/h from Paris to Avignon. From there, I drove with my parents to Uzès, where we stayed with our family friends in a small, 900-year-old apartment within the walls of the fortified town. Narrow and three stories high, the humble apartment held a cellar that could chill fruits, cheeses, and wines, even in the stifling heat. On one trip to Uzès, I remember taking a morning walk through the lavender fields then returning to the family's small pool to read in the hot midday sun under an umbrella, lounging in the refreshing water, taking naps intermittently. We shared our books—Marcus Samuelsson's *Yes, Chef* and Tamar Adler's *An Everlasting Meal*—rotating these stories and meditating on cooking, eating, heritage, and family.

Another year, with friends we came across a piece of wild boar ham strung up in a local market and somehow successfully smuggled the slab of meat into the United States. I invited chef David Kinch over for dinner at my home and he stood in awe of this beautiful piece of ham.

In Provence, I'll remember watching soccer games projected on large outdoor screens with locals of the town. I'll always remember the rivers that cut through big boulders bleached out in the sun. I'll remember strolling through the cobblestone streets of a market, picking through crates of figs, plums, and mushrooms. Oblong Picholine olives, summer truffles, fragrant Gariguette strawberries, and goat's cheese with chestnut honey dominate the restaurants nestled between the region's narrow, winding avenues.[5] Restaurant—from the French verb restaurer to restore or refresh—describes exactly what it's like to dine in the quiet cafés of Provence's hilltop villages.[6] It's hard not to romanticize the sun-dappled lavender fields, sapphire bays, and rough, peppery charms of Provençal wine.

Under Pope Clement V, the first of the seven popes to serve the Avignon papacy, viticulture thrived in Avignon, the old nucleus of the Roman Catholic papacy. Châteauneuf-du-Pape wine, or "the Pope's new castle," grows from the region's sandy soils, with a rich and plummy body reminiscent of the Provençal sage, rosemary, and lavender scrublands.[7] Rolling purple-hued fields, gurgling fountains, and shuttered earth-colored houses conjure the post-impressionist blurs of Paul Cézanne and Vincent Van Gogh's quest for the perfect image of the unflinching yellow sun.[8] But with dry, poor soils, Provence could not boast of vast wealth. And so they borrowed the simple produce found in their gardens and markets, thick and rich with the taste of the region's herbs.

A day trip one year brought us down to Camargue. In late spring, Saint Sara, or Sara la Kali, the patron saint of the Romani people, emerges from the stifling heat of her candlelit crypt. Devotees arrive from the vast corners of Europe to carry her brightly-cloaked effigy into the sea that laps against the Provençal village of Les-Saintes-Maries-de-la-Mer. As the pilgrimage progresses, the town's poppy-lined roads burst with the music of Manouche guitars, Serbian brass bands, Romanian violinists, and old Romani men playing *Djelem Djelem* on a nomadic piano.[9]

Legends say the three Biblical Marys—Mary Magdalene, Mary Salome, and Mary Jacobe—and their Egyptian servant, Sara, fled Roman persecution in Palestine around the year AD 42. Condemned to drift across the ocean, they soon washed ashore in this coastal town of misty saltwater lagoons.[10] When the Roma arrived in southern France in the 15th century, they adopted Sara as a symbol of protection and identity and perhaps even a reiteration of the Hindu goddess, Kali. But some Romani folklore claims Sara became the queen of a group that lived in the region and when the three Marys baptized her, she shared Christianity with her people.[11] Whether Sara la Kali blessed these lands or not, and whether she descends from the Roma or fled Palestine, will never change the power her presence carries, as it brings a kaleidoscope of people together along these marshlands.

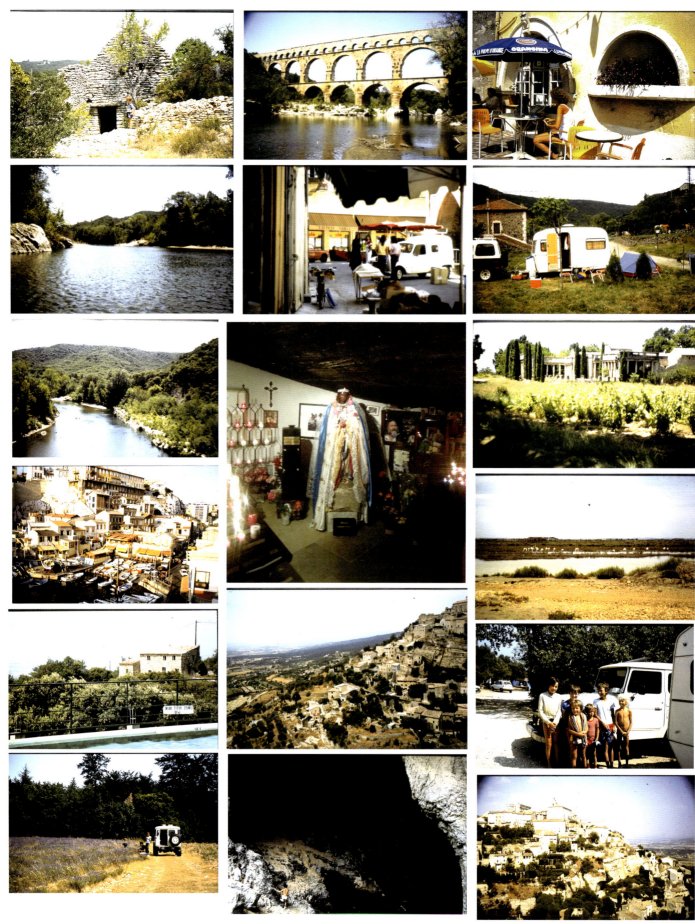

LA Petite Bourse

amphitheatre.Nimes

Bouillabaisse

Traditionally bouillabaisse was a fisherman's meal; whatever fish they weren't able to sell that day ended up in the bouillabaisse. Use the available fish for the bouillabaisse and the fish heads, bones, and/or tails to make the stock.

FISH STOCK

- 2 tablespoons olive oil
- 1 medium onion, chopped
- 1 celery stalk, chopped
- 2 carrots, chopped
- 2 leeks, white parts only, chopped
- 1 fennel bulb, chopped
- 2 plum tomatoes
- 2 to 3 pounds fish heads, bones, and/or tails (rockfish, monkfish, red snapper, grouper, or cod)
- 4 garlic cloves, crushed
- 1 bay leaf
- 6 white peppercorns
- a thin strip of orange peel
- 3 threads of saffron
- 1 cup dry white wine
- one shot glass of Pastis (an aniseed-flavored liquor)
- 8 to 10 cups cold water

SERVINGS: 4

Heat the olive oil in a large pot over medium heat. Add the aromatics: the onions, celery, carrots, leeks, and fennel bulb. Let these brown, until you can smell the sweetness of the different vegetables becoming one.

Stir occasionally and then add the tomatoes and let it simmer for 5 minutes. Add the fish heads, bones, and/or tails and cook, stirring occasionally, for about 10 to 15 minutes.

Add the garlic, bay leaf, white peppercorns, and orange peel. Add saffron and the white wine; let this simmer for a few minutes, scraping any browned bits from the bottom of the pot.

Add enough cold water to the pot to cover the fish heads, bones, and tails and the vegetables by about 1 or 2 inches. Bring the mixture to a high boil for a couple of minutes then reduce to low. Add the pastis and let this simmer gently, for about one hour. Stir vigorously to break and crush the fish bones and release the aromatics and their sweet flavors into the broth.

Strain the stock through a fine-mesh sieve or cheesecloth into a clean pot or large bowl, discarding the solids.

Let the stock cool to room temperature, then cover and refrigerate or freeze it for later use.

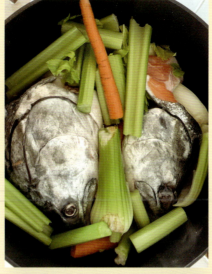

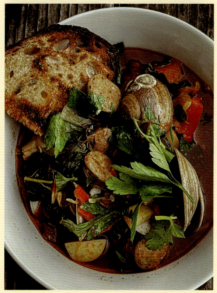

CHEF'S NOTES

PAIR WITH the PERFECT APERITIF TO GET INTO THE SPIRIT of the South OF FRANCE - PASTIS

BOUILLABAISSE

- 2 tablespoons olive oil
- 1 large onion, chopped
- 1 celery stalk, chopped
- 2 carrots, chopped
- 1 small red bell pepper, sliced lengthwise
- 1/2 leek, white parts only, chopped
- 1/2 fennel bulb, finely chopped
- one pot of fish stock
- one pound fish filets (snapper or striped bass)
- 5 or 6 small potatoes, cut in half, parboiled
- one pound assorted raw shellfish: clams, mussels, shrimp
- parsley, finely chopped for garnish
- dried red chili flakes and freshly ground black pepper, to taste

In a wide saucepan, sauté the onions, celery, carrots, red bell peppers, and leeks in olive oil over medium heat.

Add fish stock; add cut-up fish and turn down the heat to low, cook for 20 minutes or until the fish starts to fall apart.

Add parboiled potatoes and shellfish. Once the shellfish are opening up, it's done!

Serve the bouillabaisse in a bowl, ladling enough broth over the fish and vegetables so most of it is covered.

Garnish with parsley, add red chili flakes, and ground black pepper if you want that extra little kick. Serve with crusty bread. Bon Appétit!

NOTES

Galápagos Islands

ANTEDILUVIAN ANIMALS

We may have found the meaning of tranquility 600 miles off the coast of Ecuador. A trip to the Galápagos Islands with a group of pro surfers took an uncharacteristically mellow turn. Maybe it was knowing that we were tethered to the land and seas that some say is a blueprint for the origin of every species, including our own. Maybe it was the fierce, equatorial sun bearing down on us. Like the marine iguanas unique to this volcanic archipelago, sprawled across the shoreline, the morning sun's warmth dried the salty dew from our backs and thawed us from the worries of daily life.

Thirteen major islands, six smaller ones, and a constellation of islets and rocks fleck the eastern Pacific Ocean. A vast expanse of cacti covers the archipelago's lowlands, but in higher elevations, the air dampens. Guava trees, dense cloud forests, and pink and red-streaked flowers that open in late afternoon and close by morning engulf the region. When Tomás de Berlanga, the fourth bishop of Panamá, drifted off course en route to Peru, he stumbled across the islands and christened them Las Encantadas—the enchanted ones. He described the islands as an ugly, barren place, where "God . . . had rained stones."[1] But throughout our time on the few islands where people lived, we only experienced beauty.

Charles Darwin's first observations of islands teeming with strange "antediluvian animals"[2] conjure the raucous and confounding scenes of Hieronymus Bosch's Garden of Earthly Delights. Varieties of tawny, short-eared owls in open grasslands or nesting deep in lava rock tunnels.[3] Finches, each with different beaks, that could fit in your palm.[4] Flightless cormorants that now starve in their nests on Fernandina Island as fish populations dwindle.[5] But for us, the great "mystery of mysteries," was not that of "the first appearance of new beings on earth," as Darwin writes,[6] but of how to find some sort of balance and harmony.

Our days on the islands were simple. We'd dive off the pier into turquoise waters with local kids, surf the town's main reef breaks, and perch on rocks overlooking the swells like a group of blue-footed boobies. Dinner at one of the two restaurants in town became a ritual. Sometimes, a ceviche de canchalagua—smooth mollusks and pepper cured in lemon juice. Other times, steamed, bright red lobsters.[7] Or most nights, a plateful of aromatic achiote-seasoned rice and a whole fish, eyes intact and tails grilled to a crisp. My friend, Barney, a talented artist and pro surfer, brought us and other travelers bottles of wine from the mercado to share at night. A reggae beat thrummed from the radio as we picked apart the last thin bones from a meal of whole halibut, flounder, grouper, or seabass.

Barney made sure to care for the town's elder, old Pepe the Missionary, as much as he cared for us. He'd feed Pepe a banana each day, and the giant tortoise, like the kind Darwin once marveled at in a sparsely vegetated lava field,[8] simply cruised the white sand beaches, teaching us a lesson to not take life so seriously. Some days, as the sun melted below the harbor, the sky tinged dark orange or purple, I remember Barney stooped over tables outdoors, or stretched across his bed, painting vibrant curvatures of abstract bodies, or vivid, other-worldly landscapes and star patterns—something he was born to do.

Perhaps the secrets of life that Darwin unearthed on these islands show us one thing: that we share fundamental traits with thousands of other species, and that on a basic level, we each have eyes, ears, lungs, and blood. And as our lives transit and circulate around each other, crossing paths with new people and places, perhaps we have the capacity to exist in harmony.

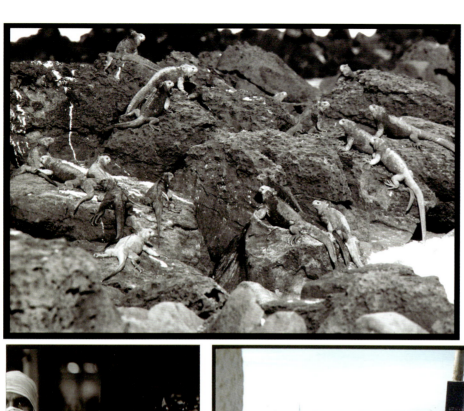
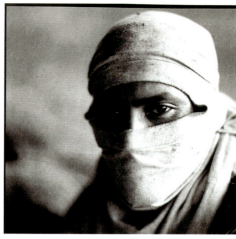
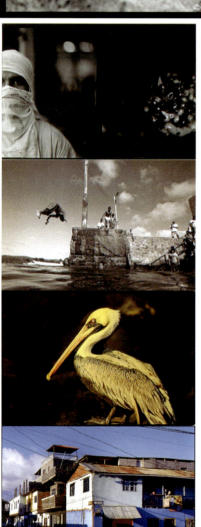
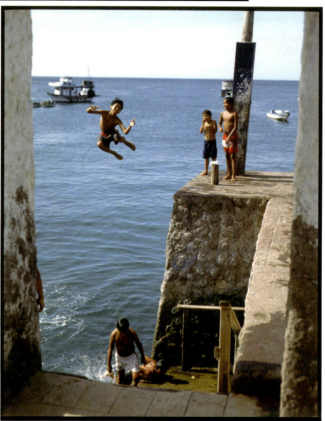

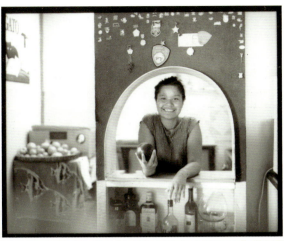

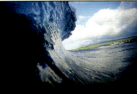

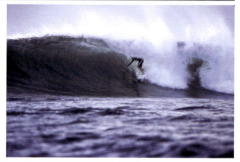
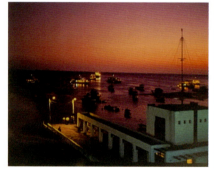

Grilled Rock Fish Pea Risotto

Chilipepper rockfish has a mild and sweet flavor with a firm, large flaky texture.

GRILLED CHILIPEPPER

- two 1 to 2 pound whole, white-fleshed fish (with the head), scaled and gutted; chilipepper, sea bass, snapper, or branzino are all good
- extra virgin olive oil
- sea salt
- freshly ground black pepper
- fresh herb sprigs (for example parsley, tarragon, or oregano) for stuffing the cavity of the fish
- 1 lemon, cut into four quarters

Servings: 2

Preheat your grill to medium-high heat.

Rinse the fish inside and out with cold water and pat it dry with paper towels.

Using a sharp knife, score the skin of the fish on both sides. Rub the olive oil all over the fish, inside and out.

Season the fish with salt and pepper, inside and out. Stuff the cavity of the fish with the herbs.

Place the fish on the grill and cook for about 5 to 7 minutes on each side, depending on the thickness of the fish. You can tell when the fish is done when the flesh flakes easily with a fork.

Remove the fish from the grill and let it rest for

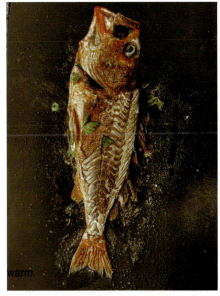

a few minutes before serving with lemon.

GREEN PEA RISOTTO

- 1/2 lemon
- 1/2 teaspoon saffron
- 1/4 cup olive oil
- 1 medium onion, finely chopped
- 2 garlic cloves, minced
- 1 cup long-grain white rice
- 2 cups chicken stock
- 1 cup fresh or frozen peas
- 1/2 teaspoon sea salt
- 1/4 teaspoon fresh ground black pepper

Juice half of the lemon; in a small saucer, stir together the lemon juice and the saffron and leave to soak for 15 minutes.

In a large saucepan, heat the olive oil over medium heat.

Add the onion and sauté for 4 to 5 minutes, or until softened.

Add the garlic and stir for 1 minute or more, until the aroma of the garlic is released.

Add the rice and stir for 3 to 4 minutes, until the grains are slightly toasty and make a clicking noise in the pan.

Stir in the lemon juice and saffron mixture, then add the chicken stock and bring to a boil. Reduce the heat so that the liquid is simmering. Cover the saucepan and simmer for 20 to 25 minutes, stirring occasionally, until the liquid is absorbed and the rice is tender.

Add the fresh peas, otherwise, add the frozen peas during the last 3 to 5 minutes of cooking time.

Add salt and pepper to taste. Serve the risotto warm.

Chef's Notes

Let your local fishmonger know that you are interested in ordering a whole fish a few days ahead — otherwise they get cut into filets the day off.

MY GREAT GRANDMA AT HER KIOSK ON KU'DAMM

FLOWERS AND CIGARETTES

There was once a small shop located along the sidewalks of the famous Kurfürstendamm promenade on Berlin's western side. That was where my great-grandmother sold flowers and cigarettes. It was the kind of place where, in the heydays of prewar hedonism, people may have stopped to pick up a pack of smokes after emerging from the cafés, jazz bars, theaters, and cabarets lining the boulevard before terror swept through the city in 1933. The Nazis pounded these streets into rubble, but in the wake of the war, reconstruction attempted to bring the boulevard back to its former glory. Then, in the 1960s, students rioted through these streets. When the Berlin Wall finally fell in '89, Berliners swept through Kurfürstendamm in waves of celebration.[1]

The Kurfürstendamm has morphed beyond recognition and my great-grandmother's flower and cigarette shop has morphed with it, buried alongside the ghosts of a not-so-distant past. I have never met my great-grandmother. I don't even know her name. But she lives on in my family's memories, suspended in a time before bombs and artillery fire set the city ablaze, before it was ripped in half then reunited and reborn from the ashes into a trend-setting capital teeming with life.

In 2013, I finally arrived in the mythical city where my ancestors, who originally emigrated from Eastern Europe, had made a life for themselves, where they endured times in history I couldn't even fathom surviving. A local gallery and surf shop 'Langbrett' invited Jim Denevan—the American multimedia artist, chef, and farm-to-table pioneer—and me to curate our collections of print and film work for a combined art show during the Berlinale, an annual International Film Festival. But unlike in Wim Wenders' film, *Wings of Desire,* Potsdamer Platz—once at the core of the Roaring Twenties—is no longer a desolate wasteland. Now, glittering skyscrapers surround this vibrant, urban center and the Berlinale's main venue.

I had grown up hearing stories about my grandfather, who grew up in the midst of the Weimar Republic's Golden Twenties, an era that conjures decadent visions of cabarets, seedy underground clubs, and clashes between Communists and Nazis.[2] Berlin was a place I could imagine only through the lens of films I loved.

Like the angels of Wenders' film, I would soar over the Berlin Victory Column and perch atop Victoria's bronze shoulder. Maybe I would swoop and hover over the remains of the Wall, over the space where a deadly minefield once spliced through a city that constantly rebuilds itself.

Hidden somewhere between sleek, spiral glass domes and Cold War–era Plattenbau buildings, I thought I could feel the rhythmic beats of techno pounding from one of Berlin's many temples to post-Wall club culture. If my grandfather had come of age in this century, would he be there now, dancing into the early morning?

At night, people eat their curry-dusted grilled sausages in the yellow glow of the currywurst stand's lights. In some parts of the world, a pig represents filth, greed, and gluttony, but early Teutonic tribes worshipped the wild boar. In battle, they wore helmets emblazoned with images of a boar as a talisman for protection.[3] Sausage became a means of survival in the harsh winter months, a deluge of snow drowning the most desolate mountain regions, where the dry northern winds cured meats.

Roasted ham hocks, plump and gamey, with garlicky crackling skin. Pork cutlets soaked in a creamy sauce of sautéed button mushrooms or chanterelles—or a well-marbled piece of pork belly, braised and resting on a bed of cabbage. Or Schweinekotelett, pork chops, browned and baked and covered until tender—classic Hausmannskost, home cooking, nothing haute. And perhaps nothing could be more Hausmannskost than Bratkartoffeln, the crisp, pan-fried potatoes that legends say surfaced from the kitchen of a Viennese housewife named Henriette Josefa Braths.[4]

And, of course, brussels sprouts. Rosenkohl. That small bud of a cabbage. Whether boiled, blanched steamed, pan-fried, or grilled, brussels sprouts may have earned their name from the Belgian city. But the ancient ancestors of these leafy, sulfurous little cabbages first sprouted from the fields of 13th-century Rome.[5] Strong enough to withstand limestone and harsh soils, the crop spread into Belgium and throughout northern Europe.[6] The sweet, earthy flavor of these bulbous buds balances the salt and fat of a hearty slab of meat.

ZWANGSRÄUMUNG BLOCKIEREN

Heute trifft es deinen Nachbarn, deine Nachbarin – aber gemeint sind wir alle!

DO. / 14.02. / 7.00 Uhr

Lausitzer Str. 8 / Berlin-Kreuzberg / U-Görlitzer Bhf

Das Gesetz hat uns verlassen und nicht wir das Gesetz – Darum: **Vom Protest zum Zivilen Ungehorsam** Eine fünfköpfige Familie soll nach über 16 Jahren aus ihrer Wohnung geräumt werden.

Aus dem Urteil:

„...die Beklagten mussten an dieser St...

BAHNHOF ZOO, MEIN ZUG FÄHRT EIN
ICH STEIG AUS, WIEDER GUT DA ZU SEIN
ZUR U-BAHN RUNTER, AM
ALKOHOL VORBEI. RICHTUNG
KREUZBERG, DIE FAHRT
IS FREI, GOTTBUSER TOR
ICH SPRING VOM ZUG. ZWEI
KONTROLLEURE AHNEN BETRUG
IM AFFENZAHN DIE ROLLTREPPE
RAUF, ZWEI TÜRKEN HALTEN DIE
BEAMTEN AUF. ORANIAN STRASSE,
HIER LEBT DER KORAN, DAHINTEN
FÄNGT DIE MAUER AN, MARIANNEN-
PLATZ ROT VERSCHRIEN, ICH
FÜHL MICH GUT, ICH STEH AUF BERLIN!

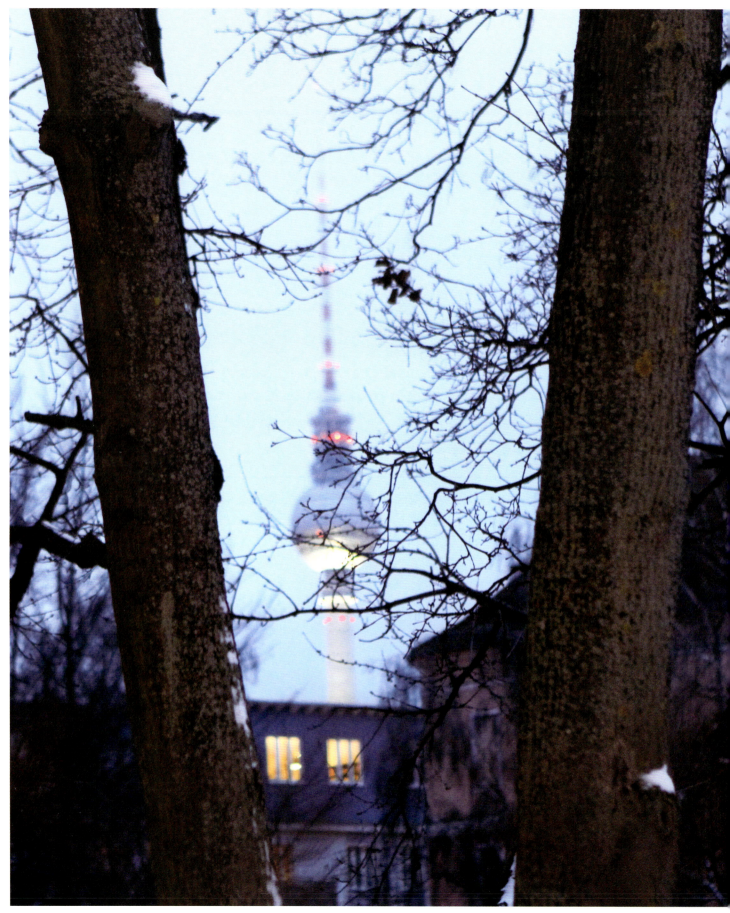

PORK CHOPS, BRUSSEL SPROUTS, ROASTED POTATOES.

Schweinekoteletts mit Rosenkohl und Bratkartoffeln is a traditional German dish that consists of pork chops, brussels sprouts, and pan-fried potatoes. It is a hearty and flavorful meal that is commonly served during the fall and winter months. This dish is often served with a variety of sauces or gravies, depending on personal preference, and can be enjoyed as a main course for lunch or dinner.

PORK CHOPS

- 1 tablespoon olive oil
- 4 thin-cut pork chops
- salt and pepper to taste

SERVINGS: 4

Preheat the oven to 400°F.

Heat olive oil in a large skillet over medium-high heat.

Season the pork chops with salt and pepper, then add them to the skillet. Cook for 3 or 4 minutes on each side until golden brown.

Transfer the pork chops to a baking dish and bake for 10 to 15 minutes until fully cooked.

BRUSSELS SPROUTS AND PAN-FRIED POTATOES

- 2 tablespoons olive oil
- 1 medium onion, chopped
- 2 garlic cloves, minced
- 1 pound brussels sprouts, trimmed and halved
- 4 to 6 medium potatoes, peeled and sliced into rounds
- salt and pepper to taste

In the same skillet that you fried the pork chops, add 1 tablespoon of olive oil and cook the onions and garlic for 2 to 3 minutes, until softened.

Add the brussels sprouts to the skillet and sauté for about 10 minutes, until lightly browned and tender.

In a separate skillet, using 1 tablespoon of olive oil, fry the sliced potatoes until they are crispy and golden brown.

Serve the pork chops with the brussels sprouts and pan-fried potatoes on the side.

For added flavor, you can also add bacon bits to the brussels sprouts while they are cooking.

CHEF'S NOTES

Schweinekoteletts mit Rosenkohl & Bratkartoffen Paired with ALTE REBEN Riesling D.Q.

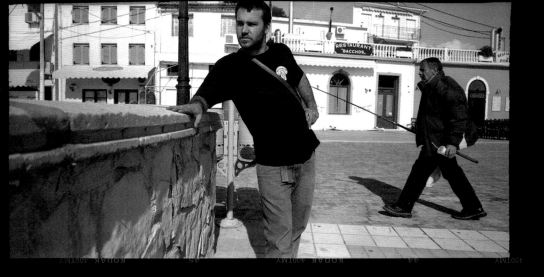
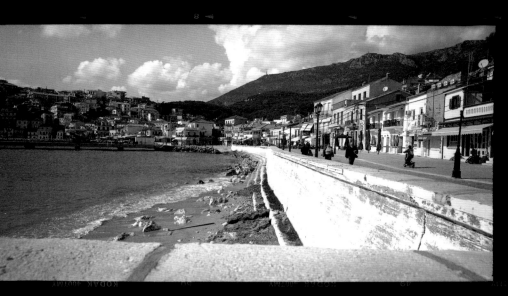

TOTENINSEL

Cheese, wine, honey, and olive oil. Remnants of beehives unearthed from the 1627 BC eruption that blanketed Santorini in volcanic ash. Tales of Alcinous' prehistoric Aegean gardens, where pear and pomegranate trees blossomed, where plump grapes and figs fed mortals.[1] Sheep, or sometimes bulls, cows, goats, or birds, sacrificed at stone altars for ancient gods.[2] Hard loaves of barley bread dipped in wine for breakfast. In a poem from Philoxenus of Cythera, a banquet of honey-glazed prawns unfolds.[3] Evenings overlooking a deep blue bay, toasting a glass of ouzo over plates of eggplant moussaka and sweet graviera cheese from Naxos.

Several thousand-year-old olive groves cloak the hillsides of Greece. Woven between green cedars, old mountain villages, and giant geraniums, the trees' gnarled trunks and branches call upon the Early Minoan days of the Bronze Age. The first exports of olive oil to mainland Greece and North Africa emerged from the narrow, sloping coastlines of the island of Crete. Minoan led to Mycenaean, a civilization known for its fortified cities, vivid frescoes, and advanced writing systems.[4] When Athens reached the peak of its power in the Classical Age, winners of the Panathenaic Games received copious barrels of olive oil as their prize.[5] The Romans learned the secrets of cultivation. Later, under the Byzantine Empire, olive oil held a sacred role for the Greek Orthodox Church: to anoint an infant in baptism, to make offerings, and to light the lamps burning before icons.[6]

Homer's Odysseus washes ashore on the island of Corfu, off the northwest coast of the Ionian Sea, and encounters the lush gardens of King Alcinous.[7] We arrived in Corfu one winter, hoping the stormy seas would bring the best surf. The shop owners and residents of the town laughed and looked at us as though we were crazy, lost, and out of place at a time when no other travelers could be found.

Here, olive groves also engulfed the rugged mountain ranges that reach the holy summit of Mount Pantokrator. The Venetian occupation of the Ionian Islands brought vast expanses of olive groves.[8] With a cluster of tall, jumbled buildings crammed between protective forts and old ports crowned with Venetian bell towers, it's as though a presence of the past remains ingrained in the landscape.

First raised for religious sacrifice, sheep grazed in the grass beneath the olive groves of ancient Greece. In the Odyssey, Telemachus, son of Odysseus, the legendary Greek king of Ithaca, docks at Pylos in search of his father. On shore, he encounters soldiers roasting lamb on a spit, similar to modern-day kokoretsi, entrails rubbed in lemon juice and salt and slow-roasted over hot coals.[9] Like olive oil, the presence of lamb in Greek cuisine echoes centuries, or even millennia, of past traditions. Marinated in oregano, lemon juice, thyme, garlic, and pepper, Greek lamb chops, or paidakia, smoke and sizzle on a grill or over a charcoal fire until well done. Tucked away between neoclassical buildings, art galleries, and cobblestone streets, some small eateries in Athens might serve these chops, thinly-cut but full of fat and flavor.[10]

In Epirus, a northwestern region of rock canyons and golden beaches, lamb and river eels fill hearty pies and stews. Along the Peloponnese peninsula, the cradle of Mycenaean civilization, roasted goat, rustic breads, and honey flourish. Thin sheets of dough brushed with olive oil or butter envelop nuts and fruits bathed in the muscat, citrus, and brandy of Byzantine cuisine. Cracked and splintered ruins of massive stone altars resurface from the undergrowth or collide beneath the foundations of a Greek Orthodox monastery. This place, grand and ageless as the Artemision Bronze, redeemed from the depths of a sunken ship—lost for some time but never forgotten.

KATSIMBALIS

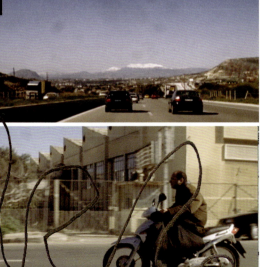

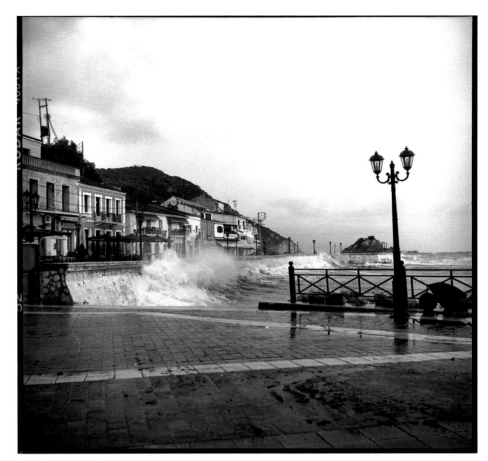

Grilled Lamb Chops, Aubergine & Greek Salad

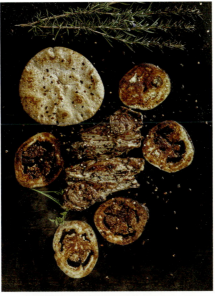

In Europe, everyone says aubergine; in North America, it's more common to say eggplant.

GRILLED LAMB AND AUBERGINES
- 4 thin-cut lamb chops
- 6 garlic cloves, minced
- 1/2 cup lemon juice
- 1/2 teaspoon dried oregano
- 3 rosemary sprigs, chopped
- one cup olive oil
- salt and pepper to taste
- 2 large aubergines, sliced

SERVINGS: 4

In a bowl, mix together the garlic, lemon juice, dried oregano, chopped rosemary, olive oil, salt, and pepper.

Rub this mixture all over the lamb chops and let them marinate in the fridge for at least 30 minutes or up to 4 hours.

Preheat a grill or grill pan to medium-high heat.

Brush the aubergine slices with olive oil and season with salt and pepper.

Grill the aubergine slices for 3 to 4 minutes on each side, until they are tender and slightly charred. Set them aside.

Grill the lamb chops on high heat for 2 to 3 minutes on each side for medium-rare.

Chef's Notes: Ouzo is the Greek National Drink and it is paired with Breakfast, Lunch & Dinner!

FETA SALAD
- 1 small red onion, thinly sliced
- 1 English cucumber, sliced 1/4 inch thick
- 1 green bell pepper, chopped into 1 inch pieces
- 2 cups cherry tomatoes, halved
- 8 ounce block of Greek feta cheese in brine, cut into slices
- 1/3 cup fresh mint leaves, torn into small pieces
- 1 large bunch of fresh dill, chopped

SALAD DRESSING
- 1/4 cup extra virgin olive oil
- 3 tablespoons red wine vinegar
- 1 garlic clove, minced
- 1/2 teaspoon dried oregano
- 1/2 teaspoon Dijon mustard
- 1/4 teaspoon sea salt
- freshly ground black pepper
- whole red peppercorns
- whole mint leaves

In a large serving bowl, mix together sliced red onion, chopped cucumber, chopped green pepper, halved tomatoes, mint leaves, and copious amounts of dill. Break feta slices in half.

In a separate bowl for the salad dressing, whisk together the olive oil, red wine vinegar, minced garlic, oregano, and Dijon mustard. Add salt and pepper to taste.

Pour the dressing over the salad and toss to coat. Garnish with red peppercorns and mint leaves.

Serve the grilled lamb chops with the grilled aubergine slices and feta salad on the side.

Other sides that pair well with these dishes include tzatziki—a dip or sauce made with strained Greek yogurt, grated cucumbers, and lemon juice with fresh garlic, mint, parsley, and thyme.

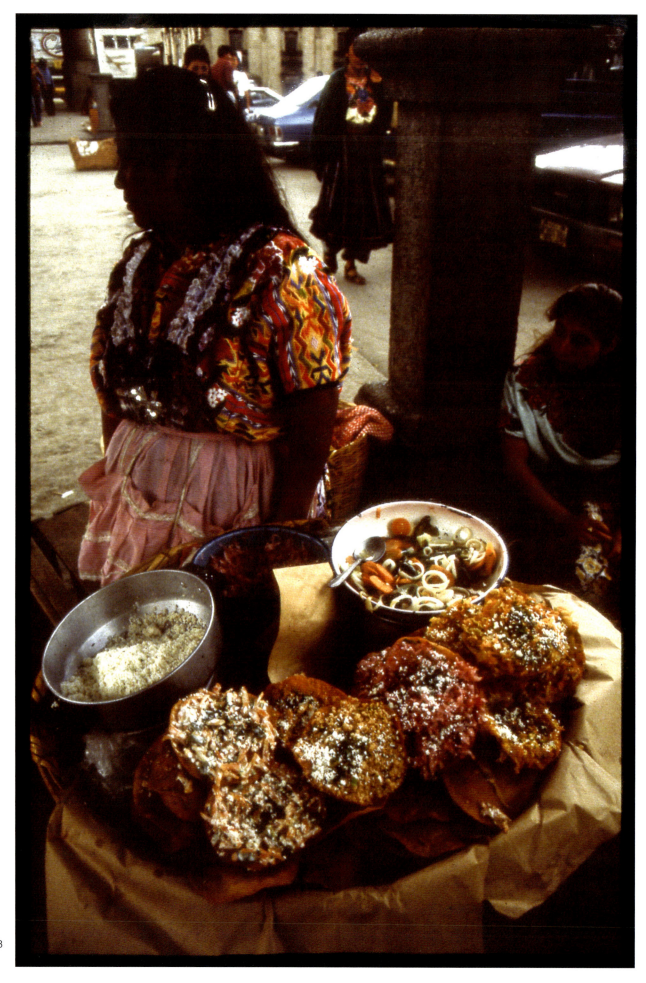

XELAJÚ

We left the swamps of Chiapas, heading south toward Guatemala, where border officials took their time checking each car, rifling through paperwork, and leaving all of us to wither in the languid humidity. Three hundred dollars and a few hours later, our van cruised into Guatemala. Long, eternal roads led us past lagoons and rivers, and the ruins of sacred Mayan sites sheltered behind the dense foliage of howling jungles. We swerved between the Sierra Madre de Chiapas to the south and the Petén lowlands to the north, reaching the highlands in the late afternoon as a cloud of mist unfolded around us.

I remember the cool, foggy air in Quetzaltenango, or Xela—an abbreviation of the original K'iche' Maya name, Xelajú—the city's true name, its name before the Spanish invasion and conquest in 1524.[1] The memories of kingdoms and battles slicing through the mountains and valleys of this coveted land echoed from bromeliad-draped trees and from the blackbirds and buzzards perched on colonial cathedrals.

In this city, far from the eco-lodge industries of Lake Atitlán, we were the only travelers. With broken Spanish and a few jokes shared over cheap Gallo beers, I befriended a local family, the owners of a small store. A humble, delicious lunch of rice and beans carried us through the evening as the dampness of rain slickened the streets. The air became thick with the smells of pan-charred tomatillos, onions, and sweet peppers in a comal, a clay or metal griddle.

These smells would follow you deeper into the highlands, into Cobán, where the bitterness and warmth of coffee and cardamom permeate long tracts of land clustered with concrete houses and mountains veiled in a nebulous fog. In Cobán, once the center of Tezulutlán—a Mayan stronghold and a "land of war"[2]—the aroma of Kak'ik, a turkey soup, would pull you in the way I was pulled into the family's store in Xela. Kak'ik, meaning red and spicy, simmers with the heat and history of a grandiose civilization.[3] The vibrant red broth represents the blood from the sacrificial rituals of the Q'eqchi Mayans' ancestors. A symbol of rebirth.[4] For over a thousand years, the Mayans of Guatemala's central highlands have cultivated the chile cobanero, reddening as they ripen. On the corrugated tin rooftops of villages, chiles dried beneath a beaming summer sun.[5] Take smoky, blackened chile paste, deep scarlet-colored guaque peppers, and fiery, inch-long cobaneros seeded and soaked in warm broth until soft. Take the lean leg of a chunto criollo, a wild turkey portrayed as a godlike figure of power and prestige in Mayan iconography.[6] Achiote, a spice indigenous to the region, peppers the broth with hints of nutmeg.[7]

Served with corn tortillas or steamed tamales—masa harina, made of ground corn—wrapped in banana leaves, this hearty dish, declared a piece of intangible cultural heritage, lines wedding banquet tables and town restaurants bordering the outskirts of Semuc Champey's crystalline turquoise ponds. There was so much we had yet to understand about these lands that have weathered violent regimes and coups and international games of power. But we would only pass through these ancient lands for a short period of time, these lands made of clay and corn, gorgeous and beaming.

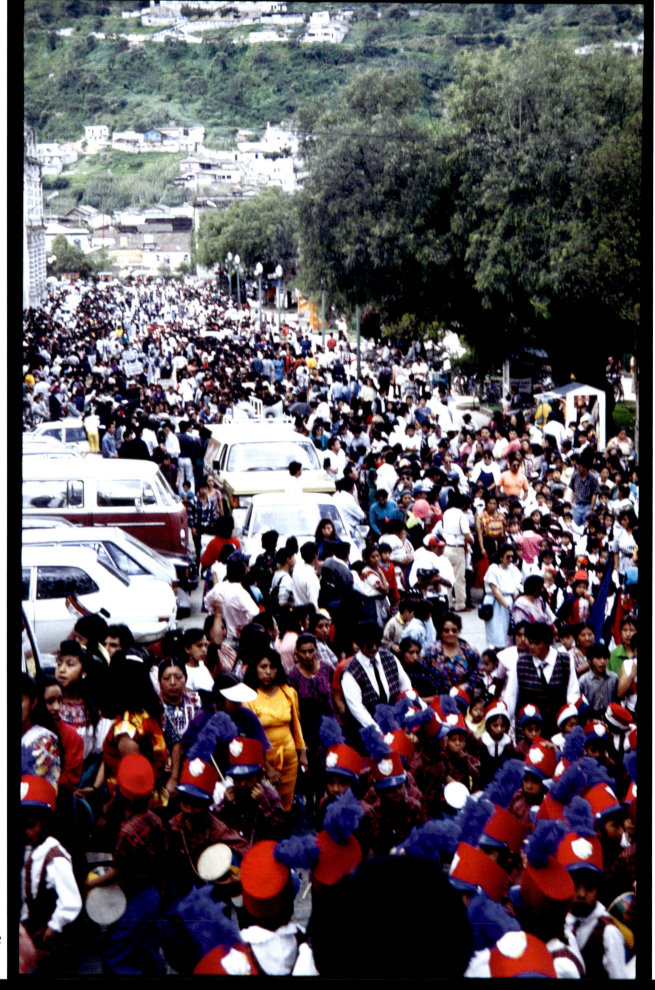

Pepián de Pollo

This velvety chicken stew is the ultimate Guatemalan comfort food. Often considered the national dish of Guatemala, pepián de pollo features tender chicken pieces in a lightly-spiced tomato, toasted pumpkin seed, and chile sauce. Pepián likely draws its name from the word pepitoria—the powder of dried, roasted, and ground pumpkin seeds—an essential ingredient in this dish and in Mayan cuisine overall. The achiote paste used features a Central American native: the red seeds of the flowering evergreen tree, known as annatto, are ground together with cumin, pepper, coriander, oregano, and cloves. Aromatic and packed with flavor, this Mayan-inspired stew is perfect for parties and surprisingly easy to make.

- 1 tablespoon vegetable oil
- 1 whole chicken (about 3 pounds), cut into pieces
- 2 medium tomatoes, chopped
- 1 green bell pepper, chopped
- 1 medium onion, chopped
- 4 garlic cloves, minced
- 2 tablespoons achiote paste
- 1 teaspoon cumin seeds
- 1/2 teaspoon ground coriander
- 1 teaspoon salt
- 1 teaspoon ground black pepper
- 2 cups chicken broth
- 1/2 cup sesame seeds
- 1/2 cup pumpkin seeds
- 3 guajillo chilies, seeded and deveined
- 2 ancho chilies, seeded and deveined
- 1/2 cup corn tortilla chips
- 1/4 cup dried oregano
- 1/4 cup raisins
- 1/4 cup almonds

SERVINGS: 4

Preheat the oven to 350°F.

In a large ovenproof pot, heat vegetable oil over medium-high heat. Add the chicken pieces and brown on both sides.

Add the tomatoes, green bell pepper, onion, and garlic. Cook for 5 minutes.

Add the achiote paste, cumin, and coriander and salt and black pepper. Stir to combine.

Pour in the chicken broth and bring to a boil. Reduce heat to low and simmer for 30 minutes.

Meanwhile, in a dry skillet, toast the sesame seeds, pumpkin seeds, guajillo chilies, and ancho chilies over medium heat until fragrant, about 5 minutes.

In a blender or food processor, combine the toasted seeds and chilies with the tortilla chips, oregano, raisins, and almonds. Blend until a smooth paste forms.

Add the paste to the pot with the chicken and stir to combine.

Transfer the pot to the preheated oven and bake for 45 minutes.

Serve the pepián de pollo hot over rice.

NOTES

CHEF'S NOTES

Quetzaltenango
K'iche Xelajú
Gallo Beers
Kak'ik
Q'eqchi'

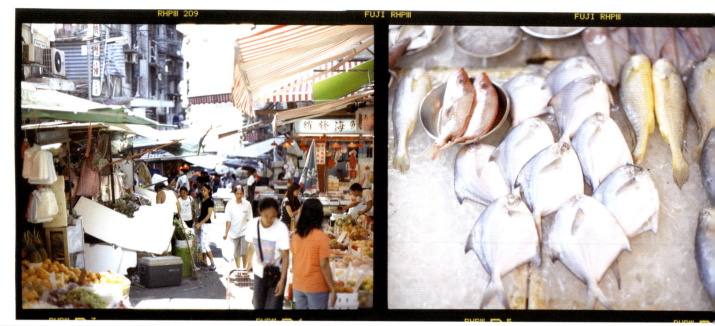

Hong Kong SAR

TAI TAT TEI

Glass skyscrapers burst from the banks of Victoria Harbour. And beyond these towering buildings that herald Hong Kong SAR's position as a world-class metropolis, steep, scarp-like concave hills surround the city and slope into the water. On the shores of the city, a small island moored in southern China's Pearl River Delta, a British naval party landed and raised the Union Jack in the mid-19th century.[1] This "Fragrant Harbor" earned its name from the Pearl River's sweet taste and from the plumes of incense that clouded Kowloon's northern coast.

Once located at the water's edge, the city's chronic overcrowding led officials to create new land, shifting this original point, where the colonial fleet seized land from the Qing dynasty, further inland.[2] The air rattled with the sounds of Cantonese opera singers, storytellers and fortune tellers, and kung fu performers. At night, street vendors dominated the area known locally as Tai Tat Tei, hawking cheap eats—carts piled high with pickled or preserved fruits and peanuts, puddings, fish balls, hot sugarcane, ox offal, or strips of pork char siu, slathered in a sweet red glaze.[3] But in the name of urban renewal, the city razed these traces of a community reclaiming space from British colonial rule. A Chinese garden framed with red columns, green-tiled roofs, glimmering pools, and pavilions took its place.[4]

Further up the street and intertwined between parts of Hong Kong Island, trendy boutiques, hip restaurants, and glitzy galleries characterize this Special Administrative Region (SAR). Clever fusions of Western and Asian cuisines result in plates of truffle fries topped with shiitake tempeh and pickled daikon or green tea ice cream sandwiched between bao, deep-fried like doughnuts. Beyond the cutting-edge eateries that garner international acclaim, alleyways and crowded footpaths snake through pawn shops, stores selling dried abalone, sea cucumber, and fish maw and cha chaan teng—tea restaurants—serving springy, frizzy noodles topped with spam and a fried egg.[5]

Across from island of Hong Kong SAR, a surreal, amorphous monolith once mushroomed over the peninsula in the Opium Wars' aftermath: the Kowloon Walled City. What began as an early Chinese military fort soon morphed into an unregulated Chinese enclave wrought with gangs, brothels, and opium dens and then into one of the most densely populated places on earth. This towering labyrinth of tight, twisting corridors with over 33,000 residents formed a tight-knit community. Factories within the walls produced fish balls and dumplings for export to the rest of the city, the fine flour dust used for crafting noodles coating entire corridors. Then, in 1994, a few years before Britain handed Hong Kong SAR over to China, the Chinese government and colonial authorities demolished the colossus, piece by piece.[6]

But Kowloon still pulses with life. Daylight burns through the smog and night markets sprawl across the corners of the city. Canto-pop pumps from open-air bars and people from all walks of life swirl into the streets. At dai pai dong, low-budget Cantonese food halls, diners cluster around small plastic tables and share plates of steamed shrimp with garlic and vermicelli, deep-fried prawns coated in salted duck yolk, and sweet green mung bean soup.[7]

Bare-bones restaurants with steaming dishes behind wide glass windows entice passers-by to stop for a quick, affordable take-out meal at the famous "two dishes and rice" establishments. Long queues curl around the block, glowing beneath the night's neon buzz. Patrons point or shout their orders to workers who ladle out to-go boxes of spicy eggplant, beef and leek stir fry, sweet and sour pork, or for a few extra dollars, a whole steamed fish.

A long history of fishing permeates Hong Kong SAR and the industry once blossomed in neighboring waters along the southeastern shorelines. Fishermen once raised marine fish in floating net-pen and, in the 1960s, fish farming gained popularity with the pressure to feed a growing population. As Hong Kong SAR has expanded over the past few decades, high-rises replaced the fishponds and few fish are caught in local waters.[8] But a whole, steamed fish still captures the essence of a bustling city's fresh flavors. Hong Kong-style steamed whole fish is a traditional Chinese dish that has been enjoyed for centuries. The dish is typically made with fresh whole fish, steamed to perfection, and served with a flavorful sauce. Once gutted and scaled, a silver perch or sea bass steams with julienned ginger and sliced scallions. The scallions and ginger are cut into thin strips and placed underneath and over the fish, as well as inside the cavity of the fish. During steaming, these lend a beautiful, subtle aroma to the fish. Be generous with the ginger and scallion if you appreciate their tastes as I do. As the fish becomes silky smooth and tender, a drizzle of hot oil and a light soy sauce dressing marinate the finished dish.

After more than 150 years of British colonial rule, Hong Kong SAR escapes the simple imaginations of a postcolonial or postmodern metropolis. Some places, like Kowloon Walled City, have been lost in time, preserved only in memory. But others—the markets, the frenetic atmosphere of fragrant crab-and-beer stalls, the small, hidden tea shops where I ate decadent slices of smoked duck—retain an eternal glow.

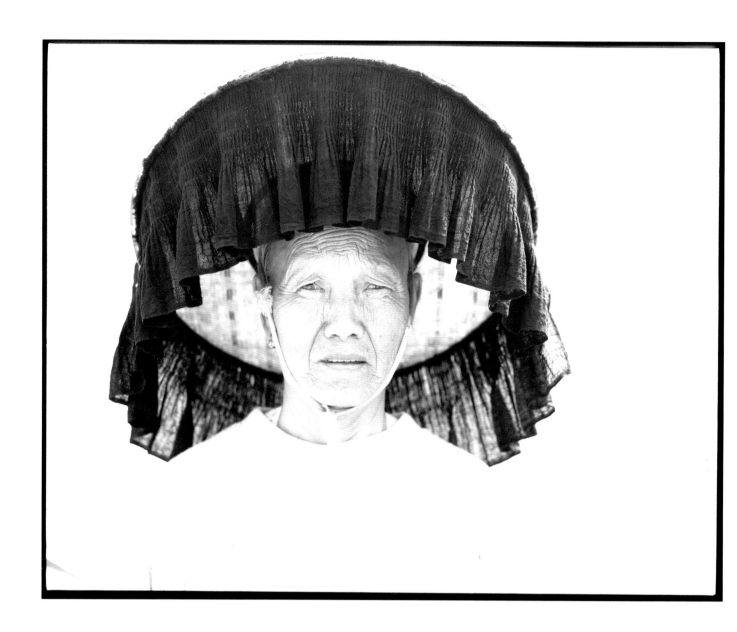

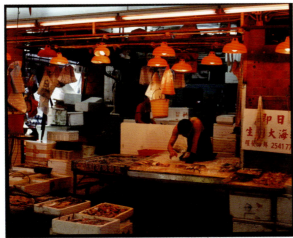

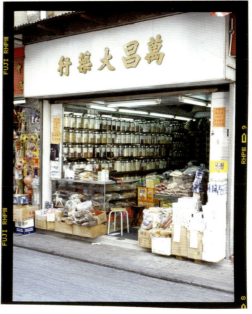

STEAMED FISH

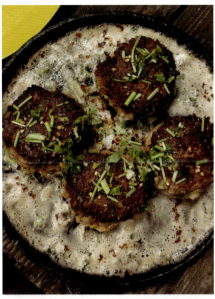

STEAMED WHOLE FISH WITH GINGER AND SCALLION

- one whole fish, about 1.3 pounds, cleaned and scaled; sea bass or red snapper are good options; I used a barred surf perch that my friend Dave caught.
- 2 scallion stalks, chopped into thin rounds
- 1 thumb-sized piece of ginger, sliced into thin strips
- 2 tablespoons soy sauce
- 1 tablespoon vegetable oil
- 1 tablespoon Shaoxing wine or dry sherry

RICE BALLS
- 2 cups cooked arborio rice
- 2 large eggs
- 1/4 cup chopped fresh parsley
- salt to taste
- 1/4 cup coconut oil

SERVINGS: 4

In a large mixing bowl, combine the cooked rice, eggs, parsley, and salt. Mix well until all the ingredients are fully combined.

Using your hands, form the mixture into balls, a bit smaller than a tennis ball.

Heat the coconut oil in a large frying pan over medium-high heat.

Once the oil is hot, carefully add the rice balls to the pan, two at a time. Fry for 2 to 3 minutes on all sides, or until golden brown and crispy. Place on a paper towel to drain excess oil.

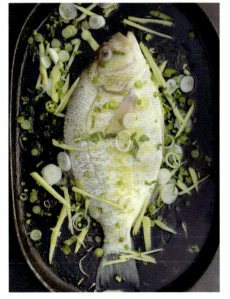

Set up a large steamer, filled with hot water. If you don't have a steamer, you can use a large saucepan with a lid and place an upside down bowl in the saucepan for the plate to rest on. Bring the water to a slow boil.

Season the fish inside and out with salt and white pepper.

Arrange the sliced scallions and ginger on a heatproof plate that will fit inside your steamer. Place the fish on top of half of the scallions and ginger; sprinkle the rest inside the cavity of the fish and on top of the fish.

Mix together the soy sauce, vegetable oil, and Shaoxing wine. Pour this mixture over the fish.

Cover the steamer or saucepan and steam the fish over high heat for about 12 to 15 minutes or until the flesh is opaque and flakes easily with a fork.

Serve hot with steamed rice or rice balls on the side.

CHEF'S NOTES
A SILKY PAIRING WITH A BOTTLE
- of -
"MALVASIA BIANCA" DRY MINERAL INFUSED PLEASURE
BIRICHINO 2021

ROOM WITH A VIEW. FITZGERALDS HOTEL, MAIN ST. MAGHERACAN, BUNDORAN, Co. DONEGAL, IRELAND

the man at the reception looked at my passport & said:
'the first name is good, Patrick... but what happen to the last name?!!'

IRELAND

LONGING FOR SUSTENANCE

Tales of uncrowded surf spots, dark beers, and the rich, meaty smell of a hefty stew drew me out to Ireland. I had spent too much time shooting assignments in mainland Europe and imagined a soul-nurturing solo trip. I would leave behind the fumes of snarled traffic, the pulse of a chaotic world, and the routine of photography. I wasn't interested in taking any photographs in Ireland. Instead, I would just surf and ponder what would lie around the corner. I would listen to my friend Andrew's music on my MP3 player as I watched the world fade into the mist, driving past sprawling green fields of sheep and stone cottages.

In Lahinch, my first stop, I entered a bustling pub in search of dinner. Live music thrummed as the bartender filled glasses with foaming pints of beer. I spoke and laughed with some local surfers into the night, who recommended I venture out to Easkey Bay as the swells were northerly. I felt welcomed and ready to begin my solo journey.

With no hotel reservation in Easkey Bay, a small, rugged town on the northwest coast of County Clare, I spent a frigid night in my rental car, stuffed between my surfboards. I was exhausted from a day of driving and crossing webs of deep, craggy fjords and rivers on tiny car ferries, and starving after a dinner of just a few pints of Guinness at the pub in town, and so I fell into a deep sleep.

The sober light of a cold, dark October morning crept through the open windows of my rental car. It was a miracle I was awake at all, and not because of the Guinness. The windows were open, I realized, because I had left the car running as I slept. I owed my life to someone in town who had turned off the engine and rolled down the windows. As I recovered from the night before, my mind racing and ready to surf the western seas of Easkey Bay, I roamed the town's nooks and crannies for some breakfast. I filled my belly with eggs, haggis, and hot coffee, satisfied after the past day without food. I drove along empty roads, truly alone, with only rivers and inlets that rippled in the wind to keep me company.

When I arrived in Easkey, I found and checked into the only available accommodation, a small bed and breakfast just a short walk down a creek to the surf break. The ruins of a castle towered over the sea, its lichen-spotted stone walls and ancient glory washed away with time. I had come all this way to surf the clean swells that travel from the Eastern Seaboard of the United States to the reefs of Ireland, swells that rival Indonesia's clean, reeling, powerful waves. I wasted no time throwing on my wetsuit and running down the small mossy creek bed to the waterfront. The sun set and the light waned over the shoreline, casting a thick, hazy glow. I returned to town at dark, took a hot shower to defrost my limbs, and set out in search of the warm dinner I'd been dreaming of since arriving in Ireland. In the center of town, I encountered restaurants with boarded-up windows. The streets were desolate. But I found an open pub and after a few pints of dark beer and conversation with the bartender, I discovered I would go to sleep hungry once more. It was the low season, he said, there would be no dinner served anywhere in town.

The next day, I woke up as the first ray of sunlight broke through the clouds. When I put on my cold wetsuit, I felt a dampness that seeped into my bones. But a fresh new swell greeted me as I clambered down the creek bed in the early morning mist, determined to surf and make it back in time for breakfast at the BNB. I rode over hollow, fast waves, completely alone in the water. And when I returned to the BNB, there was no one to be found there, either. I had missed breakfast and I seemed to be alone in a dark and silent place. I feasted on some Twix bars and a packet of chips from a kiosk in town that sold cheap gossip magazines, razors, and hairspray. And, in the evening, I had no dinner—no creamy mashed potato colcannon or corned beef hash, not even a simple, steaming potato soup.

On this island of undulating, marram-grass-covered beaches and pristine hillsides, the potato has perhaps become synonymous with misery and starvation and mass migration. But the history that links Ireland and this cool-temperate crop of the high Andes of South America precedes the Great Famine of the mid-1800s. The potato came from the highlands of Peru in the late 16th century, as sailors on the explorer's ships through the Americas found them to be both a staple that stored well on their long transatlantic voyages and a satisfying and low-cost crop for hard-working people. As a plentiful and cheap food source, the potato thrived in Ireland's cool soils, moist from the dense blue fog that settled over the fields. And shielded beneath the earth, this crop withstood the bloody wars waged against the island in the 17th century, a symbol of resilience.[1]

Instead, for dinner I had the next best staple meal: another round of Guinness and a bowl of the pub's complimentary peanuts. The next morning, cold and starving, I repeated the same routine. Catch the early surf. Marvel at the solitude, the quiet, sort of sad but stoic beauty of a grey, windswept, and lonely place. Miss breakfast again. I packed up my car and fled toward a larger town, toward a dream of a hearty stew infused with black stout and meat.

I could only dream of the roughest, chewiest morsels of beef, slow cooked in beer and broth until succulent. Buttery potatoes and maybe some carrots, parsnips, or turnips—although these additions remain a matter of contention. The infusion of a dark, rich, and creamy Guinness may have emerged from the ingenuity of an Irish pub owner, tucked away between the cobblestone lanes that honeycomb Ireland's cities. A staple of poor Irish workers and farmers since the late 1700s,[2] the black stout tenderizes the meat, coaxing a robust flavor from a bare-bones recipe perhaps as old as the arrival of the cauldron to ancient Ireland.[3]

I could only dream of Neolithic humans heating animal fat in round-bottomed bowls over a blazing fire.[4] Or of medieval castles surfacing between shimmering lakes and tilted fields of muddy sheep, of mutton simmering in the precursor to the Irish stew. I dreamed of sheep, more prized for their wool and milk than their meat in those days. Their meat, tough and tense from old age, required long hours of stewing, releasing the mutton's final bits of fat and flavor into the dish.[5] And as the Irish filtered out across the Atlantic Ocean to colonial America, beef took mutton's place—a meat more available in the so-called New World.[6]

Guinness Stew

Irish stew can be traced back to the 1800s. Beef was a common source of protein for the Irish but it was tough and required long, slow cooking to make it tender. The beef, combined with other ingredients like garlic, onions, celery, and carrots and herbs like thyme and bay leaves create a complex flavor profile. Adding a wee bit of Guinness stout, a rich, dark beer made with roasted malted barley, adds a deep brown color and a slightly sweet taste. The long, slow cooking process allows all of the flavors to meld together, resulting in a hearty and satisfying dish that is perfect for chilly nights.

Sláinte!

- 2 tablespoons vegetable oil
- 2 pounds beef chuck, cut into 1 inch chunks
- 3 medium onions, chopped
- 3 garlic cloves, minced
- 4 carrots, peeled and sliced
- 4 stalks celery, sliced
- 3 tablespoons tomato paste
- 2 cups beef broth
- 2 cups Guinness or another stout
- 2 bay leaves
- 1 tablespoon fresh thyme leaves
- salt to taste
- 2 or 3 black peppercorns
- 10 baby potatoes, halved
- 2 sprigs of fresh thyme

SERVINGS: 4

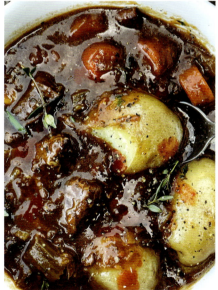

Heat the vegetable oil in a large pot over medium-high heat. Add the beef cubes and cook until browned on all sides. Remove the beef from the pot and set aside.

In the same pot, add the onion, garlic, carrots, and celery. Cook until the vegetables have softened, about 5 minutes.

Stir in the tomato paste and cook for an additional 1 to 2 minutes.

Return the beef to the pot and pour in the beef broth and Guinness stout. Add the bay leaves, thyme leaves, salt, and peppercorns. Stir well to combine.

Bring the stew to a boil then reduce the heat to low. Cover the pot and let it simmer for 1.5 to 2 hours or until the beef is tender and the flavors have melded together.

Add the halved baby potatoes to the pot and continue simmering for an additional 30 minutes, or until the potatoes are cooked through.

Garnish with sprigs of fresh thyme and serve.

 NOTES

Chef's Notes

Spend the years of learning squandering, Courage for the years of wandering through a world politely turning from the loutishness of ~~learning~~ 'learning'
—Samuel Beckett

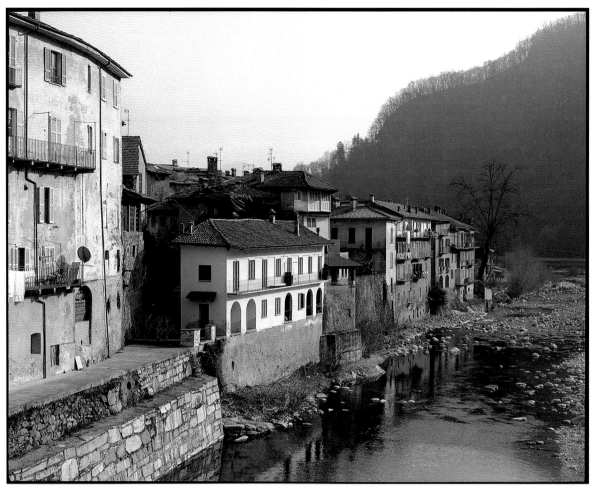

CONIGLIO ALLA CACCIATORA

Imagine the Salassi, a Celtic-Ligurian tribe, settling among spruce and silver fir and chamois scurrying through snow along the upper valley of the Dora Baltea River. As the first settlers of a territory stretching from the plains of the Po River to the foothills of the Graian and Pennine Alps, the Salassi controlled an impenetrable alpine pass.[1] And imagine the Taurini, another Ligurian group, extending west into the Piedmont and south of the Po River, even as far as the French Provence-Alpes-Côte d'Azur region. Imagine them guarding a land of brackish closed lagoons, flat valley plains, sand dunes, and wetlands woven together—until the Carthaginian military commander Hannibal laid siege to the Taurini settlement on his march through the Alps in BC 218.[2]

Imagine these Celtic-Ligurian tribes of northern Italy locked in continuous battle, losing their deep valleys and lofty mountains and fertile lowlands to the Roman Empire. The Romans defeated the Celtic-Ligurian tribes and established colonies with aqueducts, amphitheaters, and arched walkways.[3] They brought with them a cuisine of beef, mutton, and lamb doused in salt and olive oil and incorporated the bold wines left over from the Celtic-Ligurian days.[4]

Several centuries after the Celtic-Ligurian tribes, after Hannibal, and after the Romans, the Walser peoples scattered from their original homeland in the Upper Rhône Valley of the Swiss Valais to northwestern Italy. Perhaps a growing population triggered their pilgrimage to this seemingly unchanged landscape, aged and pickled in time.[5] Or perhaps an unforeseen period of warmth in the Middle Ages caused the earth to reveal its hidden arteries, exposing paths around the mottled mountain massif of Monte Rosa. Perhaps they set out in search of a lost valley of halcyon days, where rye blooms in abundance and grass remain evergreen on the other side of a glacier.[6] As these High German-speaking peoples settled in the valleys of northern Piedmont and Aosta in the 12th and 13th centuries, they built houses—known as Stadel or Rascard—made of larch wood that lean on short columns shaped like bulbous mushrooms.[7]

They crafted ricotta, goat's cheese, and bettelmatt, a rich whole cow's milk cheese that smells of wine and ripe fruit. Hearty bean and cream soups, chunks of salted, buttered, stale bread boiled in water, and meals made of buckwheat, barley, and dried meat filled their stomachs on cold nights in the mountains.[8]

Centuries of trade influenced this land-locked region's taste buds, shaping salted and dried cod from Norway or Nova Scotia or New England into stews[9] and Sicilian or Calabrian anchovies into bagna càuda, a hot, garlicky gravy.[10] Here, in Piedmont, the evening light soaks the flat, arborio rice fields in a honeyed glow. These fields, first cultivated in the Middle Ages, are Europe's largest producer of the starchy short-grain rice responsible for buttery risottos—a local specialty infuses the dish with boiled chestnuts from the lower valley's woodlands.[11]

Each region around Italy claims its invention of a rustic cacciatore, but the dish's origins remain obscure, like chimney smoke enshrouding the mountains. The Walser peoples may not have invented cacciatore, and perhaps neither did the Celtic-Ligurian tribes, the Burgundians, Ostrogoths, Lombards, Franks, or Romans that followed. But their dedication to local self-sufficiency fits the mold of what it means to cook alla cacciatora or hunter's style.[12]

Coniglio alla cacciatora, or hunter's style rabbit, cooks rabbit in a marinade of olive oil and red wine, a variation that pays homage to northern Italy. It is not the meat braised in fresh tomatoes, black olives, and white wine vinegar of Tuscany. Nor is it the tomato sauce-submerged anchovies of the Romans. And it is not the bell pepper, roast chicken, and caper-laden cacciatore of Sicily.[13] This is a recipe rich with wild herbs, sweet, gamey rabbit, and juniper berries reminiscent of pine and rosemary. The porcini mushrooms add an air of the Italian Alps, foraged from Valsesia's pine forests, through trails of fresh fallen snow at the base of Monte Rosa's black rocky crest.

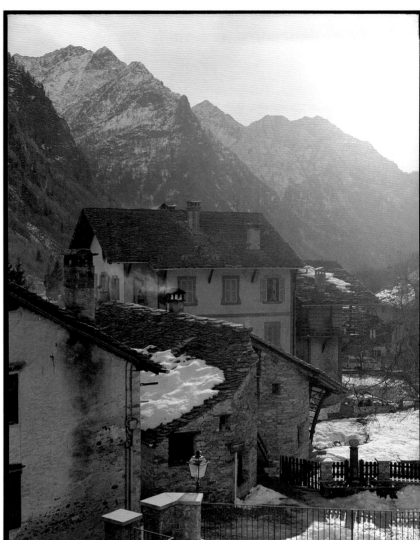

VAL SESIA, NORTHERN ITALY

RABBIT STEW
(CACCIATORE)

WILD RABBITS HAVE FIRST BEEN TAMED IN 600 AD BY FRENCH MONKS

INGREDIENTS:

1 RABBIT 3.5 lb / 450 g
PORCINI MUSHROOMS
POTATO PUREE 1.5 cups /
of GARLIC
4 JUNIPER BERRIES
1 yellow onion
½ cup of Red Wine
6 Tbsp extra virgin olive
sprig rosemary
2 bay leaves
2 cloves
½ tsp black pepper
salt to taste

Polenta or Potato Puree

every Region

☆ Soak THEM overnight in cold water in the fridge. Rinse several times in cold water & pat dry w/ paper towels

Rabbit Cacciatore

Wild rabbits were first tamed in AD 600 by French Monks. Between the 10th and 13th centuries, the German-speaking Walsers settled at the foot of Mount Rosa in northwest Italy. They later made their homes in the mountain towns of Alagna, Formazza, Macugnaga, Rima, and Rimella. Their cuisine is centered around self-sufficiency, using local mountain products like buckwheat, barley, potatoes, and turnips and wild herbs and berries, foraged mushrooms—and rabbits. The goal of Walser cooking is to satiate the appetite, a notable example being the cacciatore.

- 2 tablespoons extra virgin olive oil
- one 3.5 pound rabbit, cut into pieces
- 3 carrots, chopped
- 2 celery stalks, chopped
- 1 medium onion, chopped
- 3 garlic cloves, crushed
- 1.5 cup tomato purée
- 2/3 cup dried porcini mushrooms
- 4 juniper berries
- 2 whole bay leaves
- 2 cloves
- 2 medium tomatoes, diced
- 1/2 cup red wine
- 2 cups chicken broth
- 1 teaspoon dried thyme
- 4 to 5 fresh sprigs of rosemary
- 1 teaspoon dried oregano
- 6 to 8 fresh whole sage leaves
- 1 whole head of garlic
- salt and pepper to taste

SERVINGS: 4

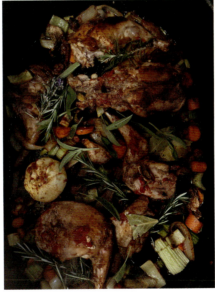

In a large dutch oven or heavy pot, heat the olive oil over medium-high heat. Add the rabbit pieces and cook until browned on all sides, about 5 to 7 minutes. Remove the rabbit from the pot and set aside.

Using the same dutch oven, use the oil in the pan to sauté the carrots and celery for 5 to 7 minutes until the vegetables are just tender.

Add the onions and garlic to the pot and sauté until softened, another 2 to 3 minutes. Add the tomato purée, stir everything well and then add mushrooms, juniper berries, bay leaves, and cloves. Stir well.

Add the diced tomatoes, red wine, chicken broth, thyme, rosemary, oregano, sage, and the whole head of garlic to the pot. Add salt and pepper to taste. Stir to combine.

Return the rabbit pieces to the pot and bring the mixture to a simmer. Cover the pot and cook for 1 1/2 to 2 hours or until the rabbit is tender and cooked through. Check on liquids, every 30 minutes or so; if needed, replenish with additional wine or stock.

When the rabbit is tender and you are ready to serve, stir in the chopped parsley and adjust the seasoning as needed. Serve the rabbit stew hot over polenta. Enjoy your rabbit cacciatore!

NOTES

CHEF'S NOTES
enjoy with a red WINE FROM the VALSUSA VAlley. FINISH THIS FESTIVE MEAL WITH Panna Cotta, followed by an Espresso & several shots of GRAPPA.

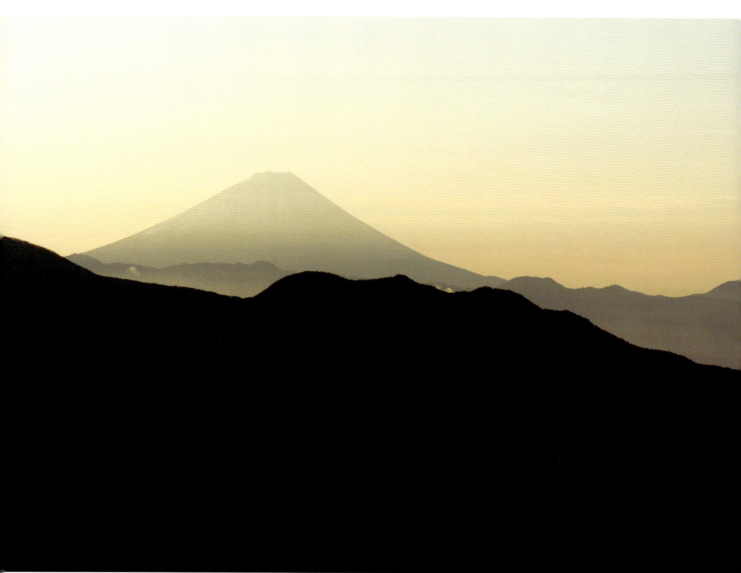

JAPAN

CHAWANMUSHI

Past, present, and future flashed together on the highway as I hung out of the side door of Daisuke's minivan. I had joined my longtime friend, film director Brian Vernor, in Japan to help him shoot a new project. There were moments when we sped past Buddhist temples, Shinto shrines, palaces, pagodas, parks, shopping malls, and industrial agglomerations. I came to experience Japan as a place that exceeded the stereotypical imaginations of a land either steeped in solemn tradition or plagued with hyper-modernity.

I remember moments when the world seemed to pass by without much of a hurry. Like when we'd warm our hands on steaming hot cans of coffee as we wandered past majestic wooden temples with curving, clay tile roofs in Nagano. We'd shoot for Brian's film and, in the evenings, the aroma of soba noodles from a warm-lit restaurant would pull us in. Sometimes, we'd slurp soba with a chilled dipping sauce made of kelp-derived dashi or served with mushrooms and vegetables from the fertile farmlands and mountains encircling the city.

Time also passed slowly when we stayed with our host, Dayko, and his young family in their tiny house in Osaka. We crashed on the floor with just enough space to hear each other's breaths. And in a Kyoto temple, I fell asleep to the smell of rice straw and wood chips from the tatami floor mats we spent the night on. The smoke from yakitori restaurants billowed out into the street around us. A slight umami flavor from a small bowl of buckwheat soup lingered in my mouth long after we'd finished eating.

The bold but delicate flavors of forest mushrooms, flaky, dried fish, and steamed rice would always stay with me no matter what part of the country we zig-zagged through. And on the northwest coast of Kyushu, the large natural harbor of Nagasaki would always pulse as a center of trade. Even in a time of self-imposed isolation from the world, raw silk, sugar, and chemicals flowed between Dutch and Chinese hands. As merchants glided along the city's curving harbor, the flavors of nations beyond Japan's cobalt-blue seas infused the nation's traditional cuisine. A new culinary style snaked through buildings built on the terraces of surrounding hills, transforming the dinner tables and Edo-era cookbooks of the cultural elite. This style, known as Shippoku Ryori—from the Chinese characters meaning table and tablecloth—removed the individual trays set before each diner. Instead of serving food on this relic of samurai society, where social class remained stratified, several small dishes sprawled across a circular, communal table.[1]

Slowly, as the years passed, this hybrid concoction of East and West snaked throughout Japan's urban areas to the earthen-walled and baked tile-roof houses and gold-gabled palaces of Kyoto and Osaka. Scores of people could breach the barriers of social class, sharing kaku, boneless chunks of marbled pork, simmered until tender, glistening with a soy glaze. Pickled vegetables, an aromatic broth of steamed snapper, or fluffy egg dumplings might accompany a shippoku luncheon special, burrowed at the bottom of a lidded lacquer bowl.[2] Basti, a soup served with a lattice-shaped pastry reminiscent of pot pie, invokes European influence, and hatoshi, a pan-fried bread filled with minced prawn, conjures up a Chinese fusion from Guangzhou.[3]

During the Edo period, small bowls of steamed savory egg custard emerged from shippoku banquets.[4] Chawanmushi, which translates to teacup steam or steamed in a tea bowl makes a delicacy of bite-sized bits of prawn, shiitake mushrooms, bamboo shoots, kamaboko fish cakes, and ginkgo nuts set in a concoction of beaten egg, dashi, mirin, soy sauce, and salt.[5] A precise ratio of soup stock to egg achieves the perfect silky smooth balance. Centuries ago, Nobutake Yoshida, a feudal lord from Iyo Matsuyama—a land of pine-peppered mountains, castles, and bubbling hot springs—ate chawanmushi for the first time in Nagasaki. Impressed with the custard's rich umami punch, he opened what is now the oldest restaurant serving chawanmushi.[6] Even today, this ancient fusion of Japanese, Chinese, and Western flavors and textures permeate both kaiseki-ryori—Japanese hâute cuisine—and home kitchens.

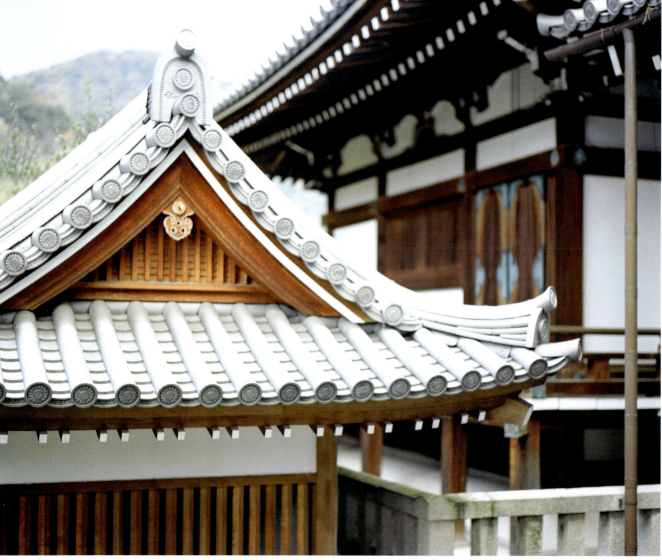

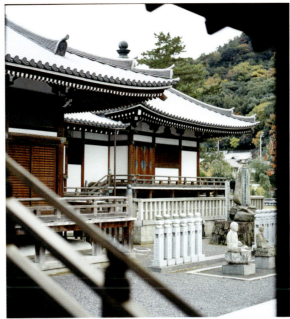

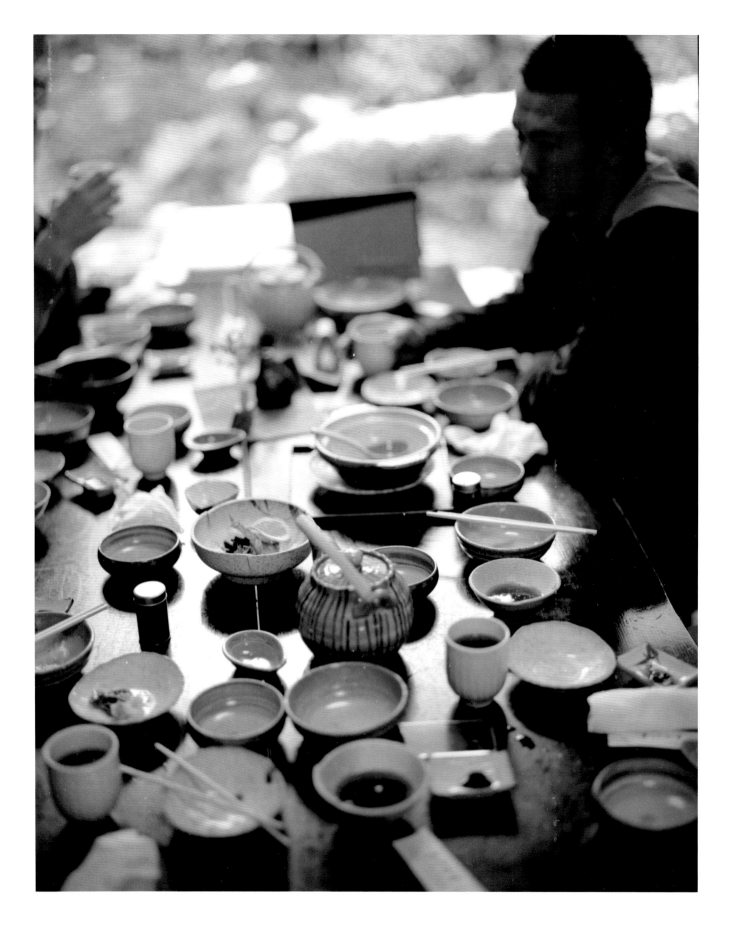

CHAWANMUSHI

Japanese cuisine is renowned for its attention to detail, use of fresh ingredients, and emphasis on natural flavors. One of the most distinctive features of Japanese cuisine is its emphasis on presentation. In Japan, food is often seen as a work of art, and chefs spend a great deal of time and effort to create visually stunning dishes that are not only delicious but also beautiful to look at. Chawanmushi is a Japanese savory egg custard dish that is usually served as an appetizer.

- 2 large eggs
- 2 cups dashi stock
- 1 tablespoon soy sauce
- 1 tablespoon mirin
- 1 1/4 teaspoon of salt
- 1/4 cup shelled edamame (soybeans)
- 1/2 cup fresh shiitake mushrooms, sliced
- ½ cup of shredded dried nori seaweed
- 1/2 cup radishes, sliced
- 1/2 cup of sliced cucumbers, soaked in rice wine vinegar
- 1/2 cup radish sprouts
- 1/2 cup chopped scallions
- 1 teaspoon ikura (salmon roe)
- 2 to 3 dried katakushi iwashi (dried and candied anchovies)

SERVINGS: 4

In a mixing bowl, beat the eggs until they are well mixed. Add the dashi stock, soy sauce, mirin, and salt; mix well.

In a small saucepan, steam the edamame for 10 minutes in an inch of water, adding a pinch of salt.

Divide the mushrooms and seaweed equally among four small heatproof bowls or cups.

Pour the egg mixture into the bowls, filling them about 3/4 full.

Cover the bowls with lids or aluminum foil and steam them in a steamer over medium-high heat for 15 to 20 minutes or until the custard is set. If you don't have a steamer, you can use a saucepan filled with an inch of water; carefully place the bowls inside the pot, cover the pot, and simmer on low for 15 to 20 minutes.

Once the custard is set, remove the lids or foil, and place the remaining ingredients (edamame, shredded seaweed, radishes, cucumbers, radish sprouts, scallions, salmon roe, and/or the katakushi iwashi) on top.

Serve the chawanmushi hot. Enjoy this rich heart-warming umami bowl—a special treat on cold days yet still very enjoyable on warm ones as well!

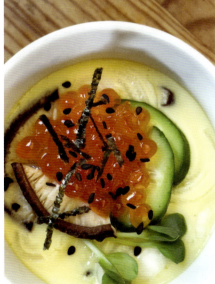

CHEF'S NOTES

THE PERFECT DINNER SOUNDTRACK FOR this Ceremonial Ritual is THE SHAKUHACHI - "the Japanese flute" BY KOHACHIRO Miyata

NOTES

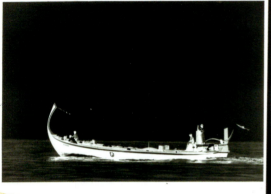

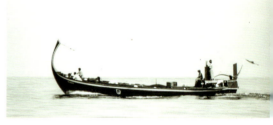

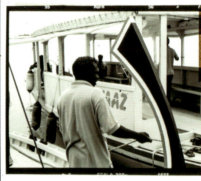
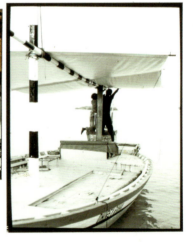

BOḌU NIYAMI TAKURUFĀNU

Starvation and death ravaged early settlers on the twenty-six ring-like atolls of the Maldives, so legends say. That is, until a faṇḍita, a sorcerer endowed with wisdom to appease the islands' spirits, brought coconut palms to blossom from the skulls of buried corpses. The faṇḍita, prepared a secret concoction and filled the mouths of every dead settler with the mixture. Shrubs and coconut palms now bound this nation, perched on bleached coral fragments and sand swept from the depths of the Indian Ocean. Since then, islanders have survived on coconuts, crafting oils, medicines, houses, and creamy, bubbling curries.

Without Boḍu Niyami Takurufānu, the famous mālimi, or navigator, no firm, plump chunks of skipjack and yellowfin tuna would ever boil in aromatic Maldivian curries. Boḍu embarked on a journey close to the mythical Dagas tree and a storm thrust his ship beyond this black, thorny coral tree at the edge of the world. As the sea calmed, a school of strange, shimmering fish leapt around the base of the tree. Boḍu and his crew sailed for what seemed like endless days and nights, the fish following in his ship's wake until they reached the atolls and safety.[1]

Sparse, dry soils on these flat coral islands imposed a lifestyle that lacked the luxuries of abundant vegetables.[2] But far from being bland or basic, Dhivehi, or Maldivian, cuisine flourishes in the creativity of reconfiguring three key INGREDIENTS coconut, fish, and starch. The mystical fandita's gift of coconuts, and Boḍu's blessing of thick, rosy tuna simmer together in kulhimas—kulhi, meaning hot, and mas, meaning fish—a warm, tangy curry. Coconut milk mellows out the fire of fresh tuna pan-seared in chili peppers and the southern Indian spices of cardamom, curry leaves, and turmeric.[3]

For centuries, kings and queens ruled the atolls, governing their lands independent of outside influence. Maldivian sailors ventured beyond their sandy beaches and crystalline lagoons to Rome and China and maybe even other lands that have escaped popular documentation.[4] Soon, Buddhist seafarers from Sri Lanka and southern India came and left relics and ruins of monasteries, vast kingdoms, and religious sculptures carved from coral. Arab and Persian traders sailed through the Maldives' turquoise waters, dreaming of abundant pearls, spices, coconuts, and dried fish.

With waves of conquest, trade, and settlement, Buddhist temples became mosques. Portuguese and British colonial occupations, Indian invasions, and Dutch and French attempts at conquering these palm-covered islands may have shattered periods of peace but vestiges of original Maldivian dynasties remain.[5] In Malé, tucked between colorful buildings that pop like the papayas, pitayas, and passionfruit sold in its markets, the Malé Hukuru Miskiy, or Malé Friday Mosque, faces the sun, rather than northwest toward Mecca.[6] Built on the foundations of an ancient temple pointed westward where the sun sets, some say this proves the subtle preservation of pagan religions.[7]

Civilizations have washed ashore for centuries, some leaving behind the debris of colonial destruction, others long forgotten, but slowly rediscovered like the small Buddhist statues unearthed from Kalaidhoo island.[8] But the sea might soon swallow these low-lying atolls within our lifetime.[9] As sea levels rise, as human pollution and warming waters cause the death of coral—the Maldives' lifeline—the future of these islands hang in a delicate balance.

The waves were perfect—clean, fast, and hollow. They broke over shallow coral reefs, swarming with beautiful tropical fish, and there were barely any people around. I felt pure joy. I'd flown from across the world, traveling for two days, and the team I was supposed to shoot with for an assignment had yet to arrive. But that was fine by me. I ended up spending time with a cool, local surfer named Mohammed. An aspiring photographer, we shared the same passions. I gave him a camera and one of my water housings so he could further his career from the perspective of a surfer, right from the water.

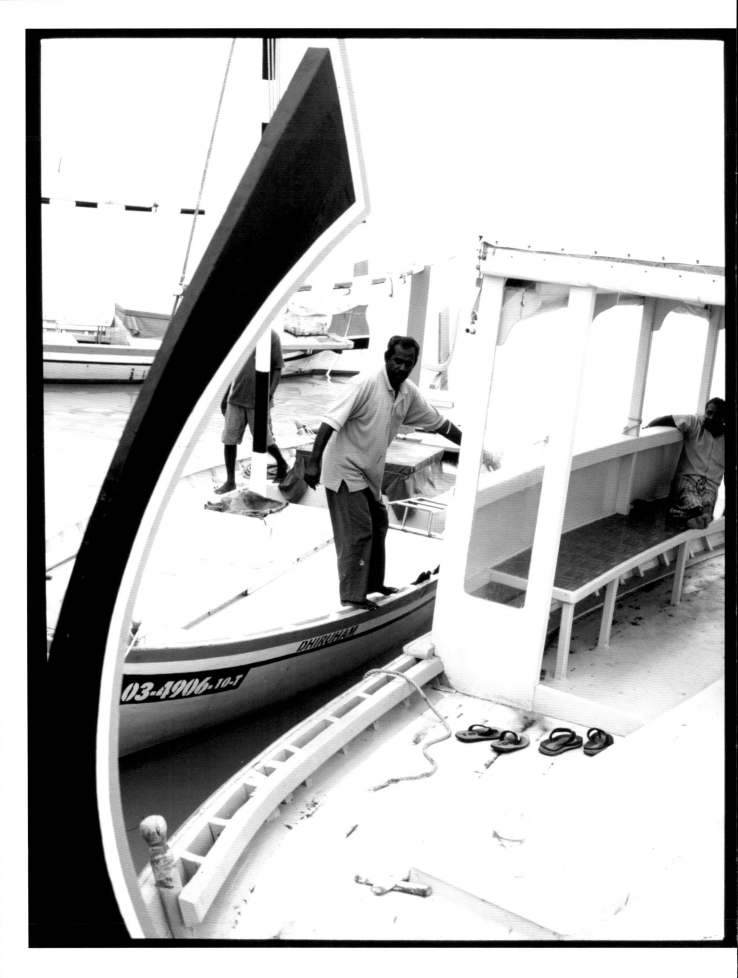

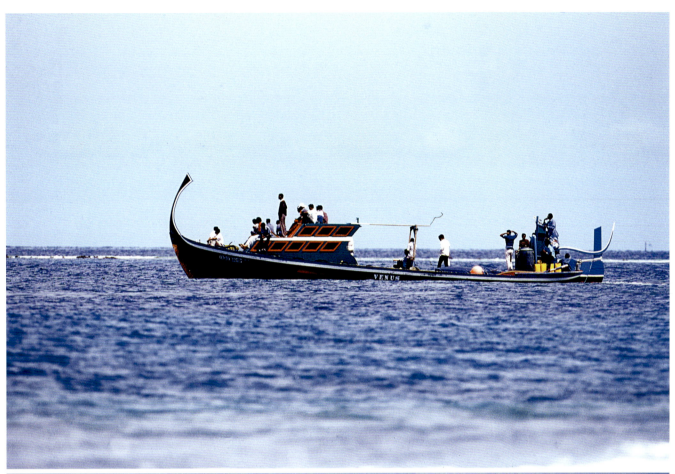
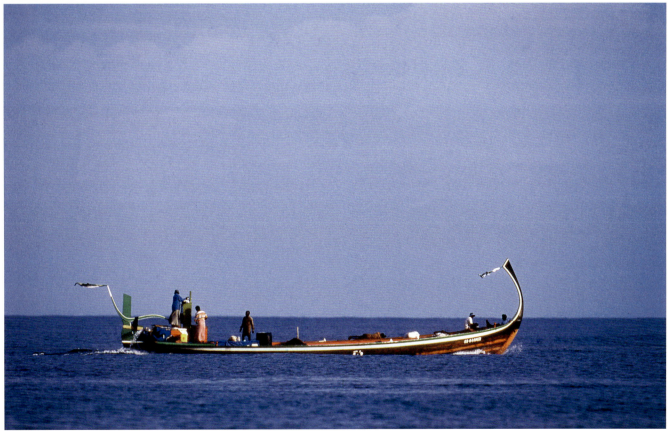

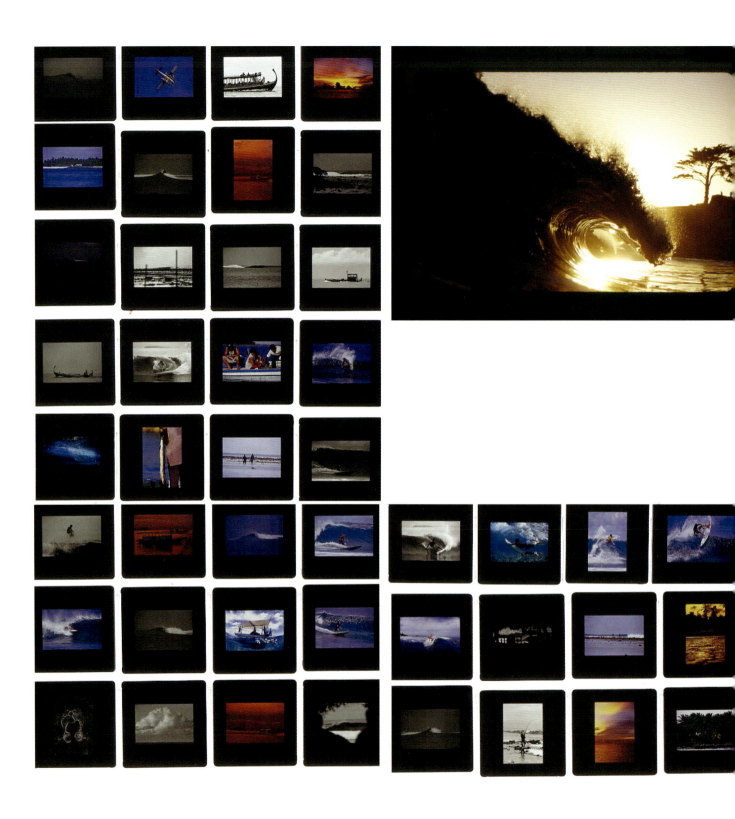

150

Dhonriha
Tuna Curry

Curry fish is a popular dish in the Maldives, an island nation located in the Indian Ocean. The dish is typically made with fresh tuna, which is a staple food in the Maldives.

- 1 pound fresh fish (yellowfin tuna, swordfish, or any other firm fish)
- 1 tablespoon coconut oil
- 1 medium onion, chopped
- 2 garlic cloves, minced
- 1 teaspoon grated ginger
- 1 teaspoon cumin seeds
- 1 teaspoon ground coriander
- 1 teaspoon turmeric powder
- 1 teaspoon chili powder
- 2 cups coconut milk
- salt to taste
- curry leaves

SERVINGS: 4

Chef's Notes
Post dinner enjoy a cup of chai tea

Clean the fish and cut it into bite-sized pieces.

Heat a tablespoon of coconut oil in a large pot and sauté the onions, garlic, and ginger until the onions are translucent.

Add the cumin, coriander, turmeric, and chili (if using) and stir for a minute until fragrant.

Add the fish pieces and stir gently to coat them in the spice mixture.

Pour in the coconut milk and add salt to taste. Add a handful of curry leaves and bring the curry to a boil.

Reduce the heat and let the curry simmer for about 10 to 15 minutes or until the fish is cooked through.

Serve hot with rice or naan bread.

Notes

CHIAPAS

FROM TUXTLA Gutierrez DOWN TOWARDS THE PACIFIC COAST IN OUR BEAT UP OLD DODGE VAN WITH TWO OLD LONG-BOARDS STRAPPED TO ROOF WE WERE SPOTTED AS OUTSIDE FROM MILES AWAY. VIA TAR. WE WERE TRAVELLING ON DIRT RO ALONG the PACIFIC OCEAN SAN JOSE EL HUATATE, LOOK FOR WAVES. AS WE PASSED OF MAYA PLAYING CARDS B- SIDE of Pothole ridden tho FATE, they HALTED IN SUSPE Yelled in UNISON: GRINGOS

SOPA DE PAN CON PLÁTANOS

We pulled into Tapachula to the smell of smoke and fire. On the side of the road at a traffic light, children gulped big swigs of gasoline to spit out and set on fire for a few pesos. They may have been migrants, passing through this southern border city in the state of Chiapas, a gateway to North America. Caught in this liminal space, tens of thousands of people—from Haiti, Cuba, Honduras, and increasingly, from the African continent—have come to call this hot, humid borderland a temporary home.[1] Short, strong women walked down narrow, crowded sidewalks with baskets of food stacked tall on their heads, navigating street vendors selling bright embroidered clothes, plastic buckets of shrimp, and kilos of rambutans, bananas, and soursop.

We drove for six hours out of Tapachula and further up into the eastern highlands of Chiapas along deeply rutted roads. Steaming jungles. Sandbag-lined bunkers. Large troop encampments. Fertile fields of coffee and cacao. Razor wire fences. The air outside felt sticky with unease. Soldiers eyed us from their checkpoints as they blended into a blur of lush green forests with lavender-pink flowers on tall, branching stalks.

It was 1992 and we had no idea of the revolution brewing within these highlands. A legacy of disease, enslavement, and exploitation ravaged the Indigenous peoples of the Americas, and here in Chiapas, the Zapatista Army of National Liberation (EZLN) would soon declare an uprising. At the hands of the Mexican state, centuries of malnutrition, maternal mortality, illiteracy, and unequal land distribution tore deep wounds across this lush, winding landscape. The Zapatistas, an Indigenous peasant movement of Tzeltal, Tzotzil, Chol, Tojolabal, Zoque, Kanjobal, and Mame communities, would arm themselves, seize mountain towns of wooden homes and thatched pigsties, and farm on reclaimed lands.[2]

But this conflict would not erupt until two years after our journey in the '68 Dodge van. For now, we made our ascent into the sultry, wooded hillsides surrounding the ancient Mayan city of Tenam Puente. The ruins of grandiose, limestone fortifications jutted out from the dense undergrowth. Built along a historic trade and transportation route, Tenam Puente lies along an artery connecting the region's highlands and lowlands. The Acropolis, with its patios and plazas overlooking the southeast edge of the Comitán Plateau, felt solemn and still, half buried into the side of a mountain.[3] We continue onward.

More than six thousand and five hundred feet above sea level, San Cristóbal de las Casas rises amid Mexico's rugged southern highlands, shrouded in a thick fog. Indigenous Tzotzil and Tzeltal villages surround San Cristóbal's elegant colonial mansions and colorful houses with terracotta rooftops. We arrive as Holy Week processions plod through the city's narrow, cobblestone streets as devotees carry sunflower and dahlia-crusted shrines venerating Jesus and the Virgin Mary.[4] The aroma of thyme, plantains, and boiled eggs simmering in a warm chicken broth wafts out of the windows, melding with the copal incense burning from ocher-and-rust-colored Baroque churches.

Sopa de pan, also known as sopa de fiesta, is a bread soup of celebration that may have emerged from the kitchens of Spanish colonizers.[5] The Spanish peppered their dishes with raisins rooted in Persia and Egypt; the Phoenicians traded juicy dried muscats, sultanas, and currants with the Romans and Greeks.[6] Oregano and thyme flavor the broth and saffron, that essential ingredient of Spanish cuisine, imparts a rich golden hue. Some bakers still craft local bread, or bolillo, made of pork lard, flour, sugar, salt, yeast, and water, slices made for soaking up the steaming broth. Layers of plantains, squash, and tomatoes reflect the Indigenous influence of Mayans who continue to fight for living life on their own terms, on their own ancestral land.

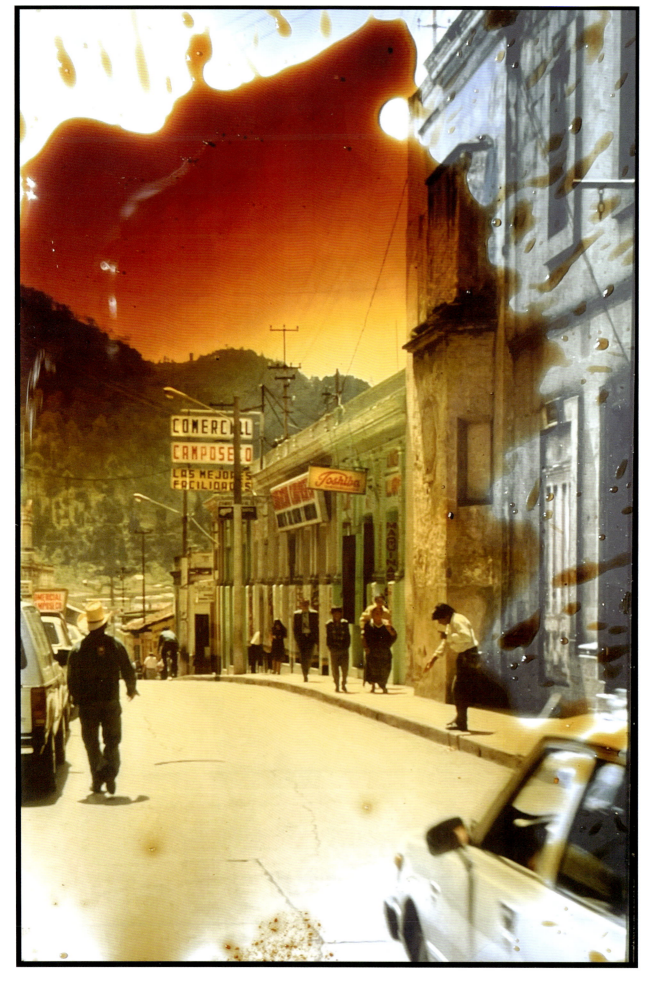

Sopa de Plátanos

Here's a recipe for a Chiapas-style bread soup that is a delicious and comforting dish.

- 1 large baguette or other crusty bread, torn into bite-sized pieces
- 2 tablespoons olive oil
- 1 large onion, chopped
- 4 garlic cloves, minced
- 2 large tomatoes, chopped
- 2 carrots, peeled and chopped
- 2 medium zucchini, cut into rounds
- 1 ripe yellow plantain, peeled and chopped
- 4 cups (1l) chicken or vegetable broth
- 2 sprigs of fresh oregano
- 1 teaspoon ground cumin
- salt and pepper to taste
- 2 hard-boiled eggs, chopped
- chopped fresh cilantro and oregano leaves, for garnish
- optional: queso fresco (a soft Mexican cheese) or chopped avocado

SERVINGS: 4

Preheat your oven to 375°F. Spread the bread pieces in a single layer on a baking sheet and bake for 10 to 15 minutes, or until they are lightly toasted and crispy.

In a large pot, heat the olive oil over medium heat. Add the onion and garlic and sauté until the onion is translucent. Add the chopped tomatoes, carrots, zucchini, and plantain to the pot and stir to combine.

Pour in the broth and bring the mixture to a boil. Reduce the heat to low and simmer for 20 to 25 minutes, or until the vegetables are tender.

Add the toasted bread pieces to the soup and stir to combine. Let the bread soak in the soup for a few minutes until it's softened and absorbed some of the liquid.

Add the oregano, cumin, salt, and pepper to taste, and stir to combine.

Ladle the soup into bowls and top each serving with chopped boiled eggs, garnish with fresh cilantro and fresh oregano. You can also add a bit of queso fresco or chopped avocado.

Note: You can adjust the thickness and seasoning of the soup to your liking by adding more or less broth, spices, salt, and pepper. Additionally, you can garnish the soup with crumbled queso fresco or chopped avocado if desired.

¡listo!

CHEF'S NOTES

PLANTAINS CONTAIN ANTIOXIDANTS THAT FIGHT FREE RADICALS
HIGH IN VITAMIN C, B6
& GREAT SOURCE OF FIBER
PREBIOTIC

NOTES

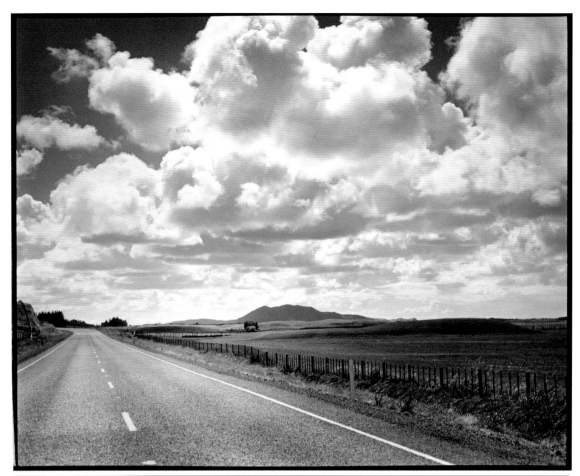
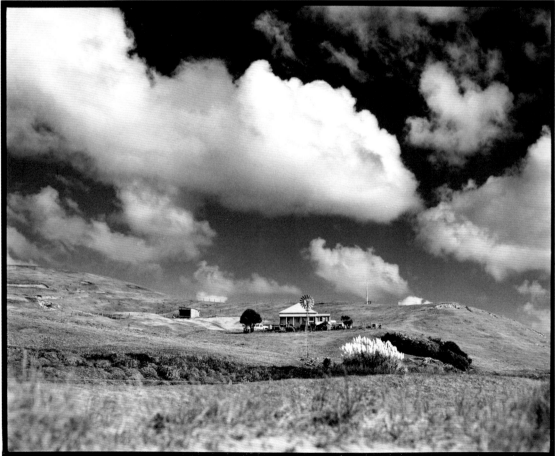

PAPATŪĀNUKU

Some say Aotearoa—New Zealand's current Māori-language name—symbolizes the constellation of clouds that guided early Polynesia navigators to the North Island's ridged volcanic spine.[1] Others say that when Kupe, the legendary Polynesian navigator landed, he named this "land of the long white cloud" after the canoe that brought him there.[2] His arrival sparked the birth of Māori civilization.

In a land forged from volcanic fire and later calmed by glaciers, the island's sharp mountain peaks rise and curve like a jagged backbone. By the time the Dutch Abel Tasman crashed on the shores of Golden Bay in 1642, Māori had formed iwi, or "nations," and already settled every corner of the land. Aoraki/Mount Cook in the southern Alps. Mount Taranaki to the north. Mount Ngauruhoe, an active stratovolcano with its red-rimmed mouth along the Central Plateau.

For 127 years, Māori remained undisturbed. Communal māra, or gardens, sprawled across vast plains. While the British would later bring their own potatoes, Māori cultivated indigenous taewa—some cream-colored with a buttery taste, some with yellow and purple speckled skin, others deep violet and yam-like.[3]

The classic Māori parāoa rēwena takes these potatoes and ferments them to make a sweet and slightly tangy sourdough loaf. Feeding the fermented potato starter, known as a "bug," requires sugar and lukewarm potato water over a couple of days until the bug begins to bubble. Without the contemporary comforts of refrigeration, the bug keeps for days, maybe even years on end, and can make several loaves of bread.

In oceans, lakes, and waterways, women gathered shellfish and men scooped mussels, fished with rotational hooks made of bone, wood, and colored stone.[4] They hunted wood pigeons, bright blue and green takahē, and iridescent bronze and green tūī.[5]

British colonizers imagined New Zealand as an unspoiled, harmonious wilderness. In the late 18th century, waves of British and French settlers brought smallpox, measles, and muskets—a cycle of history that seems to repeat itself, spoiling and disrupting the land and the people. The British colonial project confiscated lands they deemed agriculturally viable. Lands they would use for intensive production and extraction. Lands warped into the commodification of bodies, foodways, and Papatūānuku—Mother Earth.[6]

Sheep became a tool of colonization, drawing settlers inland and away from Aotearoa's shores and steep fjords and cementing colonial authority.[7] Now, sheep outnumber people. The only indigenous land mammals left are a species of bats.[8] And there are almost six sheep for each human on the islands. This often-cited statistic populates most modern guidebooks but needs explanation. In the mid-19th century, the islands became Britain's backyard farm. In 1882, the first export of frozen meat from New Zealand launched sheep farming as a symbol of the budding settler colony.[9] These days, that symbolism carries on, as a Pākehā—non-Māori New Zealander—menu might consist of lamb loin chops with a caramelized crust and juicy, pink center, paired with sweet potatoes and peas. Or a garlic, rosemary, and olive oil-roasted rack of lamb, French-trimmed. With each lamb dinner, we are reminded of the transformation of Aotearoa.

Wi Naihera of the South Island's Ngāi Tahu iwi, once likened the loss of land to its disappearance under the sea, as Māori "[cling] to the tops of these rocks . . . which alone remain above water," echoing the myth of land rising up from the sea.[10]

Unlike other British colonies, the islands were not conquered. Crafted in 1840, Māori and the Crown reshaped the course of history with Te Tiriti o Waitangi, the Treaty of Waitangi. Māori retained the right to manage their own affairs and to full ownership of their own taonga or treasures, both natural and Māori made. But a treaty cannot conceal the roots of persistent injustice or the erasure of Māori heritage. Throughout the decades, leaders like former prime minister Jacinda Ardern have moved toward progress and justice. In recent years, Nanaia Mahuta, Minister of Foreign Affairs, entered Parliament as the youngest Māori woman to ever gain a seat.[11]

Perhaps in a way, this new progressive direction in governance conjures a Māori past: one where women held a firm grip over their whakapapa—their genealogy, the core of Māori knowledge.[12]

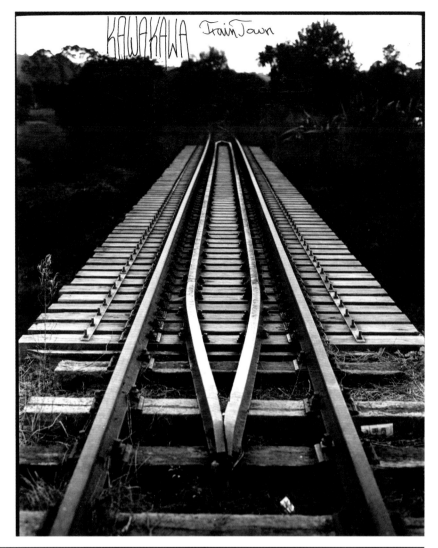

KAWAKAWA TrainTown

Rack o' Lamb

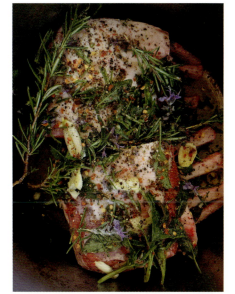

All of the Maoris I met eat lamb, just as the white settlers do. Here's a recipe for a rack of lamb with an herb and garlic crust.

- 2 racks of New Zealand lamb
- 2 garlic cloves, minced
- 1/4 cup chopped fresh parsley
- 1/4 cup chopped fresh thyme
- 1/4 cup minced fresh rosemary
- 1 cup panko breadcrumbs
- 2 tablespoons olive oil
- salt and pepper to taste

SERVINGS: 4

GLAZE

- 1/4 cup Dijon mustard
- 2 tablespoons honey
- 1 tablespoon soy sauce

Preheat your oven to 400°F or get a grill ready outside.

In a small bowl, mix together the garlic, parsley, thyme, rosemary, breadcrumbs, olive oil, salt, and pepper.

Season the lamb racks with salt and pepper and rub them with the herb mixture, pressing it onto the meat to form a crust.

In a separate bowl, mix together the Dijon mustard, honey, and soy sauce to make the glaze.

Heat a large skillet over high heat and sear the lamb racks for 2 to 3 minutes on each side, until browned on all sides.

Transfer the lamb racks to a baking dish and brush them with the glaze, making sure to coat them well.

Roast the lamb in the oven for 15 to 20 minutes for medium-rare or until the internal temperature reaches 140°F. For medium, cook for 20 to 25 minutes or until the internal temperature reaches 150°F. For well-done meat, cook for 25 to 30 minutes or until the internal temperature reaches 160°F.

Remove the lamb racks from the oven and let them rest for 5 to 10 minutes before slicing and serving.

Chef's Notes

Pair with Matua Pinot Noir 2020 with the lamb served medium the Rare Pinot is a fantastic choice!!

BARRICADES AND SOLDIERS

We had survived Honduras and our 1968 Dodge van carried us south to Nicaragua. Only a few years before we entered the country, the Sandinista Revolution[1] had removed the US-backed, right-wing Somoza dictatorship from power and earned a victory against the Reagan-funded Contras.[2] We followed the Pan-American Highway before splintering off into León, a northwestern city and a stronghold of the Sandinistas. León bears the weight of its history in the bullet holes piercing colorful murals and in the walls of its main colonial Baroque cathedral—standing stoic and solid through earthquakes, eruptions, and civil wars.

We left León for Managua, driving behind decommissioned American school buses packed with passengers and crates of crowing roosters. Initially founded as an Indigenous fishing town on the southern shores of Lake Managua, or Lago Xolotlán, Nicaragua's capital city has since rebuilt itself from years of political upheaval.[3] Several decades before we arrived, an earthquake demolished the city's wide, vibrant boulevards. A patchwork of modern, squat residential buildings and still-standing neoclassical structures remained. Bustling markets shielded pyramids of papayas, pineapples, and plantains beneath corrugated tin roofs. On street corners, vendors sold rings of crisp, corn flour rosquilla cookies wrapped in plastic and quesillos—a fresh cheese, boiled, salted, and soft as yogurt—served with diced vinegar-fermented onions, a tortilla, and smothered in sour cream.[4]

On the road leaving Managua, protestors had built barricades, blocked the highway with trucks and tractors, and set barrels ablaze. We pulled over onto the side of the road, deliberating our next move, when a Belgium ambassador—as lost as we were in the thick of what seemed like intense conflict—approached us. He suggested we grab our passports and traveler's checks and make a dash for the valley below us. From there, he said, we could hike 10 miles back to Managua and find safety in the US embassy. In that moment, we felt afraid of what would become of us. The army advanced, seated in the shovels of big tractors with their machine guns pointed straight at protestors. But after some negotiation, the barricades dissolved, and the protestors retreated to some momentary semblance of peace. We resumed our journey, past forested mesas that flanked the road, past coffee farms and terraced hillsides veiled behind a dense mist.

Tangles of bougainvillea and poinsettia and hibiscus and palm trees and banana trees blanketed the countryside. These days, eco-tourism outposts fleck the Pacific coast and cloud forests; cafés and smoothie stands line the streets of several cities. But at the time we traveled through Nicaragua, armed guerrillas had only recently fought for their lives. Nicaragua had become a proxy war battleground of the Cold War. Indigenous Chorotega, Cacaopera, Matagalpa, Ocanxiu or Sutiaba, and the Nahoa or Nahuatl had hunted and farmed along the Pacific coastal plains and up into the steep, central mountain ranges. And on the opposite side of us, Miskitu, Rama, Sumu, or Mayangna peoples inhabited the Caribbean coast.[5]

Nicaragua's food pays homage to the crop that brought life, abundance, and sustenance to Indigenous peoples in the region. On Sunday mornings or special occasions, nacatamales, corn tamales stuffed with annatto-spiced pork, potatoes, and bell peppers boil in wrapped banana leaves for hours.[6] Ripe jocotes, derived from the Nahuatl word xocotl used for any kind of sour or acidic fruit, as well as tamarind, cassava, and starchy quequisque roots have made their way into daily cuisine.[7]

For an endless stretch of days, we navigated slick roads and winding curves through torrential downpours; at the end of the day, an aromatic sopa de pollo—chicken soup—seemed like the perfect meal. In a simple, but richly flavored homemade dish, salt and pepper-seasoned chicken simmers in a translucent, herbed broth with parsley, cilantro, and onion and thick wedges of carrots and zucchini.

As we continued to travel further south down the Pan-American Highway, the road vanished beneath what looked like a vast lake. We came to an abrupt stop and looked at the grassy fields and hills around us, where people sat on the roofs of their houses to stay dry. Then, a school bus charged ahead of us and barged through the lake to the other side. We rode in the wake of the bus, for what seemed like a couple of miles. For a moment, our engine died and the Dodge submarined beneath the murky waters. A stroke of luck revived our engine. We thought we had left danger behind us until a lightning bolt struck the transformer of the utility poles lining the road. Right next to us—BAM—a loud explosion with a big sparkling fireball as one of the poles burst into flames. But somehow we continued our journey driving through the dark, raw, gutted, but beautiful country, unscathed.

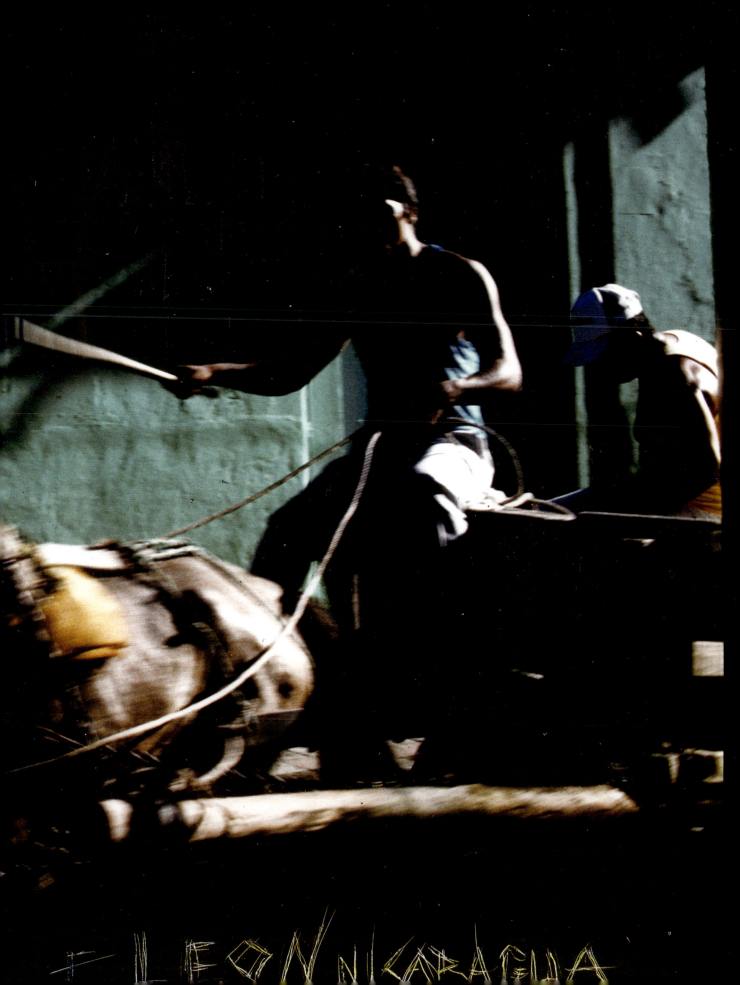

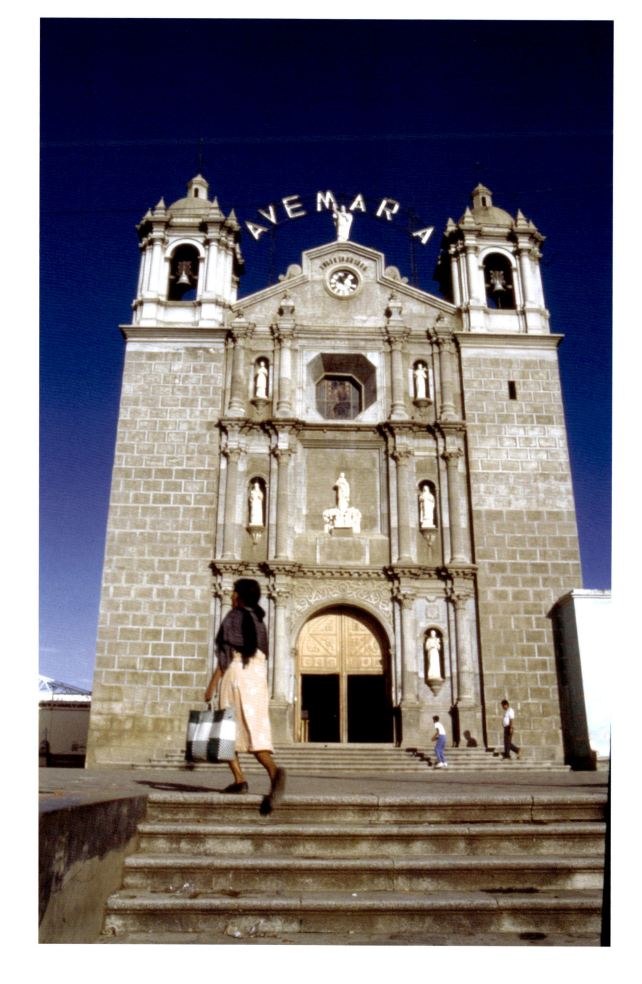

Sopa de Pollo

- 2 tablespoons vegetable oil
- 1 medium onion, diced
- 2 stalks of celery, finely chopped
- one 3 to 4 lb. whole chicken, cut into 8 pieces
- 3 garlic cloves, minced
- 8 cups water
- 1 bay leaf
- 2 carrots, diced
- 2 potatoes, diced
- 2 zucchinis, sliced
- 1 teaspoon dried oregano
- 1 teaspoon ground cumin
- 2 tablespoons chopped fresh cilantro
- 2 tablespoons chopped fresh parsley
- salt and pepper to taste

SERVINGS: 4

Pour oil into a large pot and add onion and celery and cook for a minute on high heat; toss around, then add chicken pieces until they are browned. Throw in the garlic, stir, and immediately add 6 to 8 cups of water to the pot, along with a bay leaf.

Cover the pot and bring the soup to a boil. Add the carrots, potatoes, and zucchini to the pot. Season the soup with oregano, cumin, and salt and pepper to flavor.

Put the lid back on the pot and let it simmer on medium heat for about 30 minutes.

Remove the chicken from the soup, debone, and shred the chicken before putting the shredded chicken back in the soup.

Serve in a bowl garnished with fresh chopped cilantro and parsley before serving.

CHEF'S NOTES

The right jam to prep the SOPA to would be the compilation album called: MUSICA FOLKLÓRICA

NOTES

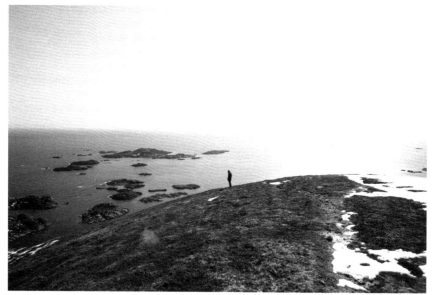
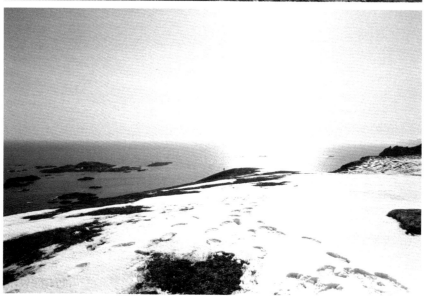
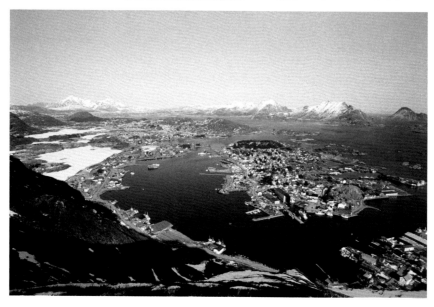

Norway

VIKINGS AND COD

Rows of unsalted cod, cleaned and gutted and hung by their tails on slatted wooden frames, extended above me, out to the rocky foreshore. In Lofton, an archipelago with icy pinnacles piercing the sky, Norwegian fishermen have scooped cod from the reefs and shoals of the islands for more than eleven thousand years.[1] The right balance of wind, sun, and rain dries the cod into stockfish, the currency of Vikings, who traded this firm, salty fish for barley and fur.

The smell of salt is inescapable here. It's a smell I remember from my first time on the archipelago, filming a documentary on world champion surfer and musician Tom Curren and his band. It's a smell that reminds me of summer holidays to the mainland with my family years ago when we'd pluck blueberries, kayak through pristine waters, and fish for pollock, haddock, mackerel, and cod. It's a smell that conjures ancient Norse sailors slicing through the seas in long, slender vessels piled with this white gold.

But the smell also brings to mind neighborhood trattorias in Italy's northeastern Veneto region, where baccalà mantecato pairs with a crisp prosecco. For centuries, Venetian chefs have soaked and whipped Norwegian salt cod with olive oil into a smooth, creamy cloud. It all began when a fisherman rescued Italian merchant Pietro Querini and his crew off the west coast of Norway in 1432. In Lofoten, Querini observed the stockfish beaten with a knife until the flesh became "as thin as nerves" and was then drenched in butter and herbs.[2] Battered and starved from weeks of drifting through frigid waters, stockfish brought them back to life.

In Norse myths, a god shapeshifts into a salmon to evade the wrath of another deity, diving into a frigid river.[3] For the Indigenous Sámi peoples, sacred, odd-shaped stones known as sieidier may mark spots of sacrifice for a successful fishing trip.[4] In prehistoric rock carvings or rust-pigmented paintings, cormorants, salmon, halibut, elks, and whales populate the walls.[5] The 13th-century lawbook of King Magnus Lagabøte declared that "the salmon shall travel unhindered upstream through the deepest part of the river."[6] And so they did, until the 1830s, when word that Norway's unruly seas and treacherous currents carried an abundance of salmon and sea trout, enticing British anglers to the region's shores. These "salmon lords" of the British upper classes built houses and farms, controlling Norwegian riverbanks for over a century.[7] While the catch from the rivers remains stable, levels of salmon from the seas beyond this land's rugged, windblown coastline have dropped since the 1970s.[8]

A history of harvesting the sea courses through Norwegian heritage. Salmon, whether dried over a small fire for endless hours to trap its rich fat or cured with salt and sugar and dill or spruce twigs, is present across everyday breakfast or dinner tables. In pristine timber homes balanced on pilings over a curving bay, simmered salmon sets kitchens aglow with the warmth of a creamy fiskesuppe broth.[9] Or outdoors, surrounded by slender birch trees, salmon collars—the fattiest cuts sliced from the fish clavicle, right behind the gills—smoke over hot coals until flaky. A buttery smell fills the air as the Arctic summer's midnight sun dips below the horizon, soaking the western sky in streaks of rose and gold and apricot.

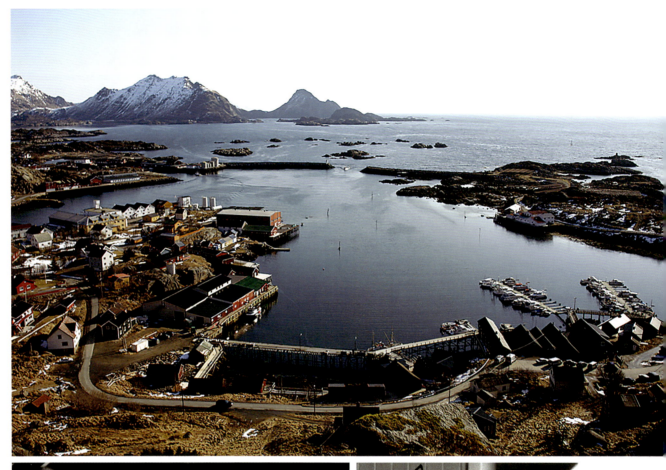

LOFOTEN

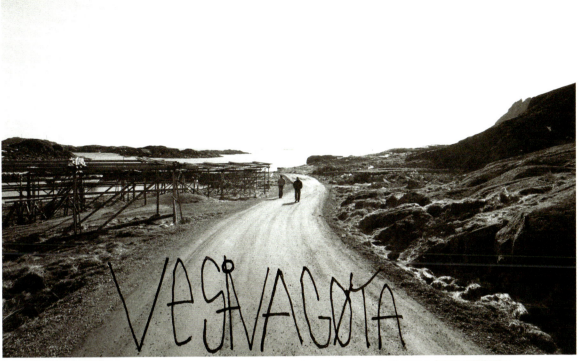

VESTVAGOYA

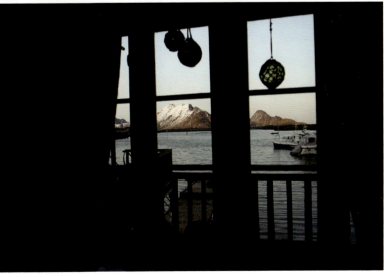

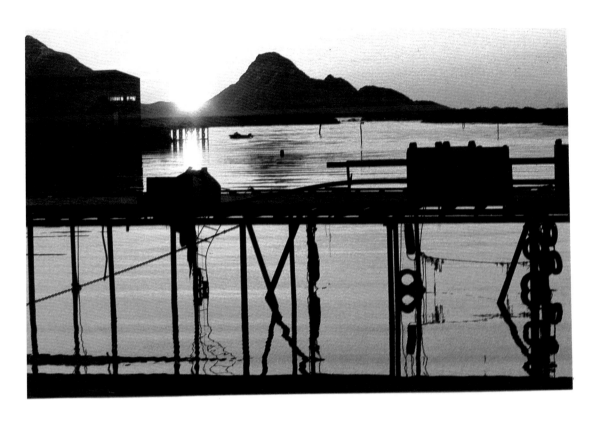
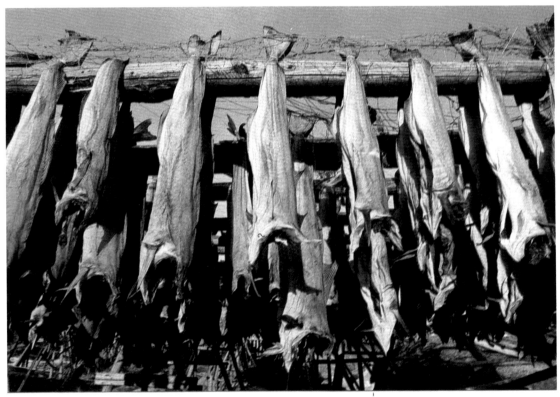

LOFOTEN NORWAY

Pickled Herring

Julesild (traditional Norwegian pickled herring) is usually served on rye bread. Herring, sardines, smelt, or whitefish can all be pickled this way.

- 1/4 cup kosher salt
- 5 cups water
- 1 pound herring filets
- 1/4 cup sugar
- 2 cups distilled or white wine vinegar
- 1 teaspoon mustard seed
- 2 teaspoons whole allspice
- 2 teaspoons black peppercorns
- 3 bay leaves
- 3 cloves
- 1 lemon, thinly sliced
- 1 medium red onion, thinly sliced

Servings: 2 to 4

CHEF'S NOTES

Serve AKVAVIT chilled, unmixed in small shot glasses — it creates the perfect balance as it cuts through the vinegar fish acidity.

Heat 4 cups of water until warm enough to dissolve salt; add the salt. Let this brine cool to room temperature.

When the brine is cool, submerge the herring filets in the brine and refrigerate overnight or up to 24 hours.

Meanwhile, in a small saucepan, make the pickling liquid: add the sugar, vinegar, the remaining cup of water, and the mustard seed, allspice, peppercorns, bay leaves, and cloves and bring to a boil. Simmer for 5 minutes, then turn off the heat and let this steep until cool.

When the herring have brined, layer them in a glass jar with the sliced lemon and red onion. Divide the spices from the pickling liquid between your containers if you are using more than one. Pour the cooled pickling liquid over the herring and close the jars and let cool to room temp; then store in the fridge for up to 1 month. Wait at least a day before eating.

NOTES

PORTUGAL

THE WHEELS OF BIRTH AND DEATH

One evening in Lisbon, I entered a dimly lit, cavernous room, the air heavy with the smell of tender, olive oil-drenched octopus, the entire bar silent but for the deep voice of a woman belting fado. Since the 1800s, fado sings of destiny or fate, of mourning, loss, and melancholy.[1] And without knowing exactly what it was that had been lost, I felt this woman's voice envelop me as I slowly sipped glasses of crisp vinho verde.

Maybe she sang of resistance to the oppression of Europe's longest dictatorship. Maybe she sang of the decaying vestiges of a colonial Christian empire. Or of the Arab-Amazigh Muslims from North Africa who ruled Al-Andalus, so far from their homes, and felt saudade, that feeling of nostalgia and longing lodged in the pit of your belly. Maybe the nostalgia of her words came from the brothels of Lisbon, from the tascas, the unpretentious neighborhood bars once symbolic of the working class.[2] But the birth of fado remains muddled and tangled throughout space and time, like most of Portugal's mythic history.

Legends attribute Lisbon's founding to the Greek hero Odysseus, who battled sea monsters and once escaped a bolt of lightning in an unknown land. Following Zeus' orders, Odysseus constructed a city named Olissippo where the bolt struck, and that city became Lisbon.[3] To the Phoenicians, the city turned into Alissubo, denoting a "pleasant haven" or "safe harbor."[4]

Like most places in the region, the Romans touched this earth, too. They built bathhouses, theaters, and underground galleries.[5] In the outskirts of Lisbon's Alfama neighborhood, four Roman reservoirs may have been linked to a plant for conserving and salting fish, buried beneath the ancient Casa dos Bicos—the house of pointed stones.[6] To the north of Lisbon lies Porto, called Portus Cale in Roman times, where a Roman fortress once dominated the Douro River.[7] Colorful medieval townhouses clad in orange clay tile rooftops cluster around the water. Romans garlanded the local cuisine with onions and garlic, which now form the base of almost every dish. They planted wheat, olive trees, and grapevines.[8]

But the Romans soon met their demise in the region at the hands of the nomadic, pastoral Alani peoples from the steppes of the Black Sea. And then the Alani lost their land here to the Germanic Suebi peoples. The Visigoths came to claim possession, conquering all but a sliver of northern Portugal and modern-day Spain's Galicia. Only traces of Visigothic fortresses remain.

Dynasties from North Africa would soon seize the region. The omnipresence of Arab influence extends through the medieval and partially Moorish citadel of Lisbon's Castelo de São Jorge, perched atop one of the city's many hills.[9] The peak beckons those staring at it from below to hike up and witness a view of terracotta-tiled rooftops that give way to water. The legacy of Al-Andalus permeates Porto's blue-and-white azulejo tiles, the word itself coming from the Arabic word al-zillīj, or "polished stone."[10]

The Arab culture of Al-Andalus infused Portuguese cuisine with the tangy citrus zing in sweet, dense slices of syrupy torta de laranja, an orange roll cake. They cultivated figs, almonds, and apricots that thickened sauces, pastes, sweets, and cakes. In the Algarve, a southern region of whitewashed fishing villages on rugged, low cliffs overlooking sandy coves, the blossoming almond trees Arabs first planted paint the springtime countryside white-like fields of powdered snow. Arabs also marinated meats in vinegar for several centuries and brought these practices to Portugal. And in southern port cities, Jewish merchants imported pickled vegetables, like gherkins and cucumbers, and capers, truffles, figs, and lemons soaked in salt and vinegar.[11]

Arab cookbooks of the time mention foods that still feature in Iberian palates today: flatbreads like pão estendido, or fried ones like pão de sertã, and stuffed eggs and aubergines, spiced meatballs, and shish kebabs known as espetada.[12]

In the Middle Ages, the Arabic word kabab meant fried meat, although the Persian word tabahajah, had gained wider use at the time. The Turkish word shish, or şiş, emerged to describe the appearance of meat roasted on a sword or skewer. From there, the dish of roasted chunks of skewered meat spread across much of the world.[13] Portuguese espetada transforms the simplest ingredients and transforms them into a local delicacy with roots in the balmy, subtropical archipelago of Madeira. Seasoned with crushed garlic and bay leaves, soft, cubed cuts of beef—tenderloin, sirloin, or short loin—grill between wedges of bell peppers and onions over hot coals or grape wood embers, a traditional method on the islands. Sometimes, squid or monkfish, turkey, sausages, or chicken have also been used.[14]

In Sagres, a town that sits on the country's southwestern tip, its wind-whipped, seaside fortresses symbolize the country's nautical past. Colonizers and merchants ushered in a supply of spices from Gujarat to Goa, Macao (China) to Malaysia. Along the windswept dunes, ocher cliffs, and frothy oceans, seafood became a staple of the Portuguese diet. The poorer classes depended on the sardines, conger, lamprey eels, whiting, shad, and shellfish of the Atlantic; some records show women as the primary fishmongers.[15]

Today, in quiet cafés or restaurants that rattle beside Lisbon's old canary-yellow trams, innovative seafood dishes call upon this past with new touches of creativity. Variations of amêijoas à Bulhão Pato, a piping hot bowl of plump clams garnished with lemon, garlic, and cilantro. Tender anchovy strips in a vinaigrette. Or a simple fried cuttlefish with paprika mayonnaise.

Back in Lisbon, the evening I spent shrouded in the mystery and longing of the fado singer's voice enthralls me, like Wim Wenders searching for the sounds of a city in Lisbon Story. I'll never know whether sailors, who made the sea salty with their tears, sang fado first, or whether Africans enslaved under colonial rule created these poetic verses wrought with passion. When I left the bar and resurfaced into the dark streets of the Alfama neighborhood, I felt as though I'd just woken up from a dream.

A LARGE TANGY STEW OF HISTORY, LEGEND, MYTH, RELIGION, AND FANTASY. HORROR, HUMOR, LYRICISM, PATHOS & SCATOLOGY.

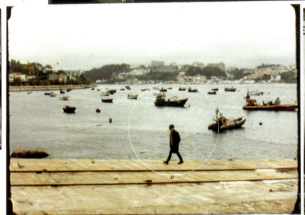

NOBODY EVER LIVES THEIR LIFE ALL THE WAY UP EXCEPT BULLFIGHTERS

the Flounder

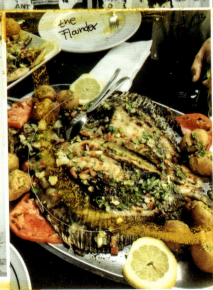

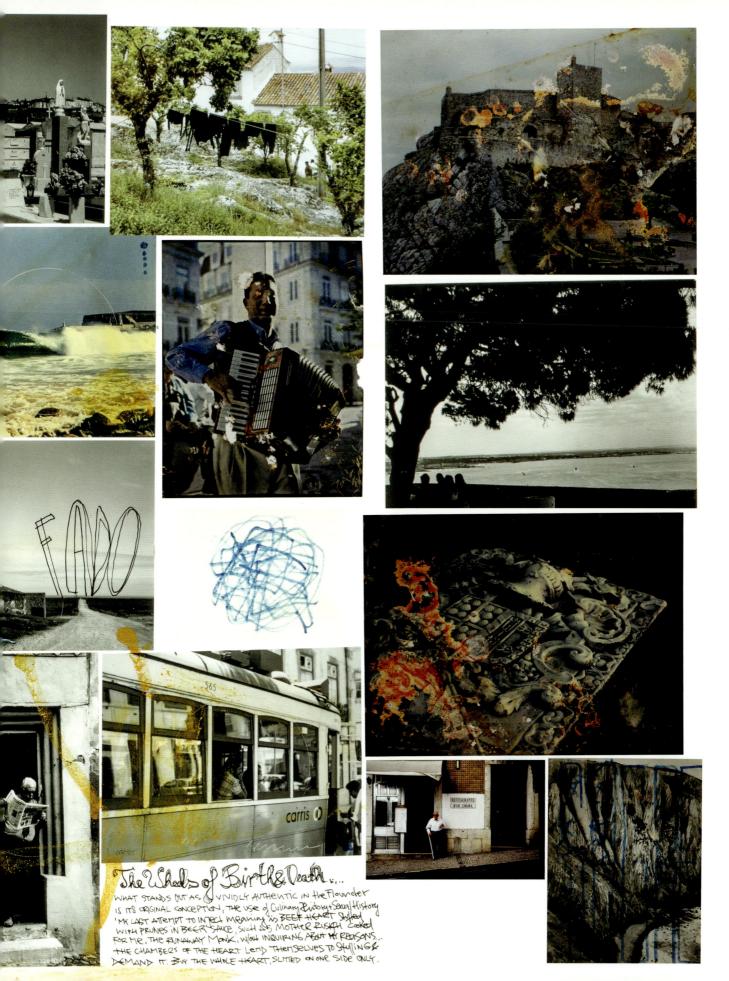

The Wheels of Birth & Death...
WHAT STANDS OUT AS VIVIDLY AUTHENTIC IN THE FLOUNDER IS ITS ORIGINAL CONCEPTION, THE USE OF CULINARY HISTORY + SEXUAL HISTORY 'MR LAST ATTEMPT TO INJECT MEANING AS BEEF HEART STUFFED WITH PRUNES IN BEER SAUCE, SUCH AS MOTHER RUSKA COOKED FOR MR. THE RUNAWAY MONK, WOOT INQUIRING ABOUT MY REASONS... THE CHAMBERS OF THE HEART LEND THEMSELVES TO STUFFING & DEMAND IT. BUT THE WHOLE HEART, SLITTED ON ONE SIDE ONLY.

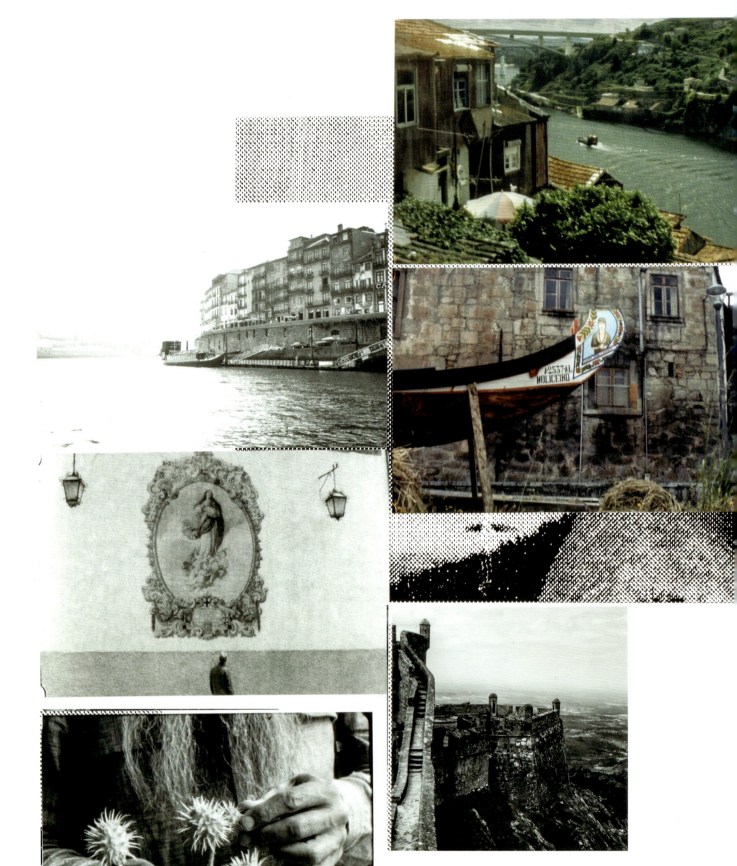

CARNE ESPETO

- wooden or metal skewers
- 1 pound beef sirloin, cut into bite-sized pieces
- 2 to 3 bell peppers (red, green, and/or yellow), cut into bite-sized pieces
- 1 large onion, cut into bite-sized pieces
- 1 to 2 zucchini, cut into bite-sized pieces
- 1 to 2 garlic cloves, minced
- 1 to 2 tablespoons olive oil
- 1 to 2 tablespoons red wine vinegar
- 1 to 2 tablespoons sweet paprika
- 1 to 2 teaspoons ground cumin
- salt and freshly ground black pepper to taste

SERVINGS: 4

CHEF'S NOTES

COOK ALONG w/ FADO musik "LISBON STORY" Soundtrack a WIM WENDERS FILM featuring THE GREAT MADREDEUS

If using wooden skewers, soak them in water for at least 30 minutes before using them to prevent them from burning on the grill.

In a large bowl, combine the beef sirloin, bell peppers, onion, zucchini, garlic, olive oil, red wine vinegar, sweet paprika, cumin, salt, and black pepper. Toss to coat the meat and vegetables evenly with the marinade.

Thread the beef and vegetables onto the skewers, alternating between the different ingredients.

Heat a grill or grill pan with a bit of olive oil to medium-high.

Add the skewers and cook for 8 to 10 minutes, turning occasionally, until the beef is cooked to your desired level of doneness and the vegetables are lightly charred and tender.

Remove the kebabs from the grill and serve immediately, garnished with fresh parsley or cilantro if desired.

 NOTES

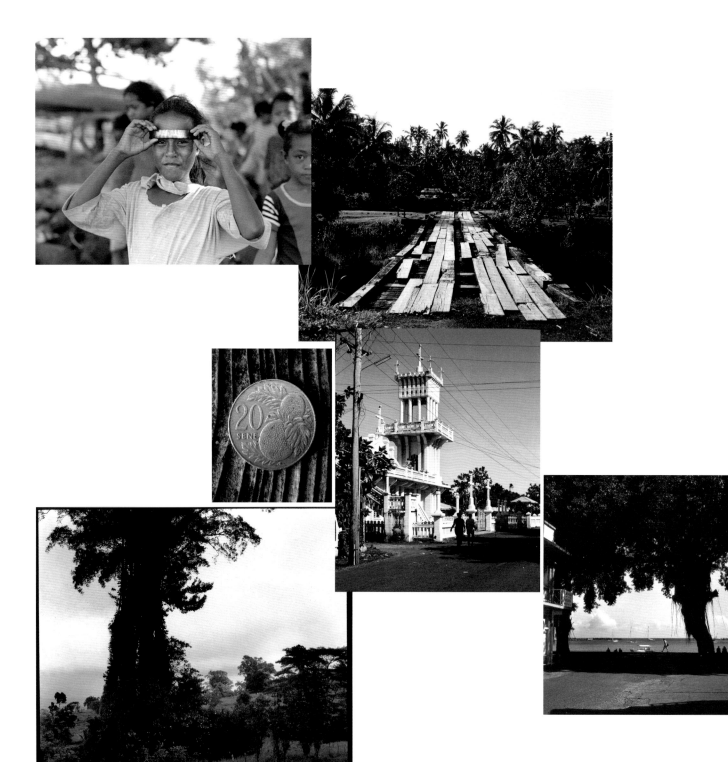

TODO, YOU'RE LUCKY

Imagine a quiet day in a small village on the archipelago—a Sunday—the air syrupy. Heat rises from a narrow, asphalt path that winds between coconut palms and red hibiscus shrubs. Waves crest and crash along the same Pacific white sand beaches the Lapita peoples landed on at Mulifanua, at the western shore of the Upolu island, approximately 3,000 years ago or more.[1]

Over centuries, Samoans tilled the islands' volcanic earth and left lands fallow for the rebirth of new nutrients.[2] In marshes, they cultivated taro in hand-built beds of earth and mulch preserved slightly above the water level.[3] They traveled from island to island, carrying coconuts, yam, breadfruits, and bananas. Sometimes, they clashed with the chiefdoms of Fiji and the kingdoms of Tonga.

More than eight hundred years later, European and American trading and whaling vessels began to rupture these same shorelines. The worst of the islands' wars came in the late 19th century, with a colonial penchant for political intervention. Germans soon monopolized trade, processing cocoa beans, rubber, and pressed copra for coconut oil in sprawling plantations.[4] Militaries occupied the lava fields, tropical rainforests, and waterfalls. British, American, and German warships bombed villages on stretches of sandy beaches along Upolu, Savai'i, Apolima, and Manono. During World War I, an independent New Zealand, with the support of Britain, annexed Western Samoa and continued military rule for the next decades.

But even New Zealand's colonial control over the islands could not stifle fa'a Samoa—the Samoan Way. The Mau Movement—Mau meaning "resolute" or "unwavering" or "testimony"— rose in resistance. Samoans assumed control, withdrawing their children from New Zealand's government schools until some forcibly closed. They left coconuts to rot rather than process the dried sweet fruit into oil. They left banana plantations neglected in defiance.[5] In 1962, Samoa gained self-government and in 1965, became the first Pacific island nation to achieve full independence.

Now, on Sunday, this day of mandatory rest, the morning is calm. No fishermen casting nets from 'alia double canoes. No workers sawing lumber frames and laying tin roofing for a new home. No street vendors frying sweet banana fritters beneath the shade of a Polynesia banyan.

But the urge to grab a board and head out to sea strikes, so in fa'a Samoa fashion, you ask the matai, or chief, of the village for permission to surf on this sacred day of rest. Today, you're lucky. He grants it and watches you as you leave, venturing through bamboo thickets. As the king indulges in an 'ava, or kava, session with the other members of his clan from his thatch roof platform, you paddle offshore to the fringe reef breaks, in search of the perfect waves.

Women often assume the duty of mixing 'ava, the mildly sedative root drink, but the dangerous task of testing and gathering lava rocks for the umu, an above-ground earth oven, typically falls onto the men. Following this day of relaxation, the smells of smoked pork wrapped in banana leaves may rise from an umu.[6] Today, some reserve umu preparation for special occasions: a wedding, a funeral, the selection of a new matai to oversee the village's communal interests. In some remote areas across the archipelago, umus remain a family staple. For several hours, the aroma of charred chicken, pork, and breadfruit and of taro and banana leaf-wrapped parcels full of coconut cream imbues the village air with a call to feast.

UMU OVEN — PIG · CHICKEN · FRUITS

Anyone who has experienced a contemporary Hawaiian lu'au (feast) will be familiar with this method of cooking; kalua pig is always a main part of the menu. The word kalua refers to the process of cooking in an earth oven (ka, the; lua, hole). A traditional Polynesian cooking method is called umu; an umu is an earth oven or cooking pit and is one of the simplest and most ancient ways of cooking; Traditionally, umu pig is cooked in an underground pit and served in plaited baskets made of coconut fronds or on large banana leaves. The shredded pork is just as tender and moist as a pork butt roasted in an electric or gas oven. Here we have added whole chickens.

- 1 whole pig, dressed and cleaned
- 6 to 8 whole chickens, dressed and cleaned
- 10 sweet potatoes
- 10 yucca
- 6 to 8 large banana leaves
- 2 to 3 cups fine sea salt
- 2 to 3 cups hardwood or coconut husks
- wet burlap bags or other cloth

Servings: LOTS

Build the umu oven by digging a pit in the ground that is large enough to hold the pig and chickens. Line the pit with rocks or bricks and build a fire in the pit using hardwood and/or coconut husks. Let the fire burn for 2 to 3 hours until the rocks are hot.

While the fire is burning, season the pig and chickens with sea salt and wrap each in a large banana leaf, making sure the pigs and chicken are completely covered.

Once the rocks are hot, remove the ashes and place the banana-wrapped pig and chickens on top of the hot rocks, and add the sweet potatoes and yucca. Cover the pig and chickens with more banana leaves and then with a layer of wet burlap.

Cover the entire pit with a layer of dirt or sand, making sure no steam can escape. Let the pig, chickens, yuccas, and yams cook in the pit for 12 hours.

After the cooking time has passed, carefully remove the dirt or sand from the pit and uncover the pig and chickens. The meat should be tender and fall off the bone.

CHEF'S NOTES

PART OF THE SPIRITUAL ACT OF BUILDING AN UMU, IS THE TRADITION OF DRINKING KAVA WHICH ALLOWS PARTICIPANTS TO FEEL CALM & RELAXED WITH A CLEAR MIND.

NOTES

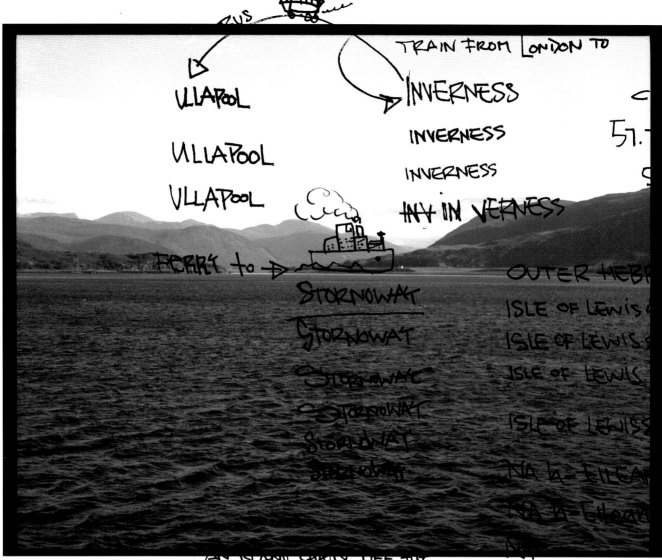

OUTER HEBRIDES

When the ice sheets that once enshrouded this archipelago melted, Mesolithic hunter-gatherers roamed the fertile, grassy machair plains, marooned in the middle of the North Atlantic Ocean. I arrived in the Outer Hebrides as New York's twin towers collapsed and the United States fell into plumes of smoke and sirens and war.

But here, bracken and reeds rustled in the breeze. On frost-white sands that frothed into the sea, surfers—young and old, champions and amateurs—gathered to take part in an unconventional surf symposium. Surfer and journalist Derek Hynd invited an eclectic roster of surfers: Tom and Joe Curren, Skip Frye, Andrew Kidman, Kassia Meador, Jesse Faen, Frankie Oberholzer, Hans Hagen, and Christian Beamish. There were local plumbers, fishermen, and oil rig workers, gliding through blustery, cold waves alongside the world's iconic competitors. As cliché as it sounds, it would have been easy to feel like the last person on earth here without them. With the chaos of the world beyond us, it would have been easy to feel lost among the long slivers of sea cliffs that sliced through a pounding surf.

The Outer Hebrides' earliest inhabitants may never have questioned whether their time on this planet would be immortalized. They may never have experienced the existential crises of feeling like their lives will be forgotten in time, buried beneath windswept beaches, jagged black outcrops, and steel-gray seas. But on these islands, studies of ancient pollen, the remains of charred hazelnut shells, and flint fragments tell their stories, as they sourced food based on the seasons.[1] They shifted between the islands, fishing below rocky cliffs or hunting for deer in swooping fields.[2]

And this practice of nourishment, indelibly linked to the seasons, lives on. From the Stone Age onwards, Hebridean Blackface sheep and Highland cattle have grazed the hills, moors, and uninhabited offshore islands. On Soay—or island of sheep in Old Norse—the only living relic of man's earliest semi-domesticated sheep roam this abandoned isle of the St. Kilda archipelago.[3] Following tradition, the islands' later inhabitants passed down their lands from generation to generation, and crofts, an ancient form of land tenure, emerged.

When the last of the Ice Age evaporated, lids of wet earth sealed the roots of plants, halting the growth of new ones. Crofters graze sheep and cattle on these rough peatlands that blanket the islands.[4] And in heather and primrose-cloaked fields, sheep and lambs white as sea foam clustered within communal pens. Once slaughtered and sold to butchers across the islands, the matured mutton yields a lean, gamey flavor.[5]

Seabirds clamor above gray-stone and thatch fishing villages scattered across the archipelago and over the sheepfolds and igloo-shaped storage huts called cleitean on the now-desolate island of Hilta.[6] Vestiges of large cod, ling, and saithe suggest Norse settlers ventured for food offshore and scooped flounder, turbot, and plaice from shallow waters.[7] For almost a century, the women of the Hebrides formed the backbone of the fishing industry, traveling across the treacherous waters each season to the main Scottish and English fishing ports. They spent long hours gutting herring for low wages.[8]

Later, islanders continue to catch wild summer salmon, trout, and herring, and hand dove for scallops and langoustines in the cold sea that roils around the Outer Hebrides. Spongy blocks of peat that once fueled almost every hearth with a pungent smoke lean against most farmhouses. While small coal-burning furnaces have since replaced several original peat hearths, smokehouses still roast salmon and scallops over locally cut peat, gently cooking the meat in sealed kilns until robust and creamy.[9] After mornings of surfing on shortboards or longboards, fish or single-fins or eleven-foot gliders, we'd seek warmth in the smokehouses. And later on, as a storm surged, we'd huddle in a local pub and play pool over a few golden pints.

Sometimes a fiery sunset would burn through the clouds after a storm. A brooding isolation may hover over this land of sheep-cropped moss, and verdant, yet treeless lunar hillsides. But the Outer Hebrides are neither moored in the past nor lost to myths of Mesolithic humans, Celts, or Vikings. The quiet lives of this society will carry on, for as long as the ocean pulses and pounds against these islands' gnarled bedrock.

OUTER HEBRIDES
ISLE OF LEWIS & HARRIS
ISLE OF LEWIS & HARRIS
ISLE OF LEWIS
ISLE OF LEWIS & HARRIS
NA h-EILEANAN SIAR

NA h-Elleanan Siar
~~NA~~
NA h-Innse Gail ISLAND OF
SOVEREIGN STATE
COUNTRY: SCOTLAND

~~Grilled~~ Sardines w/ Lambchops & Potatoes ·Grilled·

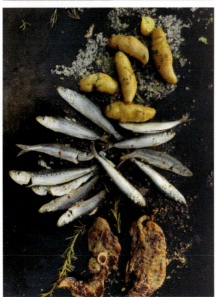

Grilled whole local sardines and lamb chops make for a delicious and flavorful meal that highlights the unique flavors of Scottish cuisine.

- 8 to 12 sardines, cleaned and gutted
- 4 lamb chops, thin cut
- 2 garlic cloves, minced
- 2 tablespoons olive oil
- 2 sprigs fresh rosemary
- salt and pepper to taste
- lemon wedges, for serving

SERVINGS: 4

Chef's Notes

Poor yersell a Genorous cup full of SCOTCH WHISKY ADD WATER IF DESIRED.

Preheat your grill to medium-high.

In a small bowl, mix together the garlic, olive oil, and rosemary. Season with salt and pepper to taste.

Brush the sardines with the garlic mixture, making sure to coat both sides. Place them on the grill and cook for about 4 to 5 minutes per side, or until they are cooked through and nicely charred.

Using the rosemary sprigs, brush the lamb chops with the same garlic mixture, making sure to coat both sides. Place the chops on the grill with the rosemary sprigs on the side; cook for about 5 to 6 minutes per side, or until they're cooked to your desired doneness and the rosemary is slightly charred.

Once both the sardines and lamb chops are done, remove them from the grill and let them rest for a few minutes before serving.

Serve the grilled sardines and lamb chops with lemon wedges and your favorite side dishes, such as roasted or boiled potatoes.

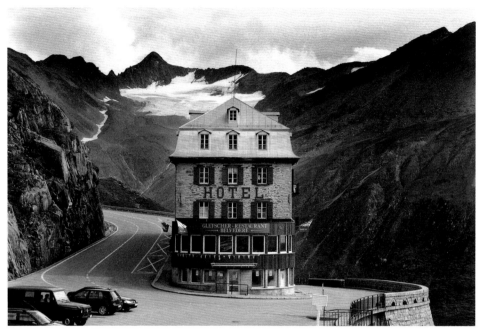

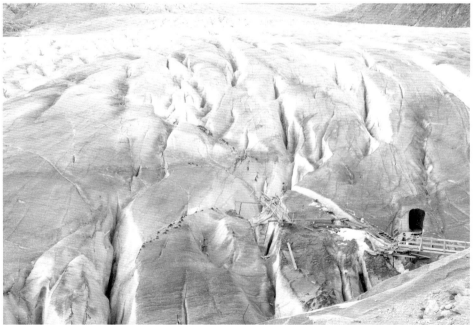

ESCARGOT AND GRUYÉRE

The Alps arch like a curved spine across south central Europe—a tangle of frigid streams, jagged peaks, and, for a little over a century now, train tracks, high-end hotels, ski lifts, and lumber yards. Before tourists booked expensive ski lessons and hit the slopes for a few hours, Hannibal's Carthaginian army of soldiers, mules, and battle elephants once stormed through an impenetrable alpine pass.[1]

Ancient civilizations hailed Hannibal's invasion through the Alps as a standard of military tactics and gained praise from Charlemagne and Napoleon. Memories of struggles for autonomy from the Holy Roman Empire brought Switzerland centuries of neutrality, although Swiss mercenaries had once ranked among Europe's most feared.[2] Napoleon would later conquer the land but his eventual defeat at Waterloo sealed the nation's fate as a place of perpetual neutrality.[3] With four official languages—German, French, Italian, and Romansh—multilingualism unites the country's twenty-six small administrative states, each with its own distinct identities and cultures.

In southern Switzerland, the first climbers of the Matterhorn fell to their deaths on this mountain, a pyramid devoted to the unpredictability of nature.[4] I found myself in Zermatt one year, a resort town at the Matterhorn's base, in search of work. Away from the crowded ski bum hangouts of Chamonix and Verbier, Zermatt's car-free avenues hide untouched powder fields lost in the wilderness.

One season, I lived in a loft built of timber in an old remodeled barn owned by the Julen family and worked with Brandon, a New Zealander. We shared a passion for surfing and he often spoke of the point breaks in Queensland, Australia. Brandon worked as a barback at the Vernissage, an old-school cinema, concert venue, and bar that the illustrious local artist Heinz Julen owns. That season I secured a spot as a film projectionist at the Vernissage. Reel-to-reel 35mm film projection. Lots of times I'd be still in my ski clothes, coming straight from the mountain for the 5:00 p.m. matinee, ganging up the reels on the old projectors from the 1930s, a stange glass of Walliser Bier in hand, quenching my parched body. Working nights gave me the freedom to explore the vast out-of-bounds terrain every day for 180 days in a row.

Much of Zermatt's clientele slept in 5-star grand hotels, some adorned with Victorian stained-glass windows and marbled floors, others with seven-stage spas and ornate Baroque wood carvings. A horse carriage pickup at the Mont Cervin Palace gets you to the nearby gondola station. A day of skiing the powdered slopes around Zermatt included lunch on the terrace of Chez Vrony, where the skiers would ladle spoonfuls of fondue or hay soup, made from barley and the air-dried beef of cows peppering Findeln's pastures. Maybe they'd order a raclette as they gazed out toward the Matterhorn, stony and stoic, a glass of chilled Fendant in hand.

As early as the late thirteenth century, medieval texts from Swiss convents make note of these plates of melted cheese, first called Bratchäs, "roasted cheese," in Swiss German.[5] Derived from the French word racler, to scrape, raclette emerged from the cow herders who carried cheese with them as they shifted cows between Swiss pastures. At nightfall, the air becoming icier, the herders would soften fresh cheeses over a campfire and scrape them onto bread.[6] Electric table-top grills with small pans may have overtaken the traditional campfire, but the romantic beauty of scooping spoonfuls of a floral, buttery, and mildly pungent cheese onto cornichons, cured meats, and potatoes still permeates the landscape of the Swiss Alps.

I'd spend the daytime on the mountain, surrounded by the treeless white desert of the Haute Alps, breathing in sharp, clean air. Up in the mountains, it was easy to forget about the chaos and restlessness of the world below, and I maybe understood why the Walser peoples had scattered across the lakeshores and high altitudes to farm in seclusion. Named after the Wallis or Valais in French—the uppermost Rhône valley—the Walser peoples herded their goats through rugged terrain and set up homesteads eastward, in the slopes of modern-day Liechtenstein and the fringes of Italy and Austria.[7]

In the evenings, I'd rush into the cinema, still in my snowboarding gear with fingertips still cold from hours outdoors. As the lights of Zermatt gleamed at twilight, and parties at the local discos thumped well into the night, I was tasked with the tedium of exchanging giant film reels every half hour, switching from one projector to another.

In a way, I felt as though I'd arrived to a second home. I remembered Easter holidays with my parents, navigating the four simple ski lifts of a humble ski village above the Rhône Valley. The Rhône, an artery that often floods the towns flanking its banks, emerges from the depths of a glacier. And this glacier, which thousands and thousands of years ago reached ninety-six hundred feet, a sea of ice that once covered the region, now melts each year. Now, scientists swaddle the glacier in synthetic blankets, insulating thick winter snow during the warmer months.[8] A last attempt to save the landscape we knew before.

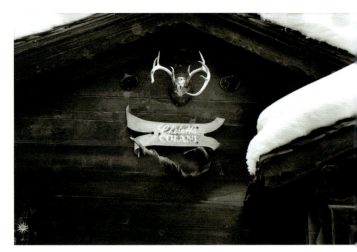

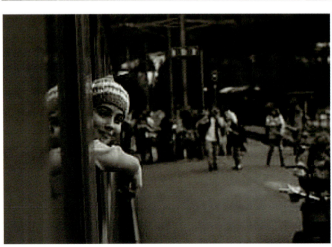

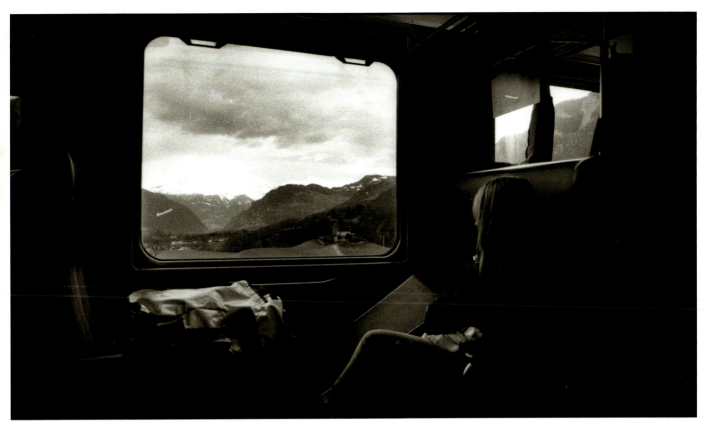
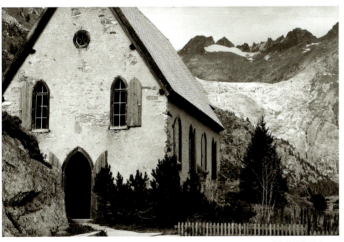
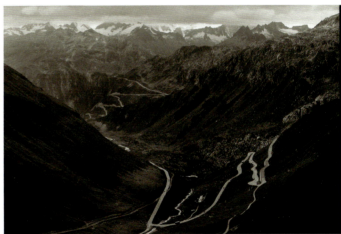
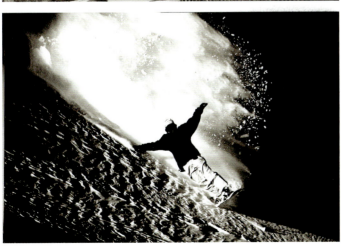

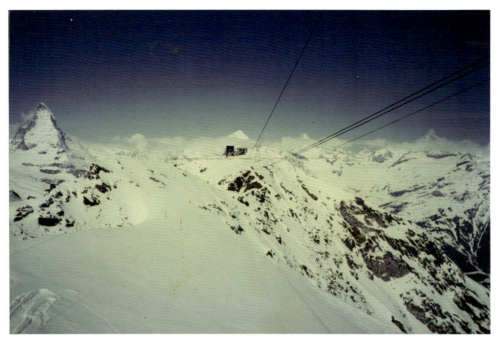

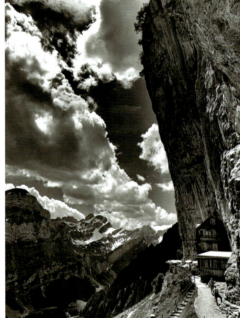

Gruyère Escargot

I came across an old cookbook called *Basler Kochschule* (the Basel Cooking School). It was published in 1903 and has very detailed descriptions of Swiss recipes. While the description of how to break down a whole ox was a bit overwhelming for me, it was the little side dishes and appetizers that intrigued me. When I came across the chapter "Froesche und Schaltiere"—frogs and snails—I was intrigued; here's something unexpected for the modern-day palette. I suggest serving this delicious dish with a glass of a Swiss white wine, such as a Valisian Chasselas.

- 1/2 cup unsalted butter
- 1/2 cup finely chopped shallots
- 3 garlic cloves, minced
- 1/2 teaspoon dried thyme
- 2 mushrooms, finely chopped
- 1/2 cup dry white wine
- 1/2 cup chicken broth
- 12 large escargots, de-shelled and cleaned
- salt and pepper to taste
- 1/2 cup gruyère cheese, grated
- 2 tablespoons freshly chopped parsley
- 4 slices of baguette, toasted

SERVINGS: 4

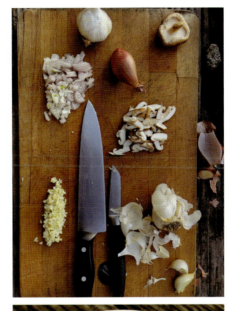

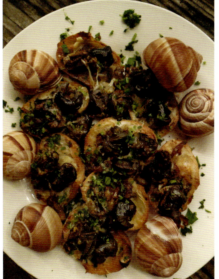

Preheat the oven to 375°F.

In a large saucepan, melt the butter over medium heat. Add the shallots, garlic, thyme, and mushrooms; cook until softened, about 2 to 3 minutes.

Pour in the white wine and chicken broth and bring to a simmer. Reduce the heat and let the mixture simmer for 5 minutes. Season with salt and pepper to taste.

Arrange the escargots in a single layer in a large baking dish. Pour the sauce over the escargots, making sure they are well coated.

Sprinkle the grated gruyère cheese over the top of the escargots and sauce.

Place the baking dish in the oven and bake for 15 minutes or until the cheese is melted and golden brown.

Garnish the escargots with freshly chopped parsley and serve hot on top of toasted baguette slices!

CHEF'S NOTES

2020 L'ALPAGE VALAIS an ideal pairing w. this savory dish would be a Fendant style wine from the Kanton of Wallis/Valais w. its moderate fruit, chalky minerality & excellent cut

2020 MRA

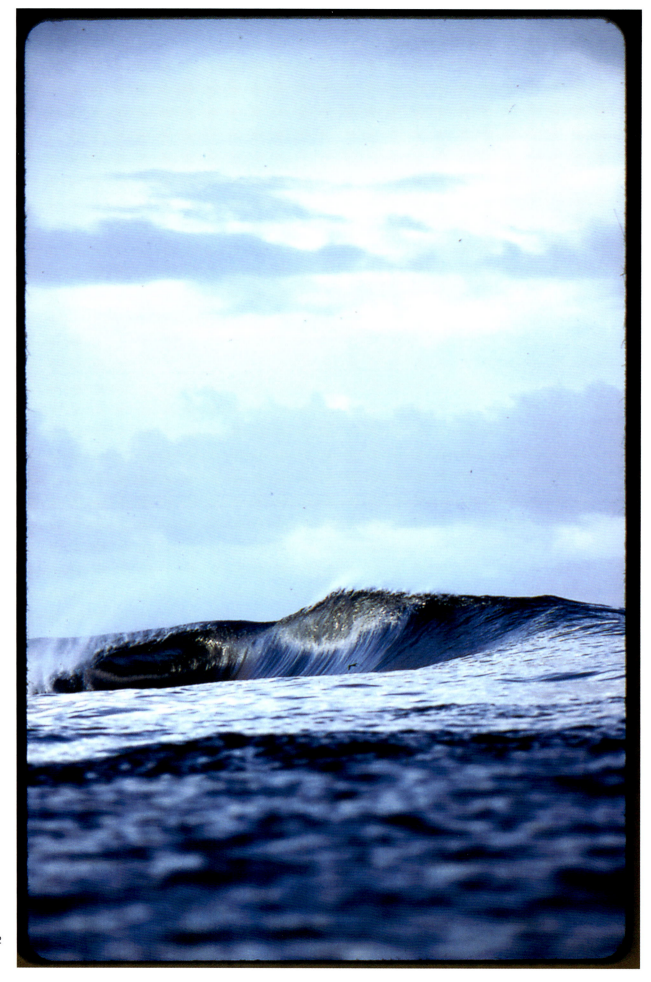

E'IA OTA OR POISSON CRU OR OTA 'IKA

In the minds of many European writers and artists of past centuries, French Polynesia—and Tahiti in particular—became both an emblem of utopia and a land in need of civilizing. Philibert Commerson, a naturalist accompanying colonial French navigator Louis-Antoine de Bougainville, first likened Tahiti to an earthly paradise.[1]

In the midst of discontent leading up to the French Revolution, eighteenth-century philosophers and their followers imagined Tahiti as an ideal state. Here, they painted a picture of eternal harmony and virtue with nature, where the conflicts, vices, and follies of Europe compared unfavorably to life on this island in the Pacific Ocean. But in the nineteenth century, after the Revolution, this image of a Polynesian Eden disintegrated into a land of so-called depraved peoples, subjects of the white man's burden.[2]

Life on the largest piece of a remote chain of islands and coral reef atolls can no longer be reduced to the exotic fantasies of colonial literature and colonizers. Thousands and thousands of years ago, seafarers from Southeast Asia navigated the open ocean in large, double-hulled canoes from island to island. By day, the sun, the shapes of clouds, and the direction of swells guided them. By night, they relied on the paths of stars and the rhythms of the ocean to sail down through Tonga and Samoa.[3] Then, over the centuries, the seafarers diffused north to the Hawaiian Islands, east to Rapa Nui, and south to the Tuamotu Archipelago and the remaining Tahitian Islands.[4]

The Pacific's swells would signal land ahead. Tahiti's powerful, hollow reef breaks that crack over shallow, sharp coral have gained international acclaim. The glassy wave of Teahupo'o, one of the world's heaviest, crashes over the island's southwestern tip. Known for pummeling and pounding some surfers to their deaths, the name translates as "to sever the head" or "place of skulls."[5] Some local legends say the name honors the son of a murdered king, who ate and drank the fresh brain of his father's murderer to avenge his death.[6]

From beneath these swells, perch, mahi mahi, and parrot fish abound, and the thick-lipped Long Nose Emperor fish glides through lagoons. The refreshing tang of poisson cru, or e'ia ota—raw fish—slices through the sweltering heat of a day on the island. Tuna bathes for a brief moment in a bath of lime juice. Creamy chunks of coconut meat, typically wrapped in cloth and then squeezed over the fish and vegetables, mellow the acidity. Coarsely chopped, seeded cucumbers and tomato distinguish this Tahitian dish from the finely diced Latin American ceviche.[7]

The consequences of climate change are becoming inescapable: dying coral colonies, rising sea levels threatening to submerge Tahiti's low-lying beaches, and shrinking schools of lagoon fish.[8] But somewhere hidden off the island's coast, deep sea explorers have unveiled a pristine reef, blooming in the shape of rose beds—a distant symbol of hope.[9]

TAHITI

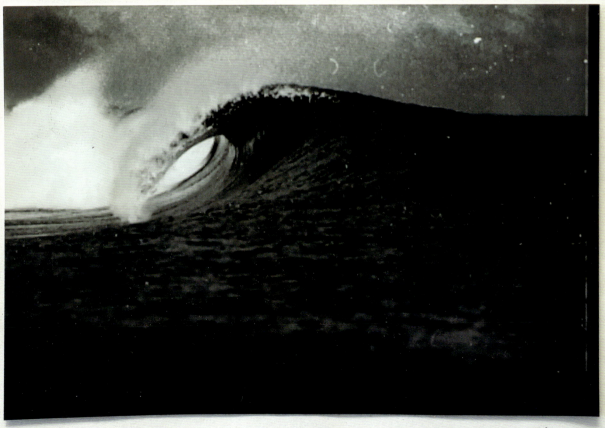

end of the Road

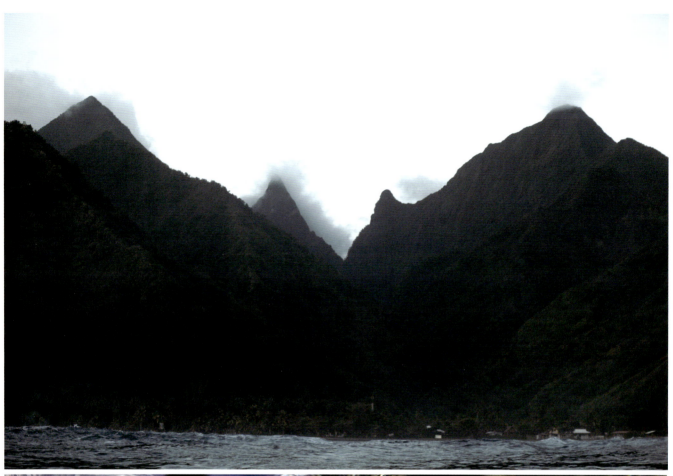

'OTA 'IKA 'poisson CRU'

In Tahitian, raw fish is called e'ia ota (pronounced ee-ah oh-tah); poisson cru is translated from French as raw fish. It is generally considered the national dish of Tahiti and the islands of French Polynesia. Ota 'ika, a raw fish salad, is like Tahitian warrior food: it gives you so much energy that you want to rip out trees! When I first prepared this dish, I ate it as an early lunch and didn't have the desire to eat anything until the next day. The coconut milk combined with tuna and vegetables gave me energy for the whole day! According to Pacific Islanders, coconut is the tree of life, the cure for everything. Coconut is filled with healing properties that protect the body from free radicals thanks to the high levels of antioxidants. The fat in coconut meat contains MCT oil and coconut milk contains lauric acid (which is also in mother's milk)! For this dish, use very fresh, high-quality fish, usually marked sushi grade in the market. Other possible additions could include cubed red peppers, grated carrots, diced red onion, or minced garlic.

CHEF'S NOTES

ENJOY WITH AN ICE COLD BOTTLED HINANO BEER

- 1 3/4 pounds fresh sushi-grade tuna
- 8 limes, juiced
- 1 large white onion, chopped
- 1 green bell pepper, chopped
- 1 medium tomato, cubed
- 1/2 medium cucumber, cubed
- kosher salt and freshly ground black pepper to taste
- 1 cup fresh or canned coconut milk (make sure it does NOT have sugar added)
- 1 scallion, finely chopped for garnish

SERVINGS: 4

Rinse the fish in cool water and pat dry; chop into bite-sized pieces and place in a bowl.

Squeeze the lime juice over the fish and stir.

Add the chopped onion, green pepper, tomato, cucumber, and coconut milk to the bowl and stir.

Place in the refrigerator to marinate for 15 to 20 minutes.

Drain excess liquid and adjust seasoning. Garnish with some freshly chopped scallions and serve.

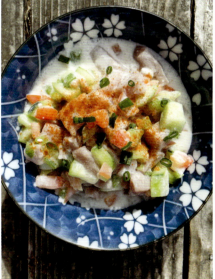

NOTES

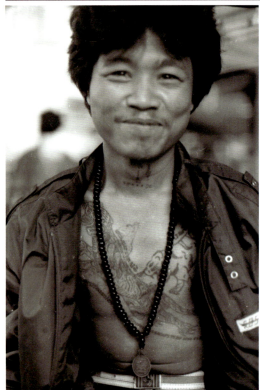

THE CROWN JEWEL

It was the late 1980s. Thousands of devoted Buddhists swarmed Chiang Mai to commemorate the cremation of Luang Pu Waen Sujinno: a monk who had dwelled alone in forests, who could cure illness, and according to one airforce pilot, could levitate in the sky.[1] Then, on the day of His Majesty King Bhumibol Adulyadej's 60th birthday, a procession of slender, long-tailed boats originally built to transport royalty across a country veined with rivers and canals dragoned through Bangkok's Chao Phraya River.

I was only a teenager when I landed in Thailand to visit my father. He had left Europe to live in a balmy kingdom of ancient, gilded palaces, military coups, insurgency, teak bungalows lurching with each undulation at the water's edge, and fluorescent-lit food stalls selling steaming heaps of wok-fried noodles and fiery minced meat curries.[2]

There was no space for stagnancy here. Tuk tuks clamored through the city's traffic-clogged boulevards, exhaust pipes belching smoke into the choked-up air. Giant elephants layered in wrinkles like an ancient, undecipherable script hauled loads of cargo as they sauntered between lanes. But even above the heavy grumble of motorbikes, the shouts of customers buying durians, rambutans, and mangosteens from street vendors and the rhythmic chimes of temple bells calling monks to prayer, I could still hear cicadas buzzing somewhere in the bushes.

My father and I walked for hours through a cityscape that seemed like the pure essence of chaos, but everything had its role and place. The dizzying smells of skewered pork and chicken slathered in tangy, mouth-searing sauces. The long-tailed Khlong boats slithering through thick, matted weeds and water hyacinth in the Chao Phraya River's canals, a river that shaped the history of the modern Thai capital.[3] The wooden, stilted houses leaning against each other along the waterways, suspended in the amber glow of dusk.

One evening, my father took me away from the frantic streets of the metropolis. We glided into the tangled, winding canals of Thailand's main artery, where boats piled with baskets of bananas, freshly caught sea bass, and silvery mackerel floated beside each other, fitting like puzzle pieces. I could smell plump, pan-fried mussels doused in chili sauce and the sweet, burning aroma of sticky rice soaked in sugar and coconut milk baking in a bamboo stalk. On some boats, I could see vendors serving up bowls of slippery noodles suspended in a pink soup and plates full of a ubiquitous green papaya salad.

North of Bangkok in Isan, in the border region with Laos, layers and layers of rice paddies, water buffalo wading in muddy ponds, and gold-trimmed temples line the Mekong River. Here, one of Thailand's most famous dishes earned international acclaim: som tum, also known as green papaya salad. Som refers to the lip-puckeringly sour taste of lime and tum to the act of pounding the hot chilis, fermented fish sauce, dried shrimp, garlic, and lime with a pestle.[4] This is no leafy salad piled with conventional greens. Once cut and seeded, thin slices or shreds of tart green papaya form the base of the salad; some street vendors add shredded carrots for color and crunch. And sometimes, sweet palm sugar softens the punch of spicy Thai chilis.

The dish's roots reach far beyond this northern land of silk weavers working looms in quiet villages.[5] The culinary interest in the crisp tang of sliced and shredded green papaya may trace back to Central and South America, where papaya was first domesticated in steamy subtropics similar to Southeast Asia. The papaya came to Southeast Asia around 1550 when the Spanish brought papaya from the Americas to the Philippines.[6] Some speculate Chinese-Lao settlers living in the low-lying Chao Phraya plains of modern-day Central Thailand first crafted the refreshing salad.[7]

The taste of Thai chilis sizzled on my tongue that evening in the Chao Phraya River's floating markets, as my father and I ate dinner with a local family. We sat on the floor of their home, on pier planks that doubled as a bed and living room.

The earliest civilizations of Southeast Asia had risen from the basins of this so-called River of Kings.[8] Merchants from China, Japan, India, and the Middle East traded teak wood, silk, tea, sandalwood, spices, and porcelain. When these merchants settled here in the 19th century, churches, mosques, shrines, and shophouses—buildings that are both a residence and a business—soon unspooled along these looping banks that flow south into the Gulf of Thailand.[9]

On the western shores of the Gulf of Thailand lies Surat Thani, once the crown jewel of the ancient Srivijaya empire, and then, a bustling transport hub shuffling people and cargo across the country. My father and I boarded an overnight train south from Bangkok to Surat Thani. The train jolted along the tracks, sometimes so fast I thought I would catapult out the window. Sometimes the train stopped along rice paddies, long enough to watch men in straw hats and women in cotton skirts trudge through murky terrain.

We arrived in the dead of night and waited for the bus that would take us to the port, where we would board a ferry to the palm-fringed beaches of Koh Samui. We were the only tourists waiting for the bus in the dark of night. I began to clean my nails with a knife in an effort to appear tough in front of the shadowy characters lurking at the station, but my father snapped at me, telling me that this was not the moment to act macho.

When we reached Koh Samui, Thailand's second-largest island, I could think only of filling my grumbling stomach with chicken simmering in a coconut milk gravy or something like Khua Kling, a dry meat curry and a staple of southern Thai cuisine. We checked into the island's only hotel. Two humble restaurants and a barber shop were the only other businesses on the rest of the island, a paradise of satin sands and coconut groves that would later become a hotspot for honeymooners and yogis hoping to balance and cleanse their chakras. We sauntered over to a restaurant, and I longed for a plate of minced pork sautéed with kaffir lime leaves, lemongrass, and southern Thai curry paste made of sharp bird's eye chilis that could blow my head off. After time apart, my father and I had embarked on a sort of pilgrimage in this land that was not our own, linked together not by space or time, but by blood. And food.

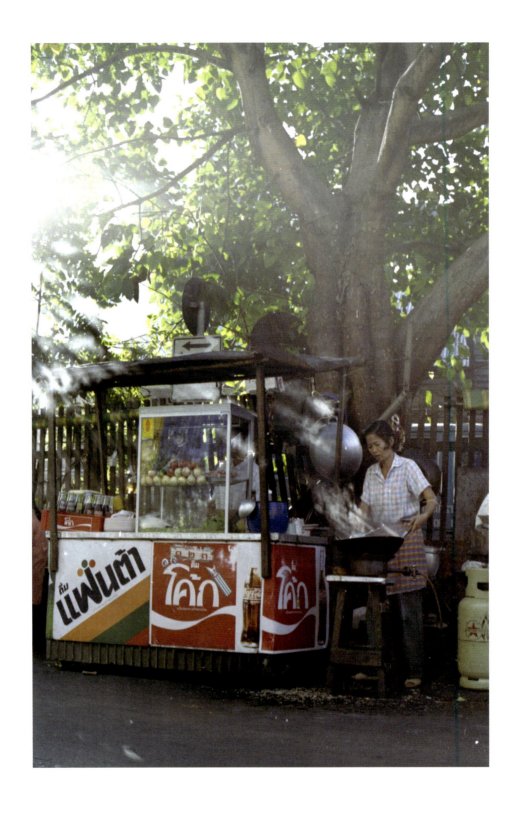

SOM TAM
"Papaya Salad"

Papaya salad, also known as som tam in Thailand, is a traditional dish in Thai cuisine. It is a refreshing and healthy salad made with shredded green papaya, tomatoes, peanuts, lime juice, fish sauce, sugar, and chili peppers.

- 1 green (unripe) papaya (about 1 pound), peeled and shredded
- 2 to 3 garlic cloves, minced
- 3 to 4 Thai bird's eye chilies, chopped (adjust according to your spice preference)
- 1/4 cup dried shrimp, soaked in hot water for 10 minutes and drained (optional)
- 2 tablespoons fish sauce
- 2 tablespoons lime juice
- 1 tablespoon palm sugar (or brown sugar)
- 1/2 cup cherry tomatoes, halved
- 1/4 cup roasted peanuts, roughly chopped
- 1/4 cup cilantro, chopped

SERVINGS: 4

In a large mixing bowl, combine the shredded green papaya, minced garlic, chopped chilies, and dried shrimp (if using). Use a pestle or a wooden spoon to gently pound and mix the ingredients together.

In a separate bowl, whisk together the fish sauce, lime juice, and palm sugar until the sugar has dissolved.

Pour the dressing over the papaya mixture and toss to coat evenly.

Add the halved cherry tomatoes, chopped peanuts, and cilantro to the bowl and toss again.

Serve cold as a side dish or as a healthy energizing meal on its own.

CHEF'S NOTES

A refreshing and nutritional addition to this meal is a whole, young coconut, served with a straw.

 NOTES

TUNISIA
HARISSA TINTED COUSCOUS

Sixteen years old, armed with a Minolta SR-T 101 and 30 rolls of expired Agfa slide film, a certain spontaneity and innocence pulled me toward Tunisia. I had spent the summer in Germany washing dishes at the Deutsche Bank canteen to save up for my first solo trip. Away from Europe. Away from languages I could understand. Away from signs I could read. I cloaked myself in linen pants and shirts buttoned up to my neck. I boarded trains and buses each morning to visit new towns, our stomachs stuffed with the shade-grown fruits of an oasis somewhere in the dusty outskirts: figs, dates, ripe, downy apricots, and tart oranges.

I spent weeks winding through the crowded souks. Vendors hung deep red, wrinkled chili peppers from the coastal towns of Nabeul and Gabès out to dry, which they'd later pound harissa. This fiery paste infuses couscous, stews, and hunks of goat and lamb with chilis, cumin, garlic, caraway, and olive oil—a relic of the Muslims and Sephardic Jews who fled Spanish brutality and sailed across the sea to the Ottoman province.[1] I remember the tin bowls of herbs and orange and yellow spices piled like dunes from the desert surrounding us. Fresh silver and red mullets, slick-skinned eels, and pale-tentacled cuttlefish filled wooden crates, conjuring scenes from a Roman mosaic preserved in Tunis' Byzantine-style Bardo Museum.[2]

Time passed differently here. And maybe it was something about traveling alone for the first time so young, in a place where waves of Phoenicians, Romans, Vandals, Arabs, Spaniards, Turks, Indigenous Amazigh peoples, and the French had all shaped this small country, tucked between Algeria and Libya.[3] Thousands of years ago, Hannibal's Carthaginian army first planted olive trees along the far northeastern Cap Bon peninsula.[4] Pressed over stone, the profits from ancient olive oil later fueled the construction of marvelous Roman amphitheaters, aqueducts, and elegant palaces with arched windows.[5] In the Amazigh village of Chenini, at the Sahara's outer fringes, camels still churned the old olive presses.

While the Romans may have planted wheat in Tunisia's fertile, rolling fields,[6] the root of couscous, a hard durum semolina dish, traces back to the Amazigh word for "small pieces" or "well rounded."[7] Once pounded, sieved, and dried in the open air, nomadic Amazigh groups preserved couscous throughout their journeys across the open desert.[8]

Steaming heaps of couscous sustained the days through lanes overlooking the Gulf of Tunis and the misty peaks beyond. Sometimes, I ate harissa-tinted couscous. Sometimes mixed with fresh butter, mutton, saffron, and chickpeas. Sometimes garnished with hot milk, raisins, almonds, pistachios, hazelnuts, and walnuts. In Tunis, I wove my way through the medina's maze-like streets, the beating heart of the city. In alleys alive with the aromas of rose water, thick Turkish coffee, and slabs of meat suffocating in the full force of the day's heat, butchers strung up halal goat and sheep carcasses in front of turquoise-trimmed doorways.

In adherence to the Quran's Islamic law, animals are cared for and fed well before halal slaughter. The butcher pronounces the name of Allah or Bismillah—in the name of Allah—and points the animal's face toward Mecca. With a sharp blade, smooth and devoid of nicks, the butcher severs the animal's windpipe, jugular veins, and carotid arteries with one swift, deep move. All blood must drain, leaving the meat clean and tender.[9]

From roadside stalls and hidden corner cafés, I sometimes snacked on kofta, round balls of charbroiled halal meat, sometimes beef, sometimes lamb. The forces of trade and travel to this sliver of North Africa left their mark on the fast food staple, as kofta means "to grind" in Persian. Boneless, lean meat melds with smashed onions, minced garlic and parsley, and splashes of coriander, caraway, turmeric, nutmeg, cumin, and black pepper.[10]

In this part of town, centuries of Almohad and Hafsid kingdoms and caliphates built mosques, mausoleums, madrasas, and fountains, transforming the city into the crown jewel of the Islamic world.[11] I wandered past men dressed in traditional Kaftans lounging with cups of mint tea, smoking water pipes. Sunset tinged the Mediterranean Sea yellow. From a white-domed mosque appearing to rise out of the waterfront, the muezzin recited the adhan, or call to prayer. His voice, smooth and solid as polished wood, unraveled like a thread through the loudspeaker.

Some nights, I'd sit beneath the shade of an olive tree, the Mediterranean Sea unfurled and rippling before me. The heartbeat of Tunisia thrummed through me, and without knowing what I'd eat next, who I'd speak to next, or where I would go from here, I somehow felt freer. Maybe I had learned to become happiest on the move, untethered from the life I'd become used to living, and hopeful of the life I had yet to establish. A small breeze might have rustled the branches above my head. I felt out of time, but perhaps not out of place.

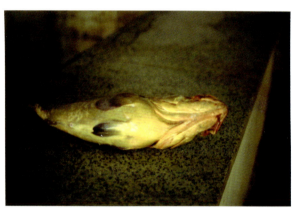

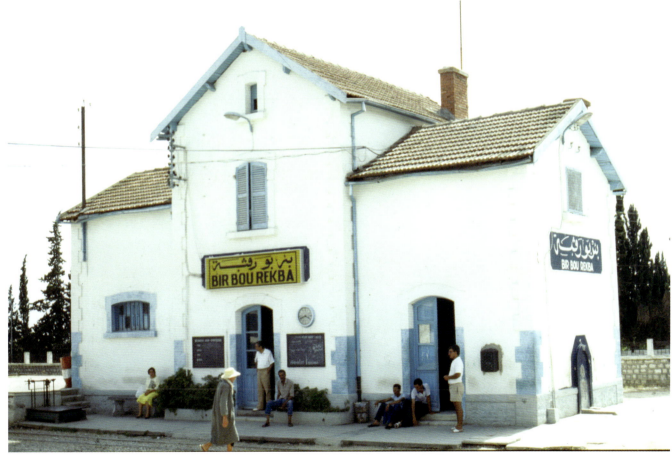

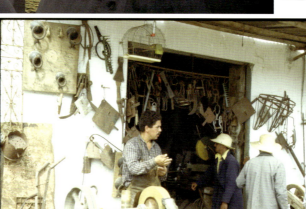
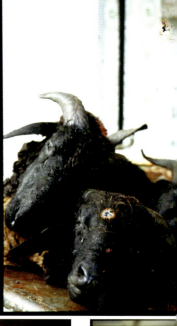

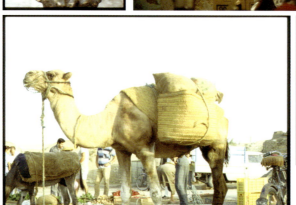

KOFTA TANGINE

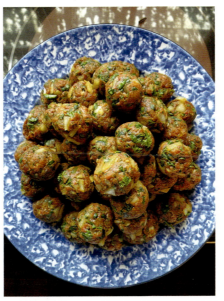

KOFTA
- 1 pound ground beef or lamb
- 1 medium onion, finely chopped
- 2 garlic cloves, minced
- 1 tablespoon finely chopped parsley
- 1 tablespoon finely chopped cilantro
- 1 teaspoon ground cumin
- 1 teaspoon paprika
- 1/2 teaspoon ground cinnamon
- 1/2 teaspoon ground coriander
- 1/4 teaspoon cayenne pepper
- salt and pepper to taste
- 2 tablespoons olive oil

SERVINGS: 4

TOMATO SAUCE
- 2 28 ounce cans diced tomatoes
- 1/2 cup water
- 1 teaspoon sugar
- 1 teaspoon dried oregano
- 1 teaspoon dried basil
- 1 teaspoon dried thyme
- 1/2 teaspoon red pepper flakes
- 2 tablespoons chopped fresh parsley, for garnish

In a large mixing bowl, combine the ground meat, onion, garlic, parsley, cilantro, cumin, paprika, cinnamon, coriander, cayenne pepper, salt, and pepper. Mix well until all the ingredients are evenly distributed. Form the meat mixture into 10 to 12 oval-shaped koftas.

Heat the olive oil in a tagine or a large skillet over medium-high heat. Add the koftas and cook until browned on all sides, about 5 to 7 minutes. Remove the koftas from the skillet and set aside.

In the same skillet you fried the kofta in, add the diced tomatoes (with their juice), water, sugar, oregano, basil, thyme, and red pepper flakes. Bring the mixture to a boil, then reduce the heat to low and let it simmer for 10 to 15 minutes until the sauce has thickened.

Return the koftas to the skillet and let them simmer in the tomato sauce for 10 to 15 minutes, until the koftas are fully cooked and the sauce has thickened.

Garnish with chopped parsley and serve hot with your favorite bread or couscous.

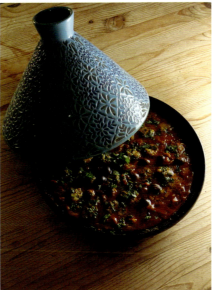

CHEF'S NOTES

Serve Mint Tea "Maghrebi" Post Dinner A Soothing Digestive

NOTES

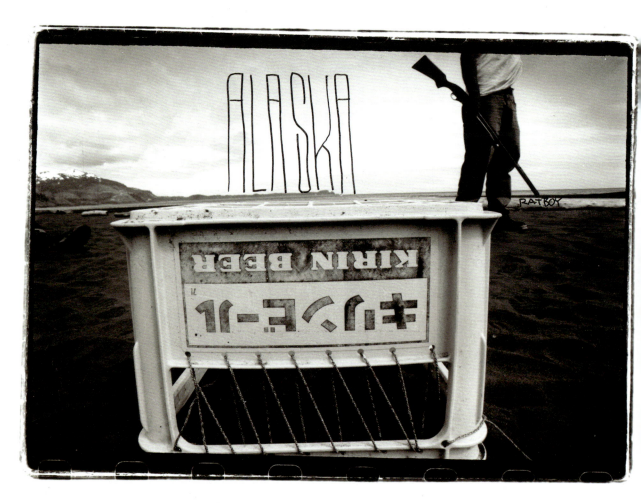
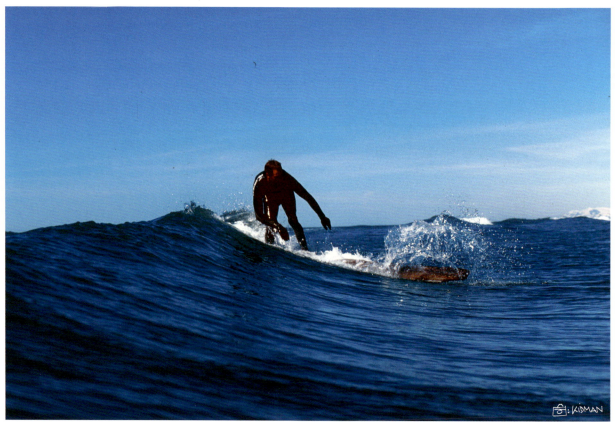

VSA: ALASKA
YAKUTAT

Generations of rugged frontiersmen have created images of Alaska as an idealized wilderness, a haven from humanity.[1] In this mythologized "Last Frontier" of colonial expansion, only the bravest of souls can battle the dangers that roam impenetrable forests, steep fjords, and tidewater glaciers. Without falling prey to this stereotype, I must admit that on a visit to Alaska, I encountered a near-death experience—or what could have been a near-death experience.

My good friend and travel buddy Josh and I arrived in Yakutat during the summer solstice, where we hoped to find south swells that are generated in Antarctica and travel up to this northern shore with Fishbone. Josh had met Fishbone on his first Alaskan surf trip back in the early 90s. As we searched for the perfect surf, Fishbone showed us the dirt roads that snaked between forests, weaving through the coastline—the ruins of American runways during World War II.[2]

Eyak and Tlingit peoples first settled across this isolated, northern stretch of the Inside Passage. As Eyak and Tlingit peoples married among each other, their daily lives merged. Then, in the eighteenth and nineteenth centuries, Russian and American gold miners, fur traders, loggers, and fishers competed for supremacy, siphoning profit from the black sand beaches and the snow-capped peaks of Mount Saint Elias; in Tlingit, known as Yas'éit'aa Shaa or mountain behind Icy Bay.[3]

In Yakutat Bay, streams once teemed with the largest and fattest king, coho, and sockeye salmon. Tlingit elders would teach younger generations to gut and filet fish. The meat, heavily marbled with fat, would be roasted fresh over a fire or frozen, dried, or smoked for preservation.[4] By the end of World War I, rampant commercial fishing and the booming canneries of wealthy industrialists caused once-rich rivers to suffer.[5] But Indigenous traditions have not been lost and no amount of the squander, waste, nor wanton killing of salmon could erase Tlingit identity.

One evening in Yakutat, my friend Andrew, and I returned to our usual campsite, where we'd built a fire pit the day before in the sand, hoping to catch a sunset after eternal, summer days. But something seemed wrong, disturbed. We soon noticed immense bear prints encircling our camp; that was all it took for us to ditch the site and watch the sunset from what we thought might be a safer vantage point. We settled in a spot overlooking the bay and, across from us, the rough tips of St. Elias towered over Yakutat.

Andrew and I watched the sky smudge into pink and orange hues around St. Elias Mountain, an 18,008-foot peak jutting out of the sea. We spoke about life and cooked burritos stuffed with eggs, potatoes, jalapeños, and avocado over our campfire. When night finally fell upon us, we noticed one of our car's tires had gone flat. Alone on the point, shrouded in the smells of our feast, we began to feel exposed and vulnerable to nature. I suggested we walk the edge of the bay back to Yakutat but in the dark, an Alaska brown bear, or the even larger Saint Elias silver grizzly, could shred us to pieces.

We decided to attempt to paddle on our shortboards, so we slipped into our rubber suits, booties, gloves, and hoods fastened tight in preparation for the frigid waters. Andrew and I attempted to drag each other along in the front runner's wake, but we seemed to make no progress. The lights of Yakutat still flared off in the distance—our only source of hope. Stories of great white sharks and outgoing tides swallowing surfers into the sea plagued our minds. But soon the wind picked up, and we lumbered through the dark. Around three and a half hours later, my foot numb from a hole in my bootie, we finally hauled ourselves into the Yakutat harbor. We trudged back to our lodging in monastic silence, exhausted from toeing the line between life and death. We had avoided becoming another statistic of travelers succumbing to the forces of wilderness.

A Tlingit story tells of the Kóoshdaa Káa, shape-shifting, otter-like creatures that beckon lost travelers into a dark maze of trees and brambles or out to the stormy bay. The Kóoshdaa Káa would attempt to repossess a person's spirit, forcing them into a version of themselves they never imagined they could become.[6] And maybe these creatures did haunt the forests my friends and I wandered through. Or maybe these tales served as a warning to the gold miner, the pioneers who conquered stolen land, the industrial fishers who left streams dry of silvery-skinned fish with scales aglitter in the rising sun.

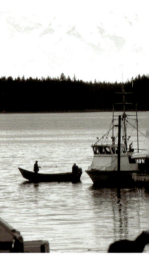

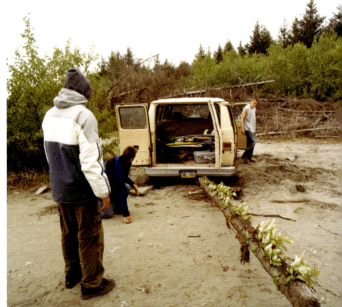

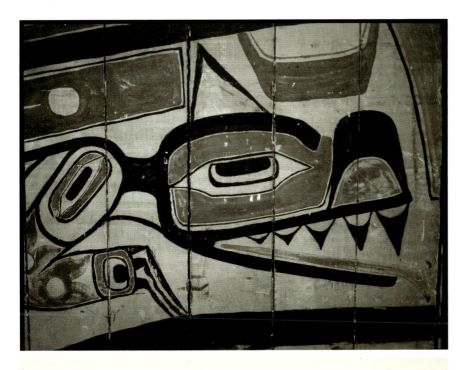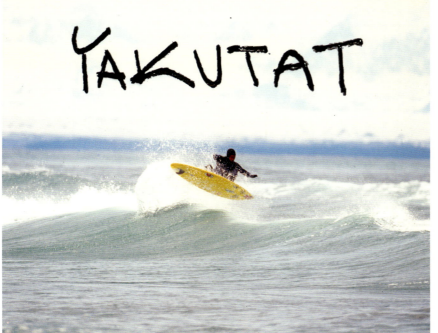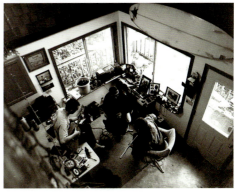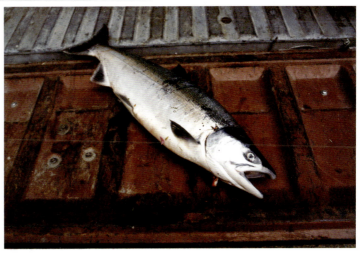

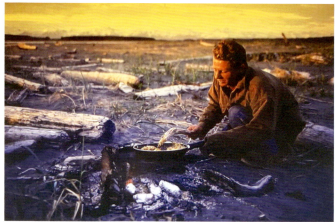

Venison Carpaccio

Carpaccio was invented by Chef Giuseppe Cipriani at Harry's Bar in Venice in the 1950s. According to legend, Countess Amalia Nani Mocenigo, whose doctor had warned her against eating cooked meat, asked the chef to create something that suited her dietary needs. The dish was named carpaccio after Vittore Carpaccio, the Venetian painter known for the characteristic red and white tones of his work.

Venison carpaccio is made from thinly sliced raw venison meat, typically served as an appetizer or a light main course. To prepare venison carpaccio, it's important to use high-quality meat. Any possible parasites that might be present can be eliminated by freezing the meat at a temperature of -4°F (-20°C) for at least 10 days. Freezing raw meat may help reduce the risk of foodborne illness, but it's important to note that freezing will not necessarily make the dish completely safe to eat. It's so delicious that a huge part of the world population eats carpaccio even though there's a chance that they may die from it!

CHEF'S NOTES

PAIR THIS RUSTIC YET REFINED HUNTERS DISH WITH A BOTTLE OF BEUJOLAIS VILLAGE CUVEE ANNIE JAQUES DERAGNEUX 2020

- 8 to 10 ounce venison loin, trimmed
- 2 tablespoons extra virgin olive oil
- 1 tablespoon freshly squeezed lemon juice
- 1 garlic clove, minced
- salt and black pepper to taste
- 1 cup arugula leaves
- 1/4 cup shaved Parmesan cheese
- 2 tablespoons capers
- toasted bread or crackers for serving

SERVINGS: 4

Freeze the venison for at least 2 hours to make it easier to slice thinly. Remove the venison from the freezer and let it thaw for 10 to 15 minutes at room temperature.

In a small bowl, whisk together the olive oil, lemon juice, garlic, salt, and pepper to make the marinade.

Slice the venison as thinly as possible using a sharp knife. Arrange the slices on a serving platter or individual plates.

Pour the marinade over the venison, making sure to coat all of the slices evenly. Cover the platter and let it rest at room temperature for about 15 minutes.

Top the carpaccio with arugula leaves, shaved parmesan cheese, and capers.

Serve the raw venison carpaccio with toasted bread or crackers on the side.

 NOTES

USA: CALIFORNIA

COASTLINES & FILING CABINETS

In the summer of 2020, a fury of lightning and thunder splintered the sky above the Santa Cruz mountains. Flames engulfed the redwoods that stood sentinel for centuries, guarding the town I'd come to call home. Since the early 90s, I'd built a new life here in California, among rugged, twisting coastlines, yellow wildflower-flecked hillsides, and garden beds sprouting string beans, lettuce, and artichokes. But a past life still remained locked away in metal filing cabinets, recorded in analog photographs of waxy-eyed fish heads, golden sunsets gleaming on the minarets of a mosque, and cobblestone streets in a balmy village recovering in the wake of a recent war. I had always felt comfort on the road, longed for distant places. What would be left of this life now?

When I first moved to California, I dreamed of launching my career as a professional photographer in the cutthroat arena of the American art world. To survive and pay for food and film in those first few years of my new life, I dug ditches, hauled heavy loads of debris washed up on the shores in the aftermath of El Niño's intense storms. With Jason, a friend I'd met traveling through Central America, I got a job clearing the collapsed redwoods, oaks, and pines that littered the beaches like the discarded bones of a colossal beast. This was the hardest job of my life, and that hard labor pushed me to hone my skill and publish my photographic work. And in the back of my mind, I still hoped to find work in the restaurant world, a world I knew all too well from my days working my way up from being a cold kitchen salad boy to a line cook back in Europe.

California, a land of open grassland specked with sagebrush and unbound horizons stretching off into tall, flat-topped buttes, is the ideal cattle country. Spanish colonizers first brought livestock to roam in California in the late 18th century, supplying Catholic missions with meat, hide, and tallow.[1] Wheat, grapes, and olives also flourished in these fertile farmlands. Then, the myth of a God-given right to conquer lands in the name of American exceptionalism propelled settlers out west in search of gold. Mining towns razed ancestral Indigenous homelands, and demand for Black Angus, Red Angus, Hereford, and Shorthorn beef fed new waves of settler-colonists from the East Coast.[2]

But today, when I think of this place, I think of the acorns, blackberries, and mushrooms of different Indigenous cuisines in the region.[3] Avocados first sprouted in South Central Mexico between 7,000 and 5,000 BC, soon making their way up the Pacific coast into the backyard of Judge R.B. Ord. Ord had brought the seed from Mexico and planted trees in his Santa Barbara home in the late 1800s.[4] Now, mailman Rudolph Hass cultivated his own grove in La Habra Heights—the genesis of a thick-skinned fruit with buttery green insides.[5] Today, trendy eateries along Sunset Boulevard would be incomplete without avocado toast, sliced paper thin, on seeded sourdough bread, topped with julienned radishes, heirloom tomatoes, or feta. The seeds of these trending Californian foods were first planted in backyard vegetable gardens; the simplicity of fresh chanterelle or morel mushrooms, green beans, heirloom tomatoes, eggplants, and beets would become the centerpieces of gourmet restaurants.[6]

Over the years, I became further embedded in this land. I cleared the scattered debris from storm-swept beaches, bearing witness to the unpredictability of nature. I grew carrots and harvested urchins from cold, shallow waters. The ability to feel connected to the earth and the broader universe became central to my creative pursuits. And finally, by some stroke of fate, I met the prolific German painter Linde Martin, who would create five enormous works of art a week. I spent time photographing her paintings, figuring out the right ways to capture the bright rivulets of oil paint that flowed across her canvases. Then, I began to produce more artists' portfolios and sent copies of my surf photos from Central and South America to surf magazines around the world. Now, the analog photographs I had locked away in metal filing cabinets were more than just reminders of a past life. They were glimpses into the future, of a life always searching for the path less traveled.

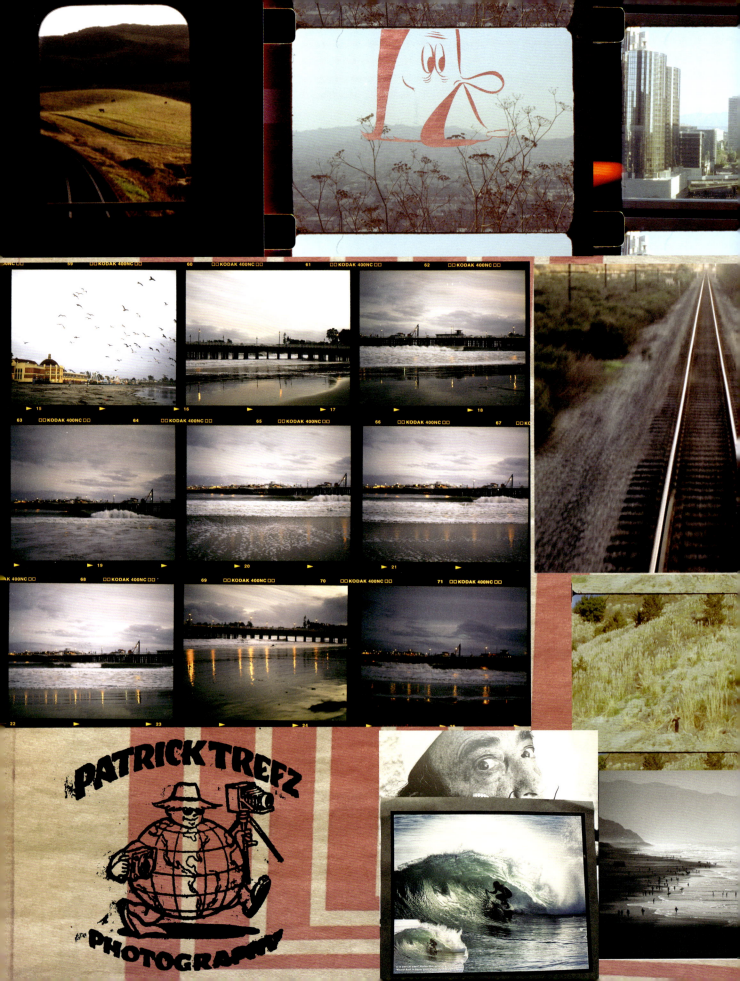

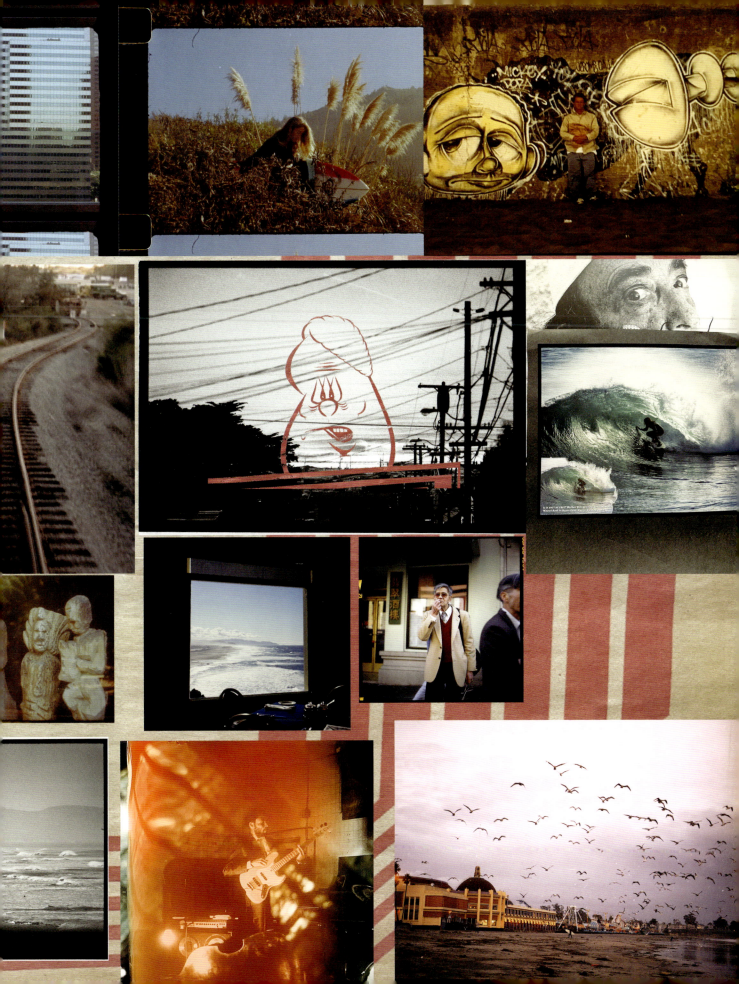

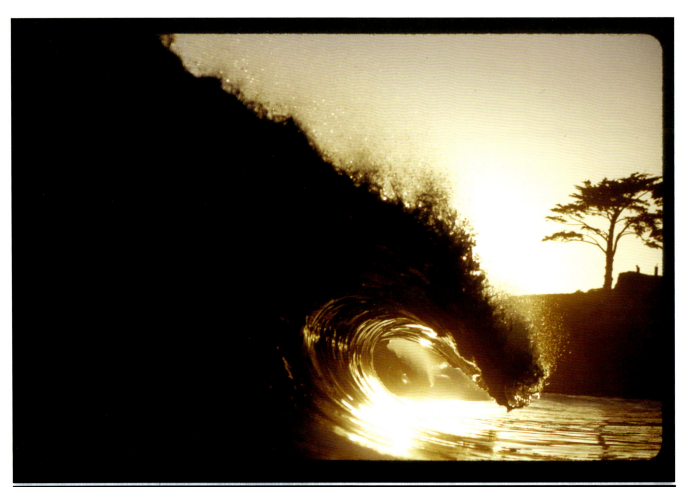

GRILLED OCTOPUS & KABUTO YAKI

In Japanese cuisine, grilled fish heads are a popular delicacy known as kabuto yaki. Kabuto means helmet in Japanese, and the dish is named so because the fish head, when grilled, resembles a helmet. Kabuto yaki is one of the easiest fish dishes to grill up. Simply season with salt and grill. Add soy sauce and lemon juice upon serving and they are often served with soy sauce, sake, or other seasonings. Grilled tuna fish heads are not a traditional Californian dish, but they may be found in some restaurants or seafood markets that specialize in Asian cuisine.

GRILLED TUNA HEADS WITH SOY SAUCE
- 2 large tuna heads
- sake
- salt and pepper
- soy sauce

Servings: 2

Heat a grill to high heat. Prepare the tuna head by rinsing it thoroughly with sake. Sprinkle salt and pepper on both sides of the tuna head, ensuring it is evenly coated.

Place the tuna head on the grill, end side down. Allow it to cook for about 5 to 7 minutes. Carefully flip the fish head onto its side and grill each side for another 2 to 4 minutes or until the fish is cooked through and the skin is crispy.

Remove the grilled tuna fish head from the grill and transfer it to a serving platter. Drizzle some soy sauce over the fish head, allowing it to soak into the flesh.

CHEF'S NOTES
Best paired with ice cold Kikusui Junmai Ginjo

OCTOPUS OVER PAN-ROASTED POTATOES
- 3 tablespoons olive oil
- 5 pounds cleaned and rinsed raw octopus tentacles, chopped into finger-sized pieces
- 1 medium red onion, diced
- 1 jalapeño, diced
- salt and pepper to taste
- 4 to 6 medium potatoes, cut into wedges
- 3 garlic cloves, minced
- handful of chili flakes
- 1 lemon, juiced
- a bottle of beer
- fresh parsley, chopped, for garnish

Heat a large cast iron pan to high heat. Pour the olive oil in and then sear the octopus pieces for a couple of minutes on each side.

Add the onion and jalapeño to the pan; add salt, toss around, and add the potatoes and toss everything together. Turn down the heat to a simmer; add the garlic and toss again. Add chili flakes and lemon juice.

Add half a bottle of beer, maybe a Japanese Sapporo or the Mexican Modelo.

Cover and let the octopus and vegetables simmer for about an hour. Let the mixture collapse and then vulcanize—like a volcano, it will collapse and then rebirth. Flip the charred pieces and serve with a parsley garnish.

NOTES

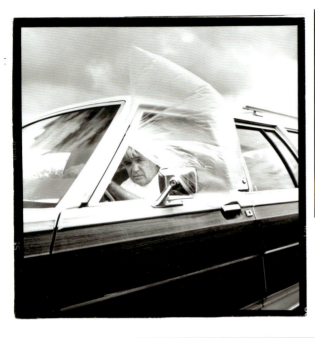
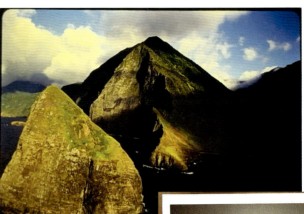

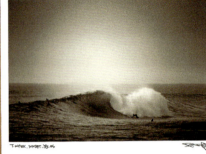

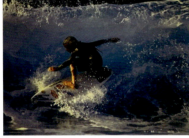

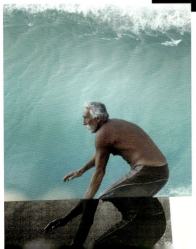

TARO & MAC SALAD

Several decades after James Cook met his death against the backdrop of Native Hawaiian peoples' resistance, wealthy American businessmen began a violent coup against Queen Lili'uokalani in 1893. And when Christian missionaries from the mainland arrived, they found the traditional pastime of surfing deplorable and denounced it along with other cultural practices.[1]

I have always had the utmost respect for the Hawaiian people and their islands, the birthplace of surfing. It is a place that should not be treated lightly. The packaged, mass-produced visions of "paradise" for US tourists on the mainland, the luxury high-rise developments, and pristine beachfront resorts do these lands no justice. This image of escape, of fleeing to a place where you can lounge in the sand with a cocktail in hand, not thinking about much else, has long dominated the US imagination. But in Hawaii, māna, a spiritual energy of life, power, and strength, emerges.[2] There were the days of Olympic swimmer Duke Kahanamoku, riding the sliders on the south shore of O'ahu on a wooden alaia. There was Buffalo Keaulana gliding along Mākaha Beach, and of course, there were the first warriors to take on the giant waves and cavernous reefs of the Pipeline on Oahu's north shore.

My first time in Hawaii, I visited Lance, a friend I'd met traveling through Costa Rica, who had invited me to stay with him and his family. I remember surfing a water break tinted dark brown from sugarcane runoff, where I'd heard warnings of tiger sharks lurking beneath the murky surface. When I finally pulled myself out of the water, I wandered through the stifling heat of Kauai to Ishihara Market. Containers of fresh lomi-lomi salmon, tako poke, kimchi clams, sea snails, and seaweed salad lined the long deli counter, feeding farmworkers in the area for nearly ninety years.

Before the British raided Hawaii's hidden coves, before disease decimated the Indigenous populations,[3] the archipelago's ancestral cuisine may have been one of the world's healthiest. Native Hawaiians once pounded taro into poi, a pale purple mixture that becomes sweet and creamy when fresh or sour like plain yogurt when left to ferment. Breadfruit, sweet potato, octopus, chicken, and saltwater eels, sometimes cooked in the caverns of an umu—an underground oven—breathed energy into warriors, and into the women who hunted and gathered and the men who cooked.[4]

But colonizers sought after new lands to plunder for profit; with colonization came sugarcane and pineapple plantations. As these plantations swallowed thousands and thousands of hectares of lush hills and verdant valleys, the need for labor grew, ushering in immigrant workers from China, Korea, Japan, the Philippines, Puerto Rico, and Portugal. In place of poi, Chinese workers preferred rice and soon the demand for taro declined.[5] A medley of styles, flavors, and textures emerged, like spam musubi, the spongy slab of canned meat belted with a strip of nori to a block of rice.

Koreans brought barbecue pits to cook marinated meats and the beef short ribs known as kalbi or galbi adapted to the sweeter flavors found on the islands. The thinly sliced beef short ribs soak in soy sauce, fresh ginger and garlic, and brown sugar, instead of the Korean choice of a subtle Asian pear.[6] The ribs feature in Hawaiian plate lunches—typically two scoops of white rice and a side of macaroni salad doused in mayonnaise. The macaroni salad added extra calories at little cost and neutralized the barrage of sweet, salty, and sauce-laden meats.[7] Rooted in the plantation era, workers wolfed down hearty plate lunches of rice and meat left over from the night before—a brief reprieve from harsh conditions.[8]

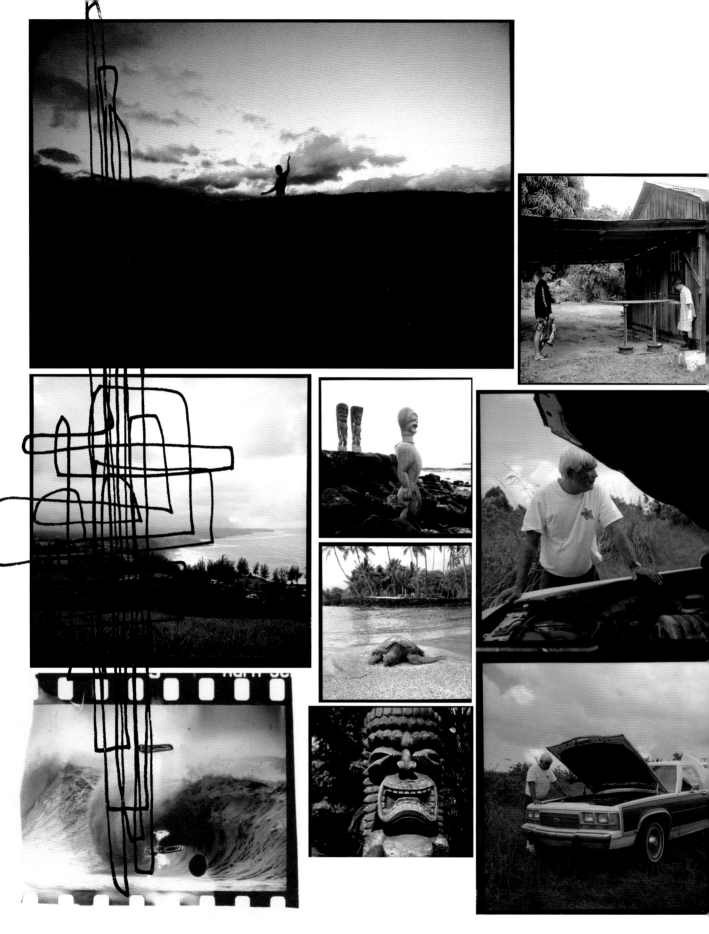

KOREAN BEEF RIBS MAC SALAD

This recipe is my homemade take on the Hawaiian plate lunch! Serve with kimchi, a fermented cabbage pickle that can be easily bought in most stores these days—or make it yourself!

KOREAN BEEF RIBS
- 1/2 cup soy sauce
- 1/4 cup brown sugar
- 3 garlic cloves, minced
- 1 teaspoon grated ginger
- 1/4 teaspoon ground black pepper
- 2 pounds beef short ribs, cut crosswise into 2-inch pieces
- 2 tablespoons vegetable oil
- 1/4 cup water
- 2 scallions, sliced

SERVINGS: 4

In a large bowl, whisk together the soy sauce, brown sugar, garlic, ginger, and black pepper. Add the beef ribs and toss to coat well. Let marinate for at least 30 minutes or up to overnight in the refrigerator.

Heat a grill to medium or preheat the oven to 350°F.

In a large oven-safe skillet or dutch oven, heat the vegetable oil over medium-high heat. Add the marinated beef ribs and cook until browned on all sides, about 5 minutes.

Pour the water into the skillet, cover it with a lid or aluminum foil, and transfer to the oven. Bake for 2 hours, or until the meat is tender and falls off the bone.

Serve sprinkled with sliced scallions.

CHEF'S NOTES: Serve with a bottle of Makgeolli — Korean rice wine

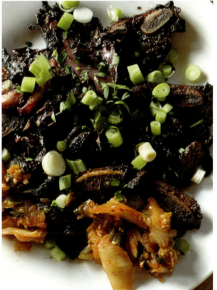

MAC SALAD
- 1 pound elbow macaroni
- 1 cup mayonnaise
- dash of apple cider vinegar
- 1/2 tablespoon sugar
- salt and pepper to taste
- 2 stalks celery, finely chopped
- 1/2 small onion, finely chopped

While the beef ribs are baking, cook the macaroni according to the package directions. Drain and rinse under cold water until the macaroni is cool.

In a large bowl, whisk together the mayonnaise, milk, apple cider vinegar, sugar, salt, and black pepper. Add dressing to the cooled macaroni and add the chopped celery and onion. Stir to combine.

Serve the beef ribs hot, garnished with sliced scallions. Serve the mac salad with rice on the side.

USA: New Jersey
NOR'EASTER

A late-season Nor'easter struck the greater New York area the morning my friend Joey banged on my door at the Chelsea Hotel. The driving sleet and strong winds ushered in powerful waves that'd be offshore south of Manhattan where the coast bends in the other direction. As we traveled along the New Jersey Turnpike on a frigid day in late February, I felt dwarfed by the immensity of its multiple, broad lanes, by the cars and trucks that zipped past us. The Turnpike is a work of art, unreal and like something from a distant dream. And it is a dream, an emblem of the so-called American Dream that has infiltrated the global subconscious.

Before this journey into the Garden State, I'd built an image in my mind based on the 1996 film Big Night, a story of two Italian immigrant brothers who run a struggling Italian restaurant in 1950s New Jersey. In a world of white picket fences, leafy suburban streets, and brick houses sprawled across the industrial greyscape of Jersey City, the smells, tastes, and traditions of Italy still linger, and not at all in secret.

The burgeoning silk and cotton mills of America's Industrial Revolution beckoned Old World peasants in search of a new life.[1] On the other side of the ocean, Italian cooks indulged in the meats of America, once a luxury to the lower classes. Spaghetti and meatballs, marinara-heavy pizzas with long tendrils of melted cheese stringing thick slices together; salami, cheese, or spiced Italian sausage wedged within bulky sandwiches of crusty bread.[2] And in newer fusions, peaches, burrata, and pistachios might pay a distant homage to a dry summer in the Italian countryside.

Italian charcoal workers covered in soot and ashes emerged from the rugged Central Apennine mountains, perhaps giving rise to the classic carbonara pasta dish. Tales of hard-working carbonaros—the sellers or burners of charcoal—recount how these hard-working men stuffed bowls of spaghetti with eggs, pecorino, and guanciale, air-cured pork jowls or cheeks. To others, this creamy pasta evolved from late-19th-century Neapolitan kitchens when chefs first tossed maccheroni alongside cheese and eggs. For others, carbonara has its roots in Rome.[3]

One contentious legend credits the birth of carbonara to chefs during and in the crumbling aftermath of the Second World War. As American soldiers found themselves stationed in Italy, they brought their daily rations of eggs and bacon to local restaurants in Rome.[4] Perhaps the rich, creamy sauce—a blasphemous addition for some serious Italian cooks—exposes the roots of American influence.[5] Later, in the new Italian enclaves stretching across the Eastern Seaboard of the United States, bacon became salt-cured pancetta, and pancetta became chunks of guanciale.[6] The memories of a recipe from a distant homeland soon adapted to the tastes and textures of a new terrain across the Atlantic.

Carbonara

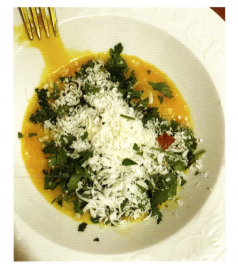

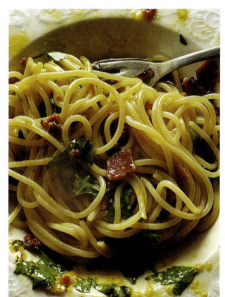

- 1 pound dry spaghetti
- 6 ounces pancetta or bacon, diced
- 3 garlic cloves, minced
- 4 large eggs
- 1 cup grated pecorino romano or parmesan cheese
- salt and freshly ground black pepper to taste
- chopped parsley, for garnish (optional)

SERVINGS: 4

Bring a large pot of salted water to a boil. Add the spaghetti and cook until al dente, about 8 to 10 minutes. Reserve 1 cup of the pasta cooking water and then drain the spaghetti.

While the spaghetti is cooking, cook the pancetta or bacon in a large skillet over medium heat until crispy, about 8 to 10 minutes. Add the garlic and cook for an additional 1 to 2 minutes until fragrant.

In a small bowl, whisk together the eggs and grated cheese.

Add the cooked spaghetti to the skillet with the pancetta or bacon and toss to combine.

Remove the skillet from the heat and pour in the egg mixture, stirring constantly until the eggs thicken and coat the spaghetti evenly. If the sauce is too thick, add some of the reserved pasta cooking water to thin it out.

Season with salt and freshly ground black pepper to taste.

Serve the spaghetti carbonara hot, garnished with chopped parsley if desired.

NOTES

CHEF'S NOTES

I RARELY WATCH [TV] DURING DINNER BUT IF I DO, IT'S THE FILM THAT INSPIRED THIS RECIPE, SET IN NEW JERSEY — +BIG NIGHT+ 'HUMBLE' IN MY OPINION, THE BEST FOOD RELATED MOVIE YET...

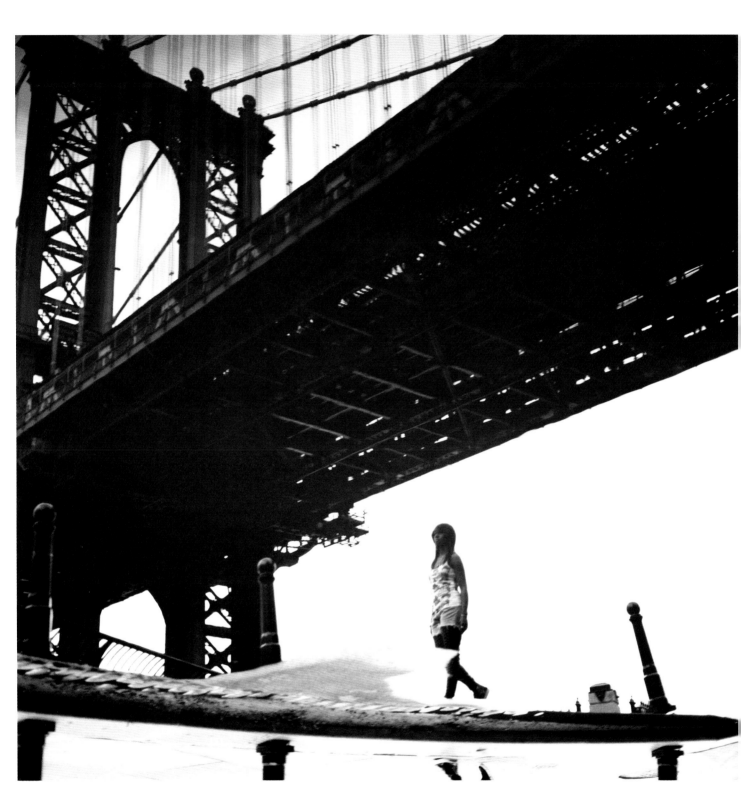

USA: NEW YORK

CHOPPED LIVER

Imagine a humble deli sandwich as a symbol of upward mobility. Yiddish for delicious or yummy, a geschmack stack of pastrami sandwiched between earthy rye bread and spicy brown mustard, speared with a toothpick blazing the American flag. But like most of New York—a city that never sleeps, where dreams are made, where Spanish or Russian or Chinese rolls off the tongues of bodega owners and suited businessmen, and all the clichés you can think of—the deli sandwich is far from emblematic of one single group of people. But there's no doubt that Yiddish-speaking Jewish Americans pioneered New York's delicatessens, the homey community hubs offering comfort within the city's chaos. The late 19th century saw waves of Ashkenazi immigrants who fled the persecution and programs of Central and Eastern Europe.[1]

A Lithuanian butcher, Sussman Volk, arrived in Manhattan's Lower East Side and allowed a Romanian friend to store meat in his icebox. Local lore says this friend, in exchange for Volk's kindness, shared a centuries-old recipe for raw beef brisket, lamb, or turkey brined, partially dried, seasoned with herbs and spices, and smoked and steamed.[2] Pastramă, from the Romanian verb describing the preservation of food, soon became the standard of a land tangled with tenements and boxy brick co-ops, and now, glass skyscrapers and high-end boutique condos.[3] Here, the flavors of Jewish immigrants' forebearers and the preferences of a fast-paced American diet fused together.

Bustling temples of rye, pumpernickel, challah, and poppy seeded pletzel piled with pickled herring, lox, chopped liver, corned beef, and hot pastrami became emblematic of rags to middle- and upper-class-riches.[4] But in efforts to save old-school Jewish American delis from their deathbed, under threat from the fears of fat, carbohydrates, and salt in recent decades, a new species of designer delis have swept through the city.[5] Beef briskets sourced from pastured Angus cows. Sandwiches layered with smoked turkey rillettes. Chopped liver made with duck jus. And as food and culture mold to fit changing times, there still remains hope that Jewish foodways will endure as more than just a memory.

I have always appreciated liver. As a child, this affinity began with various liverwursts and pâtés. Later on, in my salad-making days, I'd fry up beef liver with onions. I started to experiment with a modernized take on this classic. A combination of chicken liver, apple, garlic, sage leaves, onion, and jalapeño brings a modernized adaptation of chopped liver. This twist adds a bit of sweetness and heat, creating a more complex and flavorful dish.

Chopped Liver

Chopped liver is a popular dish in Jewish cuisine that originated in Europe and became a staple in Jewish communities around the world. Jewish immigrants brought the dish with them to America in the early 20th century. Chopped liver quickly became a fixture in Jewish delicatessens and home kitchens in New York City.

In the early days, chopped liver was often made from inexpensive chicken livers, onions, and schmaltz (rendered chicken fat). The dish was a way for immigrants to use all parts of the chicken and stretch their food budget. Over time, the recipe for chopped liver evolved to include additional ingredients, such as hard-boiled eggs, parsley, and other herbs and spices. Some versions also include chopped vegetables, such as carrots and celery, for added flavor and texture.

Today, chopped liver is still a beloved dish in New York City and it can be found on the menu at many Jewish delis and restaurants. While the basic recipe remains the same, chefs and home cooks continue to experiment with new variations and flavors, adding a modern twist to this classic dish. Enjoy this updated spicy version of chopped liver!

CHEF'S NOTES

Pair with a dry Cider

- 1/4 cup olive oil
- 2 medium onions, diced
- 1 pound chicken livers, trimmed and cleaned
- 3 to 4 garlic cloves, minced
- 1 to 2 jalapeño peppers, seeded and diced
- 2 tablespoons hot sauce (such as Sriracha or Tabasco)
- salt and freshly ground black pepper to taste
- chopped fresh parsley or cilantro, for garnish (optional)

SERVINGS: 4

In a large skillet, heat the olive oil over medium-high heat. Add the onions and cook until they are softened and lightly browned, about 5 to 7 minutes.

Add the chicken liver, garlic, and jalapeño peppers to the skillet. Cook, stirring occasionally, until the liver is browned on the outside but still slightly pink on the inside, about 5 to 7 minutes.

Remove the skillet from the heat and allow the liver mixture to cool for a few minutes.

Transfer the liver mixture to a food processor and pulse until it is coarsely chopped. Add the hot sauce and pulse again to combine. Taste the chopped liver mixture and season with salt and pepper as needed.

Transfer the chopped liver to a serving dish and garnish with chopped parsley or cilantro, if desired.

Serve the spicy chopped liver with crackers, bread, or raw vegetables for dipping.

Notes

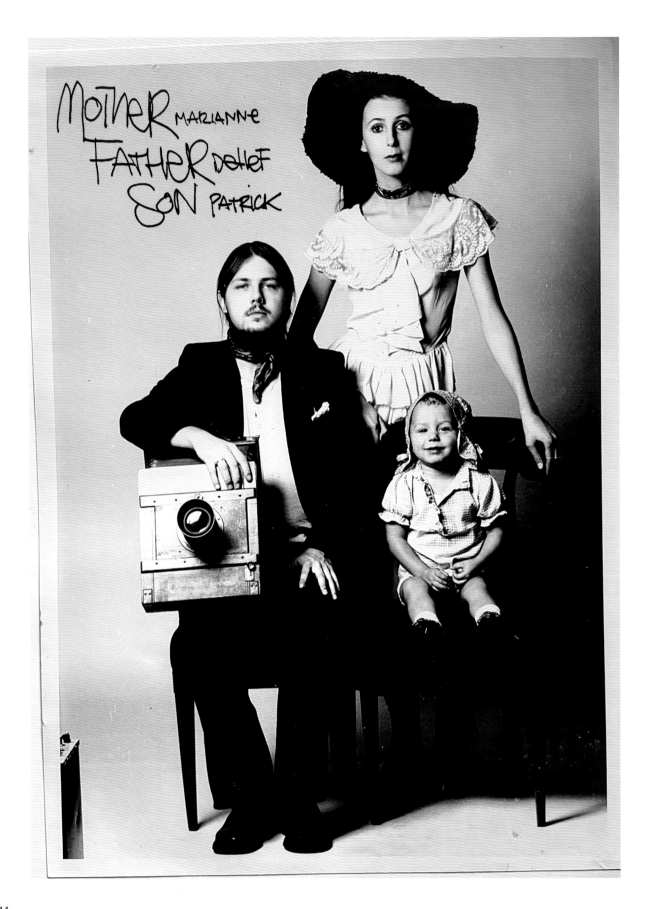

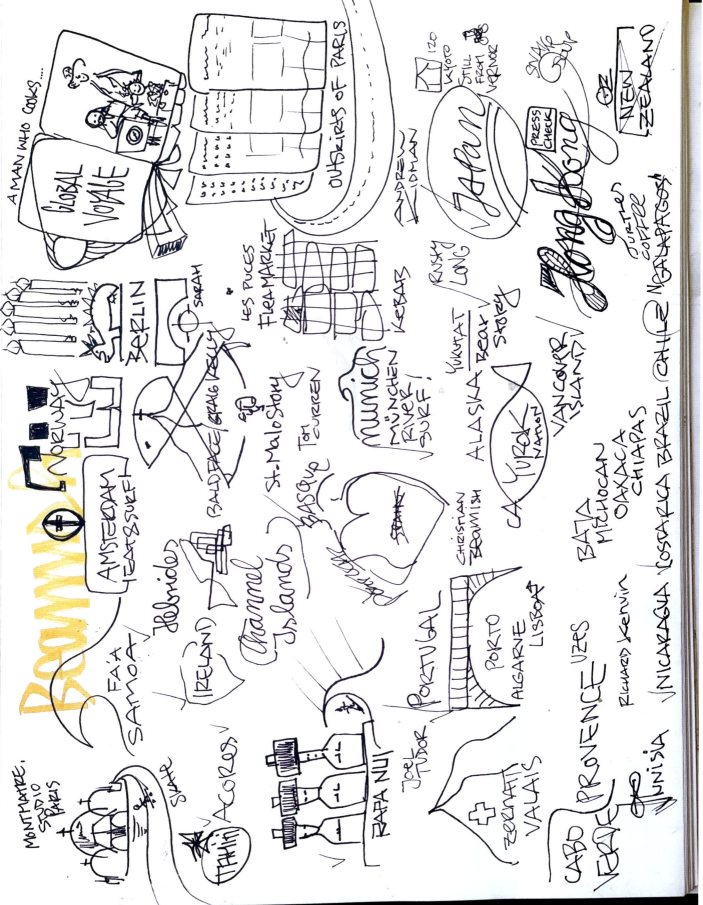

BEAMISH

Christian Beamish was the Associate Editor at The Surfer's Journal from 2004 to 2008, in which time he also built an 18-foot Shetland Isle beach boat. He then wrote "Voyage of the Cormorant" (Patagonia Books, 2012) about his single-handed expedition down the coast of Baja California aboard his self-built open boat "Cormorant." Beamish currently lives in Carpinteria, California with his wife and two children, and shapes surfboards for his company Surfboards California.

KINCH

David Kinch is an American chef and restaurateur. He owns and operates Manresa, a restaurant with strong French, Catalan, and Japanese influences, in Los Gatos, California, which was awarded three Michelin stars in 2016, and named one of the World's 50 Best Restaurants by Restaurant Magazine, in addition to America's Top 50 Restaurants by Gourmet. Kinch's culinary philosophy is fostered by the terroir, and the ingredient-driven cooking and modern technique he has studied around the world.

DENEVAN

Jim Denevan is a world-renowned American artist. In 1999, he founded Outstanding in the Field, a radical reconceptualization of the dining experience at the forefront of the sustainability movement that has gained global cult status. Denevan interacts with the earth's topography to create entirely site-specific works in sand, earth, and ice, which can span miles. Ephemeral in nature, the near meditative practice is the purpose for Denevan, who relying on intuition and parallax over measurement aids, creates mathematically and geometrically complex compositions and leaves them prone to the tides, winds and seasonal progressions. Unexpectedly confronted with the works in a natural setting, viewers are invited to interact with art beyond institutional walls. Denevan has been commissioned to create land drawings across the world, including for Desert X AlUla in 2022, and documentation of his work has been featured in the Vancouver Sculpture Biennale, Yerba Buena Center for the Arts, the Peabody Essex Museum, Christie's and MoMA/PS1. He was the subject of the recent documentary, Man in the Field: The Life and Art of Jim Denevan by Patrick Trefz. An avid surfer, Denevan is from Santa Cruz, California.

"Thanks for the support from my good friends at H&H Fish & Dirty Girl Farms

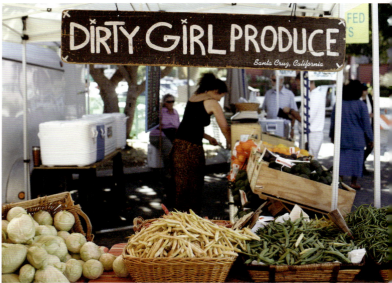

NOTES

ARGENTINA

1. "The History of Abuelas de Plaza de Mayo," Abuelas de Plaza de Mayo, last accessed April 2023, https://abuelas.org.ar/idiomas/english/history.htm.

2. "Appendix: Timeline of Argentine Political History," in Antonius C. G. M. Robben, *Argentina Betrayed* (Philadelphia: University of Pennsylvania Press, 2018).

3. Luis Abel Orquera, "Advances in the Archaeology of the Pampa and Patagonia," *Journal of World Prehistory* 1 no. 4 (1987): 333–413, http://www.jstor.org/stable/25800531.

4. Silvio R. Duncan Baretta and John Markoff, "Civilization and Barbarism: Cattle Frontiers in Latin America," *Comparative Studies in Society and History* 20 no. 4 (1978): 587–620, https://doi.org/10.1017/s0010417500012561.

5. Ezequiel Adamovsky, "La Cuarta Función del Criollismo y las Luchas por la Definición del Origen y El Color del Ethnos Argentina (Desde las Primeras Novelas Gauchescas hasta C. 1940)," *Boletín del Instituto de Historia Argentina y Americana* 3 no. 41(2014): 50–92, http://www.scielo.org.ar/pdf/bihaar/n41/n41a02.pdf.

6. Rosemary, "What Is an Asado? An Authentic Experience in the Pampas of Argentina," *Authentic Food Quest*, August 10, 2021, https://www.authenticfoodquest.com/our-first-asado-in-the-pampas/.

7. Lucy Bell, "Narrative, Nature, Society: The Network of Waste in Andrés Neuman's Bariloche," *The Modern Language Review* 110 no. 4 (October 2015): 1045–66, https://www.jstor.org/stable/10.5699/modelangrevi.110.4.1045.

8. "San Carlos de Bariloche," Place and See, last accessed April 2023, https://placeandsee.com/wiki/san-carlos-de-bariloche.

AUSTRALIA

1. Bruce Chatwin, *What Am I Doing Here* (New York: Penguin Books, 1990).

2. Martin Gray, "Mount Wollumbin," *World Pilgrimage Guide*, Sacred Sites, last accessed April 2023, https://sacredsites.com/oceania/australia/mount_wollumbin.html.

3. Robert Fuller, "The Astronomy and Songline Connections of the Saltwater Aboriginal Peoples of the New South Wales Coast," (PhD diss., University of New South Wales, 2020), https://doi.org/10.26190/unsworks/22143.

4. Alan Rumsey, "Tracks, Traces, and Links to Land in Aboriginal Australia, New Guinea, and Beyond," in *Emplaced Myth*, eds. Alan Rumsey and James F. Weiner (Honolulu: University of Hawaii Press, 2001).

5. Lynne Malcolm and Olivia Willis, "Songlines: The Indigenous Memory Code," *ABC News*, July 8, 2016, https://www.abc.net.au/radionational/programs/allinthemind/songlines-indigenous-memory-code/758178.

6. Jodi Edwards, Robert S. Fuller, and Graham Moore, "'Singing up Country': Reawakening the Black Duck Songline, Across 300km in Australia's Southeast," *The Conversation*, October 5, 2021, https://theconversation.com/singing-up-country-reawakening-the-black-duck-songline-across-300km-in-australias-southeast-167704.

7. Barbara Santich, "Nineteenth-Century Experimentation and the Role of Indigenous Foods in Australian Food Culture," *The Australian Humanities Review* no. 51 (November 2011), http://australianhumanitiesreview.org/2011/11/01/nineteenth-century-experimentation-and-the-role-of-indigenous-foods-in-australian-food-culture.

8. Tony Barta, "Relations of Genocide: Land and Lives in the Colonization of Australia," in *Genocide: Volume II*, ed. Adam Jones (London: SAGE Publications, 2008).

9. John Newton, "Terra Nullius, Culina Nullius: The Contradictions of Australian Food Culture," (PhD diss., University of Technology Sydney, 2014), https://opus.lib.uts.edu.au/bitstream/10453/36014/10/02whole.pdf.

10. Matt Mitchell, "Crocodile Laksa, Green Ant Cheesecake: It's Happening," *GRAM*, May 17, 2018, https://grammagazine.com.au/crocodile-laksa-green-ant-cheesecake-its-happening/.

11. "A History of the Meat Pie*,*" *The Freshly Baked Blog*, Ferguson Plarre's Bakehouse, April 9, 2020, https://www.fergusonplarre.com.au/blog/history-of-meat-pie.

AZORES

1. William L. Blink, "Spirits and Rocks: An Azorean Myth, *Journal of Religion & Film* 25 no. 1 (April 2021), https://doi.org/10.32873/uno.dc.jrf.25.01.033.

2. Ana Salgueiro, "Encounters and Silence between Fathers and Sons: G. T. Didial and J. M. Coetzee," *Journal of Lusophone Studies* 1 no. 1 (2016): 7–24, https://doi.org/10.21471/jls.v1i1.44.

3. Joey Carlson and Jamal Shoulders, "Atlantis: An Investigation," ArcGIS StoryMaps, May 19, 2021, https://storymaps.arcgis.com/stories/0300024558a44273920ac5112095fbaf.

4. Pedro M. Raposeiro, et al., "Climate Change Facilitated the Early Colonization of the Azores Archipelago During Medieval Times," *Proceedings of the National Academy of Sciences* 118 no. 41 (October 2021), https://doi.org/10.1073/pnas.2108236118.

5. "Faial Island History," Azores.com, last accessed April 24, 2023, https://azores.com/azores/islands/faial/history.

6. "The Aircraft Known to the Azores Islands," WOPA+ Stamps and Coins, last accessed April 24, 2023, https://www.wopa-plus.com/en/stamps/product/&pgid=13768.

BASQUE COUNTRY NORTH

1. Javi Amezaga, "The Pioneers of Surfing in the Basque Country," *Basque Tribune*, March 3, 2017, http://basquetribune.com/the-pioneers-of-surfing-in-the-basque-country/.

2. "Joël de Rosnay: Surfer and Futurist, a Look Back," Foundation Europe, September 3, 2014, https://surfrider.eu/sinformer/actualites/joel-rosnay-surfer-and-futurist-look-back-121397255286.html.

3. Bob Green, "A Paipo Interview with Javier Arteche: El Txampero in Spain," MyPaipoBoards, email interview, September 20, 2011, https://mypaipoboards.org/interviews/JavierArteche/JavierArteche_2012-0114.shtml.

BASQUE COUNTRY SOUTH

1. Maite Ibañez, et al., "1862: The First Blast Furnace in Gipuzkoa," in *Burdinaren Industria/La industria del hierro* (Gipuzkoa: Bertan, 2001), http://bertan.gipuzkoakultura.net/es/16/en/7.php.

2. Editors of Encyclopaedia Britannica, "Álava," Britannica, accessed January 23, 2023, https://www.britannica.com/place/Alava.

3. Werner Hofmann, "Picasso's 'Guernica' in Its Historical Context," *Artibus et Historiae* 4 no. 7 (1983): 141–69, https://doi.org/10.2307/1483186.

4. Anna Bitong, "The Mysterious Origins of Europe's Oldest Language," *BBC Travel*, BBC, July 24, 2017, https://www.bbc.com/travel/article/20170719-the-mysterious-origins-of-europes-oldest-language.

5. "Timeline: Eta Campaign," May 16, 2019, *BBC News*, BBC, https://www.bbc.com/news/world-europe-11181982.

6. "Basque Country DOs," Spanish Wines, accessed January 23, 2023, https://www.spanish-wines.org/basque-country.html.

BRAZIL

1. Russell White, "Brazil: Pixação São Paulo's Urban Calligraphy," Latin America Bureau, May 17, 2016, https://lab.org.uk/brazil-pixacao-sao-paulo.

2. Chris Guiton, "Architecture and Socialism," Culture Matters, April 13, 2017, https://www.culturematters.org.uk/index.php/arts/architecture/item/2500-architecture-and-socialism.

3. C. W. Minkel, Ronald Milton Schneider, and Aureliano Leite, "São Paulo," Encyclopedia Britannica, last accessed September 5, 2022, https://www.britannica.com/place/Sao-Paulo-Brazil.

4. Alex Atala,*Fine Dining Lovers*, S. Pellegrino and Acqua Panna, last accessed April 25, 2023, https://www.finedininglovers.com/people/alex-atala.

5. "Pastel," *Taste Atlas*, last accessed May 24, 2023, https://www.tasteatlas.com/pastel.

6. "Hand-Rolled Sushi Gets Brazilian Makeover," *The Japan Times*, August 7, 2014, https://www.japantimes.co.jp/culture/2014/08/07/entertainment-news/hand-rolled-sushi-gets-brazilian-makeover/.

7. "The Story of Feijoada," Unbland, January 14, 2021, https://unbland.co/en/the-story-of-feijoada/#.

8. Shaylyn Esposito, "How to Make Feijoada, Brazil's National Dish, Including a Recipe from Emeril Lagasse," *Smithsonian Magazine*, June 13, 2014, https://www.smithsonianmag.com/arts-culture/Celebrate-Brazil-with-Emerils-Feijoada-180951699/.

9. Georgia Grimond, "Brazil's Goddess of the Sea: Everything You Need to Know about Festival of Iemanjá," Culture Trip, April 12, 2022, https://theculturetrip.com/south-america/brazil/articles/brazils-goddess-of-the-sea-everything-you-need-to-know-about-festival-of-iemanja/.

10. Emily Witt, "Cleaning up after the Bolsonaristas in Brasília," *The New Yorker*, January 13, 2023, https://www.newyorker.com/news/dispatch/cleaning-up-after-the-bolsonaristas-in-brasilia.

CABO VERDE

1. Howard W. French, "Built on the Bodies of Slaves: How Africa Was Erased from the History of the Modern World," *The Guardian*, October 12, 2021, https://www.theguardian.com/news/2021/oct/12/africa-slaves-erased-from-history-modern-world.

2. "History," Capeverde.com, last accessed April 25, 2023, https://www.capeverde.com/about/history/.

3. "Cabo Verde," South African History Online, last accessed April 25, 2023, https://www.sahistory.org.za/place/cabo-verde.

4. George E. Brooks, "Cabo Verde: Gulag of the South Atlantic: Racism, Fishing Prohibitions, and Famines," *History in Africa* 33 (2006): 101–35, https://www.jstor.org/stable/20065767.

5. Lucy Burnett, "Amílcar Lopes Cabral (1924–1973)," BlackPast, August 10, 2009, https://www.blackpast.org/global-african-history/cabral-amilcar-lopes-1924-1973/.

6. Katherine Carter and Judy Aulette, "Batuku Dance as Resistance," in *Cape Verdean Women and Globalization,* Katherine Carter and Judy Aulette (New York: Palgrave MacMillan, 2009), 121–33.

7. Cesária Évora, "Paraiso di Atlantico," *Café Atlantico*, Lusafrica, 1999, https://open.spotify.com/album/69n9wWU4RiRlGodIl9vgnV.

8. Brooks, "Cabo Verde."

9. David Joseph Alpert, "A Study of Cape Verdeanness in Postcolonial Cape Verdean Poetry," (MA thesis, Rhode Island College, 2013), https://digitalcommons.ric.edu/cgi/viewcontent.cgi?article=1065&context=etd.

CANADA: BRITISH COLUMBIA

1. Leah Siegel, "War Resisters in B.C.," *British Columbia: An Untold History*, Knowledge.CA, last accessed April 25, 2023, https://bcanuntoldhistory.knowledge.ca/1960/war-resisters-in-bc.

2. Karen Wonders, "Kwakwaka'wakw," First Nations, last accessed April 25, 2023, http://www.firstnations.de/fisheries/kwakwakawakw.htm.

3. Harriet V. Kuhnlein and Murray M. Humphries, "Salmon," in *Traditional Animal Foods of Indigenous Peoples of Northern North America*, Centre for Indigenous Peoples' Nutrition and Environment (CINE), (Montreal: McGill University, 2017), http://traditionalanimalfoods.org/fish/searun-fish/page.aspx?id=6446.

4. Marjorie Mitchell, review of *Coast Salish Essays* by Wayne Suttles, *BC Studies* no. 82 (Summer 1989): https://ojs.library.ubc.ca/index.php/bcstudies/article/view/185885/185191.

5. "Okanagan Sockeye Salmon," *Slow Food*, Slow Food Foundation for Biodiversity, accessed January 23, 2023, https://www.fondazioneslowfood.com/en/slow-food-presidia/okanagan-sockeye-salmon/.

6. Ruth Kirk, *Tradition and Change on the Northwest Coast* (Seattle: University of Washington Press, 1988).

7. Deidre Sanders Cullon, "Dancing Salmon: Human-fish Relationships on the Northwest Coast," (PhD diss., University of Victoria, 2017), https://dspace.library.uvic.ca/bitstream/handle/1828/8814/Cullon_Deidre_Sanders_PhD_2017.pdf?sequence=1.

8. Leyland Cecco, "Thousands of Salmon Found Dead as Canada Drought Dries Out River," *The Guardian,* October 5, 2022, https://www.theguardian.com/environment/2022/oct/05/canada-dead-salmon-drought-british-columbia.

CHILE

1. Alina Mizrahi, "Support for Authoritarianism: The Case of Augusto Pinochet," *CUREJ: College Undergraduate Research Electronic Journal* (January 2020), https://repository.upenn.edu/cgi/viewcontent.cgi?article=1290&context=curej.

2. Peter Kornbluh, "Chile and the United States: Declassified Documents Relating to the Military Coup, September 11, 1973," National Security Archive, https://nsarchive2.gwu.edu/NSAEBB/NSAEBB8/nsaebb8i.htm.

3. Pablo Neruda, "Cuándo de Chile," Fundación de Neruda, Universidad de Chile, https://neruda.uchile.cl/obra/obrauvasyelviento6.html.

4. S. C. Montecino Aguirre, "Identidades, Mestizajes y Diferencias Sociales en Osorno, Chile: Lecturas Desde la Antropología de la Alimentación," (PhD diss., Leiden University, 2006), https://scholarlypublications.universiteitleiden.nl/handle/1887/4864.

5. H. D. Miller, "Mote con Huesillos on Cerro San Cristóbal," *An Eccentric Culinary History*, last accessed on April 25, 2023, https://eccentricculinary.com/mote-con-huesillos-the-drink-of-chile.

6. Kate Pilcher, "The Huasos of Chile," Globe Trotting, July 22, 2018, last accessed April 27, 2023, https://www.globetrotting.com.au/the-huasos-of-chile.

7. Zach Lazzari, "Chile's Whole-Lamb, Open-Fire Asados Put Your Local Barbecues to Shame," *GuideGeek*, Matador Network, December 6, 2018, https://matadornetwork.com/read/chile-asados-barbecue/.

8. Mike Benayoun, "Pebre," *196 Flavors*, December 16, 2018, https://www.196flavors.com/chile-pebre/.

9. José Toribio Medina, *Los Restos Indígenas de Pichilemu* (Santiago de Chile: Imprenta Cervantes, 1908), https://dbpedia.org/page/Los_Restos_Ind%C3%ADgenas_de_Pichilemu.

CHINA

1. MattB, "The Silver Dragon: Qiantang River Tidal Bore," *Atlas Obscura*, July 31, 2013, https://www.atlasobscura.com/places/the-silver-dragon-qiantang-river-tidal-bore-jiaxing-china.

2. Frank Langfitt, "Riding the 'Silver Dragon,' Surfers Tame China's 10-Foot River Waves," *All Things Considered*, NPR, September 12, 2014, https://www.npr.org/sections/parallels/2014/09/12/347950272/riding-the-silver-dragon-surfers-tame-chinas-10-foot-river-waves.

3. Matthew B. Shaw, "Were People in China Riding Waves Over 1,000 Years Ago?" *Surfer*, October 2, 2019, https://www.surfer.com/features/children-of-the-tide-reveals-history-of-surfing-in-china.

4. Fercility Jiang, "Song Dynasty History (960–1279), China Highlights, updated January 4, 2022, https://www.chinahighlights.com/travelguide/china-history/the-song-dynasty.htm.

5. SiLin Ye, "History of Restaurant and Its Significance in Song Dynasty," ArcGIS StoryMaps, December 22, 2019, https://storymaps.arcgis.com/stories/cb1661ba8f4b4c84bde8058e205739fc.

6. Andrew Amelinckx, "A Brief History of Peking Duck," *Modern Farmer*, June 19, 2015, https://modernfarmer.com/2015/06/a-brief-history-of-peking-duck/.

7. Sally Gao, "A Brief History of Peking Duck," Culture Trip, December 6, 2016, https://theculturetrip.com/asia/china/articles/a-brief-history-of-peking-duck/.

8. Curtis Ashton, "Beijing Duck 2008: Culinary Tourism, Cultural Performance, and Heritage Protection," *Folklore Forum*, April 20, 2011, https://folkloreforum.net/2011/04/20/beijing-duck-2008.

COSTA RICA

1. Virginia S. Williams, Roger Peace, and Jeremy Kuzmarov, "Central America Wars, 1980s," United States Foreign Policy History and Resource Guide, updated January 2022, http://peacehistory-usfp.org/central-america-wars.

2. Kent Britt, "Costa Rica Steers the Middle Course," *National Geographic* 160 no. 1 (July 1981).

3. Clyde Stephens, "Impacts of the United Fruit Company in Southwest Costa Rica," *Stapfia* 88 (2008): 635–44, https://www.zobodat.at/pdf/STAPFIA_0088_0635-0644.pdf.

4. "History of Tamarindo: Development of Tourism and Real Estate," RE/MAX Ocean Surf & Sun, 2023, https://www.remax-oceansurf-cr.com/tamarindo-history-and-development.

5. Jean McNeil and Keith Drew, *The Rough Guide to Costa Rica* (UK: Rough Guides, 2014).

6. Carlos Camacho-Nassar, "Indigenous World 2020: Costa Rica," in *The Indigenous World 2020*, ed. Dwayne Mamo, (Denmark: International Work Group

for Indigenous Affairs, 2020), https://www.iwgia.org/en/costa-rica/3619-iw-2020-costa-rica.html.

7. Theresa Preston-Werner, "Gallo Pinto: Tradition, Memory, and Identity in Costa Rican Foodways," *Journal of American Folklore* 122 no. 48 (Winter 2009): 11–27, https://muse.jhu.edu/pub/25/article/256967.

8. Esteban Cabezas Bolaños and Ana M. Espinoza Esquivel, "El Arroz en América: Su Introducción y Primeras Siembras," *Revista de Historia de América*, 126 (January–June 2000): 7–8, https://www.proquest.com/docview/235924848.

EASTER ISLAND

1. John Loret and John T. Tanacredi, eds., *Easter Island: Scientific Exploration into the World's Environmental Problems in Microcosm* (New York: Kluwer Academic/Plenum Publishers, 2003), 157, 167–168.

2. Audrey Benedict, "ePostcard #29: Rock-Boring Sea Urchins (Easter Island, Chile)," *ePostcards*, Cloud Ridge Naturalists & Cloud Ridge Publishing, April 26, 2020, https://www.cloudridge.org/epostcard29-rock-boring-sea-urchins-easter-island/.

3. "Easter Island (Rapa Nui)—Rano Raraku," World Monuments Fund, last accessed April; 26, 2023, https://www.wmf.org/project/easter-island-rapa-nui—rano-raraku.

4. Jessica Wolf, "Unearthing the Mystery of the Meaning of Easter Island's Moai," *UCLA Newsroom*, December 12, 2019, https://newsroom.ucla.edu/releases/moai-easter-island-meaning-food.

5. Sarah C. Sherwood, et al., "New Excavations in Easter Island's Statue Quarry: Soil Fertility, Site Formation and Chronology," *Journal of Archaeological Science* 111 (November 2019), https://doi.org/10.1016/j.jas.2019.104994.

6. "Moving the Statues," The Easter Island Foundation, last accessed April 26, 2023, https://islandheritage.org/intro-to-easter-island/moving-the-statues/.

7. Benjamin Lowy, "Reveling in the Enigmatic Beauty of Easter Island," *The New York Times*, April 27, 2020, updated May 7, 2020, https://www.nytimes.com/2020/04/27/travel/easter-island.html.

8. Pew Bertarelli Ocean Legacy Project, "Vaikava Rapa Nui: Easter Island's Rapa Nui People Uphold Tradition as Guardians of the Ocean," *Pew*, The Pew Charitable Trusts, July 20, 2020, https://www.pewtrusts.org/en/research-and-analysis/fact-sheets/2020/07/vaikava-rapa-nui.

9. "Tapu Rapa Nui, the Concept of the Sacred and Forbidden on Easter Island," Imagina Rapa Nui Easter Island, https://imaginarapanui.com/en/tapu-rapa-nui-the-concept-of-the-sacred-and-forbidden-on-easter-island/.

10. "Tavake Pakomio: Learning from Our Ancestors," PARLEY, last accessed April 26, 2023, https://www.parley.tv/updates/2020/3/23/parley-exxpedition-ancestors-rapa-nui.

EL SALVADOR

1. Kevin Naughton, "Passing Time in El Salvador," *The Surfer's Journal*, 10 no. 4, undated, https://www.surfersjournal.com/editorial/the-archivist-passing-time-in-el-salvador/.

2. John Tirman, "Death Doctrine," *Guernica*, July 1, 2011, https://www.guernicamag.com/john_tirman_7_1_11/.

3. John Beverley, "El Salvador," *Social Text* no. 5 (Spring 1982): 55, https://doi.org/10.2307/466334.

4. "Indigenous Communities Commemorate 1932 Rebellion & Massacre in El Salvador," CISPES, February 5, 2016, https://cispes.org/article/indigenous-communities-commemorate-1932-rebellion-massacre-el-salvador.

5. Alejandro Ramiro Chan, "The Resilience and Resistance of the Nahuat Pipil Peoples of El Salvador," Cultural Survival, May 8, 2020, https://www.culturalsurvival.org/news/resilience-and-resistance-nahuat-pipil-peoples-el-salvador.

6. Bill Fowler, "The Pipils of El Salvador," *Teaching Central America*, Teaching for Change, last accessed April 26, 2023, https://www.teachingcentralamerica.org/pipils-el-salvador.

7. Fowler, "The Pipils of El Salvador."

8. Karla T. Vasquez, "Alguashte (Salvadoran Pumpkin Seed Seasoning) Recipe," *Serious Eats*, September 2020, updated October 5, 2022, https://www.seriouseats.com/alguashte-salvadoran-pumpkin-seed-seasoning.

9. Luis Adalberto Panameño, "Historia de La Pupusa Salvadoreña (Platillo Nacional)," January 14, 2013, RedIslam, https://web.archive.org/web/20200120103513/http://www.redislam.net/2013/01/historia-de-la-pupusa-salvadorena.html.

FRANCE

1. Lewis Piaget Shanks, "In Old Provence," *The Open Court*, 1923 no. 10 (1923), https://opensiuc.lib.siu.edu/ocj/vo11923/iss10/2/.

2. "Arena of Nîmes," Sygic Travel, last accessed April 25, 2023, https://travel.sygic.com/en/poi/arena-of-nimes-poi:24678.

3. Cynthia Dea, "Another Roman Contribution to the World? Fusion Cuisine," *KCET*, July 23, 2015, https://www.kcet.org/food-discovery/food/another-roman-contribution-to-the-world-fusion-cuisine.

4. "Pont du Gard (Roman Aqueduct)," UNESCO World Heritage Convention, last accessed April 26, 2023, https://whc.unesco.org/en/list/344.

5. Paul Sullivan, "Budget and Blowout Guide to Nîmes," *BBC Travel*, BBC, July 26, 2011, https://www.bbc.com/travel/article/20110718-budget-and-blowout-guide-to-nimes.

6. Christine Bednarz, "Who Invented the First Modern Restaurant?" *National Geographic*, March 13, 2015, https://www.nationalgeographic.com/culture/article/who-invented-the-first-modern-restaurant.

7. Madeline Puckett, "All You Ever Wanted to Know About Châteauneuf-du-Papape Wine (and More)," Wine Folly, https://winefolly.com/deep-dive/all-you-ever-wanted-to-know-about-chateauneuf-du-pape-wine-and-more/.

8. Alex Ledsom, "The Most Iconic Artists to Be Associated with Provence," Culture Trip, July 21, 2017, https://theculturetrip.com/europe/france/articles/the-most-iconic-artists-to-be-associated-with-provence/.

9. "Chef Brian Discusses the Origin of Ratatouille Niçoise," *L'Academie de Cuisine Blog*, archived from the original on October 9, 2015, https://web.archive.org/web/20151009192347/https://www.lacademie.com/ratatouille-nicoise/.

10. Anthony F. Buccini, "Western Mediterranean Vegetable Stews and the Integration of Culinary Exotica," in *Authenticity in the Kitchen: Proceedings of the Oxford Symposium on Food and Cookery 2005*, ed. Richard Hosking (Devon: Prospect Books, 2005).

11. Tatiana Eva Marie, "Personal Essay: Sojourn through Romani Culture," *Quail Bell Magazine*, August 5, 2015, http://www.quailbellmagazine.com/the-real/personal-essay-sojourn-through-romani-culture.

12. "Gypsy's Pilgrimage in Les Saintes Maries de La Mer," Avignon & Provence, Office de Tourisme Les Saintes Maries, https://www.avignon-et-provence.com/en/traditions/gypsys-pilgrimage-saintes-maries-de-mer.

13. Ronald Lee, "The Romani Goddess Kali Sara," *Kopachi.com*, https://kopachi.com/articles/the-romani-goddess-kali-sara-ronald-lee/.

GALÁPAGOS ISLANDS

1. "Discovery of Galapagos," Discovering Galapagos, Galapagos Conservation Trust, last accessed April 26, 2023, https://www.discoveringgalapagos.org.uk/tag/fray-tomas-de-berlanga/.

2. Ian Tattersall, "Charles Darwin and Human Evolution," *Evolution: Education and Outreach* 2 no. 9 (December 2008): 28–34, https://doi.org/10.1007/s12052-008-0098-8.

3. "Galapagos Short-Eared Owl," Galapagos Conservation Trust, last accessed April 26, 2023, https://galapagosconservation.org.uk/wildlife/galapagos-short-eared-owl/.

4. "Galapagos," New England Complex Systems Institute, last accessed April 26, 2023, https://necsi.edu/galapagos.

5. Nicholas Casey and Josh Haner, "As Seas Warm, Galápagos Islands Face a Giant Evolutionary Test," *The New York Times*, December 18, 2018, https://www.nytimes.com/interactive/2018/12/18/climate/galapagos-islands-ocean-warming.html.

6. "Centenary of Darwin's Visit to the Galapagos Archipelago," *Nature* 136 (September 1935), https://doi.org/10.1038/136506b0.

7. "Typical Dishes of the Galapagos Islands," *Astelus*, last accessed April 26, 2023, https://en.astelus.com/platos-tipicos-de-galapagos/.

8. Frank J Sulloway, "The Evolution of Charles Darwin," *Smithsonian Magazine*, December 2005, https://www.smithsonianmag.com/science-nature/the-evolution-of-charles-darwin-110234034/.

GERMANY

1. C. G., "Berlin's Boulevard of Dreams: The 125th Anniversary of Germany's Champs-Elysées," *The Economist*, May 27, 2011. https://www.economist.com/prospero/2011/05/27/berlins-boulevard-of-dreams.

2. Andrew Dickson, "Culture in Weimar Germany: On the Edge of the Volcano," *Discovering Literature*, The British Library, May 25, 2016, https://www.bl.uk/20th-century-literature/articles/on-the-edge-of-the-volcano-culture-in-weimar-germany.

3. Thijs Porck, "Lucky Pigs and Protective Boars: The Medieval Origins of the Glücksschwein," *Leiden Medievalists Blog*, Universiteit Leiden, October 13, 2017, https://www.leidenmedievalistsblog.nl/articles/lucky-pigs-and-protective-boars-the-medieval-origins-of-the-gluecksschwein.

4. Angela Schofield, "German Fried Potatoes: Crispy Potatoes That Everybody Loves," *All Tastes German*, February 13, 2018, updated March 8, 2022, https://alltastesgerman.com/german-fried-potatoes/.

5. "Real Food Encyclopedia: Brussels Sprouts," *FoodPrint*, GRACE Communications Foundation, last accessed April 26, 2023, https://foodprint.org/real-food/brussels-sprouts/.

6. "The History of Brussels Sprouts," *The Kitchen Project*, https://kitchenproject.com/history/BrusselsSprouts/index.htm.

GREECE

1. Daniel Ogden, ed., *A Companion to Greek Religion* (Malden, MA: Wiley-Blackwell, 2010).

2. Andrew Dalby, *Siren Feasts: A History of Food and Gastronomy in Greece* (London: Routledge, 1997).

3. "Cook a Classical Feast: Nine Recipes from Ancient Greece and Rome," *The British Museum* (blog), June 18, 2020, https://www.britishmuseum.org/blog/cook-classical-feast-nine-recipes-ancient-greece-and-rome.

4. "Greek Olive Oil and History," Greek Brands, last accessed April 27, 2023, https://www.greek-olive-oil.com/history.html.

5. Sarah Thomas and Debby Sneed, "The Social and Economic Value of Oil in Ancient Greece," Department of Classics, University of Colorado, Boulder, June 15, 2018, https://www.colorado.edu/classics/2018/06/15/social-and-economic-value-oil-ancient-greece.

6. Diane Kochilas, "Olive Oil in Greek Orthodoxy," *My Greek Table*, October 14, 2011, https://www.dianekochilas.com/olive-oil-in-greek-orthodoxy/.

7. Mike Millard, "Corfu, Homer's Odyssey and Odysseus' Petrified Ship," *Greek Reporter*, March 17, 2022, updated January 28, 2023, https://greekreporter.com/2022/03/17/corfu-homer-odyssey-odysseus-petrified-ship/.

8. "Olive Groves of Corfu," Greek Gastronomy Guide, June 22, 2016, last accessed April 26, 2023, https://www.greekgastronomyguide.gr/en/item/elaiones-kerkyra/.

9. "Kokoretsi," Gastronomy Tours, accessed January 26, 2023, https://gastronomytours.com/encyclopedia/kokoretsi/.

10. Despina Trivolis, "The Chops Shops of Downtown Athens," Culinary Backstreets, September 28, 2012, updated July 12, 2021, https://culinarybackstreets.com/cities-category/athens/2021/the-chops-shops-of-downtown-athens/.

GUATEMALA

1. Christian Díaz, "Quetzaltenango: A Story of Three Names and Three Exoduses," EntreMundos, May 15, 2020, updated June 24, 2020, https://www.entremundos.org/revista/culture/quetzaltenango-a-story-of-three-names-and-three-exoduses/?lang=en.

2. "Mayan Cosmovision: Rural and Community Tourism in Guatemala. 21 Days & 20 Nights," *Adrenalina Tours*, October 2017, https://adrenalinatours.com/wp-content/uploads/2017/10/MAYAN-COSMOVISION.pdf.

3. Michele Peterson, "Kak'ik: Guatemalan Turkey Soup," *A Taste for Travel*, November 15, 2020, updated July 22, 2022, https://www.atastefortravel.ca/19859-kakik-guatemalan-turkey-soup/.

4. "Kak'ik," *Prensa Libre*, September 30, 2013, https://www.prensalibre.com/vida/escenario/que-bueno-es-mi-pais-por-su-sabor-recetas-chapinas-gastronomia-guatemalteca-kak-ik-0-1002500018/.

5. Rachel Rummel, "Chile Cobanero," *Atlas Obscura*, last accessed April 27, 2013, https://www.atlasobscura.com/foods/chile-cobanero.

6. Ana Luisa Izquierdo y de la Cueva and María Elena Vega Villalobos, "The Ocellated Turkey in Maya Thought," *PARI Journal* 16 no.4 (Spring 2016): 15–23, https://www.mesoweb.com/pari/publications/journal/1604/OcellatedTurkey.pdf.

7. "Achiote as Red Dye and Flavoring for Cacao Beverage for Maya and Aztec," Maya Archaeology, January 2008, updated May 25, 2010, https://www.maya-archaeology.org/pre-Columbian_Mesoamerican_Mayan_ethnobotany_Mayan_iconography_archaeology_anthropology_research/achiote_Bixa_orellana_annatto_cacao_drink_red_dye_coloring.php.

HONG KONG SAR

1. John M. Carroll, *A Concise History of Hong Kong* (Hong Kong [SAR]: Hong Kong University Press, 2007).

2. "Possession Street," China Tours Net, accessed January 26, 2023, https://www.chinatoursnet.com/hongkong-travel-guide/attraction/possession-street.html.

3. "Hong Kong's Food Culture," Hong Kong [SAR] Heritage Museum, n.d., https://www.heritagemuseum.gov.hk/documents/2199315/2199693/Hong_Kong_Food_Culture-E.pdf.

4. Roger Tin Sing Kho, "Revival of Chinese Calligraphy in Hong Kong [SAR]'s Architecture," in *Creativity and Culture in Greater China: The Role of Government, Individuals and Groups*, eds. Chi-Cheung Leong and Sonny Shiu-Hing Lo, e-book, (Piscataway: Transaction Publishers, 2015).

5. Sally Gao, "How to Order at a Cha Chaan Teng in Hong Kong [SAR[," Culture Trip, December 16, 2019, https://theculturetrip.com/asia/china/hong-kong/articles/how-to-order-at-a-cha-chaan-teng-in-hong-kong/.

6. James Crawford, "The Strange Saga of Kowloon Walled City [SAR]," *Atlas Obscura*, January 6, 2020, https://www.atlasobscura.com/articles/kowloon-walled-city

7. Time Out Hong Kong [SAR], "Must-Try Dai Pai Dongs and Their Essential Dishes," Hong Kong SAR Tourism Board, accessed January 26, 2023, https://www.discoverhongkong.com/us/explore/dining/must-try-dai-pai-dongs-and-their-essential-dishes.html.

8. "Hong Kong's Food Culture," Hong Kong [SAR] Heritage Museum, https://www.heritagemuseum.gov.hk/documents/2199315/2199693/Hong_Kong_Food_Culture-E.pdf.

IRELAND

1. Máirtín Mac Con Iomaire and Pádraic Óg Gallagher, "The Potato in Irish Cuisine and Culture," *Journal of Culinary Science & Technology* 7 no. 2–3 (2009): 152–67, https://www.tandfonline.com/doi/abs/10.1080/15428050903313457.

2. "The Story of Guinness," Guinness Storehouse, last accessed April 27, 2023, https://www.guinness-storehouse.com/en/discover/story-of-guinness.

3. John Linnane, "A History of Irish Cuisine," *Ravensgard*, last updated February 19, 2000, http://www.ravensgard.org/prdunham/irishfood.html.

4. Jessica Smyth and Richard P. Evershed, "The Molecules of Meals: New Insight into Neolithic Foodways," *Proceedings of the Royal Irish Academy* 115C (April 2015): 27–46, https://doi.org/10.3318/priac.2015.115.07.

5. Dorothy Cashman and John Farrelly, "'Is Irish Stew the Only Kind of Stew We Can Afford to Make, Mother?' The History of a Recipe," *Folk Life: Journal of Ethnological Studies* 59 no. 2 (2021): 81–100, https://doi.org/10.1080/04308778.2021.1957420.

6. Peggy Trowbridge Filippone, "Irish History in a Long-Simmered Stew," *The Spruce Eats*, updated October 18, 2019, https://www.thespruceeats.com/irish-stew-history-1807616.

ITALY

1. Peter Kessler and Edward Dawson, "Salassi (Gauls/Celto-Ligurians?)," The History Files, last accessed April 27, 2023, https://www.historyfiles.co.uk/KingListsEurope/BarbarianSalassi.htm.

2. Peter Kessler, "Taurini (Ligurians)," The History Files, last accessed April 27, 2023, https://www.historyfiles.co.uk/KingListsEurope/BarbarianTaurini.htm.

3. "Top Three Roman Sites in Piedmont," *Italy Magazine*, , October 20, 2016, https://www.italymagazine.com/featured-story/top-three-roman-sites-piedmont.

4. "The Cultural Influences on Italian Cuisine," Cucina Toscana, https://toscanaslc.com/blog/the-cultural-influences-on-italian-cuisine/; "Ancient Roman Cuisine," Cameler Spice Company, last accessed June 22, 2023, https://camelerspiceco.com/blogs/blog/ancient-roman-cuisine.

5. Paul Zinsli, "The Walser: Migrant Farmers Who Settled in High Places," *The UNESCO Courier: A Window Open on the World*, February 1987, UNESCO Digital Library, https://unesdoc.unesco.org/ark:/48223/pf0000072246.

6. "Legends, Traditions and Songs," *Alagna*, (blog), n.d., https://www.alagna.it/en/the-walser-today/legends-traditions-and-songs/.

7. Great Walser Trail," n.d. The Alps, https://www.thealps.com/trekking/great-walser-trail.

8. Adriano Ravera and Elma Schena, "Walser Cuisine: A German Speaking Community in Northwest Italy," Walking Palates, March 19, 2021, https://www.walkingpalates.com/en-UK/walser-cuisine.php.

9. Phyllis Quinn, "Baccala (Salt Cod Stew)," *Ask Chef Phyllis,* Selene River Press, February 16, 2018, https://www.seleneriverpress.com/baccala-salt-cod-stew/.

10. "Piedmont and the Valle D'Aosta," in *The Food of Italy*, Waverley Root (New York: Vintage Books, 1992), 311–348; Daniel Gritzer, "Bagna Càuda," *Serious Eats*, April 27, 2023, https://www.seriouseats.com/bagna-cauda-northern-italian-anchovy-garlic-dip.

11. Justin Demetri, "Riso & Risotto," Life in Italy, February 12, 2019, https://lifeinitaly.com/riso-risotto/; Kim Pierce, "The Holy Grail of Creamy Rice: How the Italians of Piedmont Make the Perfect Risotto," *Dallas Morning News*, April 30, 2019, https://www.dallasnews.com/food/cooking/2019/04/30/the-holy-grail-of-creamy-rice-how-the-italians-of-piedmont-make-the-perfect-risotto/.

12. "Coniglio alla Cacciatora," Taste Atlas, last accessed April 27, 2023, https://www.tasteatlas.com/coniglio-alla-cacciatora.

JAPAN

1. "The Roots of Yoshoku," Plenus, https://kome-academy.com/en/roots/.

2. "History, Meaning and Definition of Shippoku-ryori," Piece of Japan, https://piece-of-japan.com/eating/full-course-meal/shippoku-ryori.html.

3. Kenneth Goh, "5 Local Specialties That You Need to Try in Nagasaki," *Michelin Guide*, August 10, 2019, https://guide.michelin.com/sg/en/article/travel/5-local-specialities-that-you-need-to-try-in-nagasaki.

4. Tara Condell, "Eat This Word: Chawanmushi," James Beard Foundation, November 28, 2016, https://www.jamesbeard.org/blog/eat-this-word-chawanmushi.

5. "Chawan-Mushi," *Food Forum*, 29 no. 4 (January 2016). https://www.kikkoman.com/en/foodforum/japanese-style/29-4.html.

6. "Chawanmushi," Food in Japan, April 12, 2022, updated September 12, 2022, https://foodinjapan.org/kyushu/nagasaki/chawanmushi/#index_id12.

MALDIVES

1. Xavier Romero-Frias, *Folktales of the Maldives* (Copenhagen: North Institute of Asian Studies Press, 2012).

2. Xavier Romero-Frias, "Eating on the Islands," *Himalmag* 26 no. 2 (2013): 69–91, https://www.academia.edu/4398927/Eating_on_the_Islands_-_As_times_have_changed_so_has_the_Maldives_unique_cuisine_and_culture

3. "Maldivian Cuisine," *Maldives*, October 12, 2012, http://maldivianislands.blogspot.com/2012/10/maldivian-cuisine.html.

4. Naseema Mohamed, "Pre-Islamic Maldives," *Man and Environment Journal of the Indian Society for Prehistoric and Quaternary Studies* 27 no. 1 (2022) http://qaumiyyath.gov.mv/docs/whitepapers/history/Pre-Islamic%20Maldives.pdf.

5. "About Maldives," Embassy of the Maldives, last accessed April 28, 2023, https://www.maldivesembassy.be/en/about-maldives/history.

6. "Old Friday Mosque," Lonely Planet, last accessed April 28, 2023, https://www.lonelyplanet.com/maldives/male/attractions/old-friday-mosque/a/poi-sig/1440615/357012.

7. Teresa E. Dana, "The Dhivehis of the Maldives," in *International Handbook of Research on Indigenous Entrepreneurship*, eds. Léo-Paul Dana and Robert B. Anderson (Cheltenham: Edward Elgar Publishing Limited, 2007), 181–92.

8. Humaam Ali, "Buddhist Relics Found in Kalaidhoo Island," Raajje Television, March 16, 2018, https://raajje.mv/28739.

9. Tristan McConnell, "The Maldives Is Being Swallowed by the Sea. Can It Adapt?" *National Geographic*, January 20, 2022, https://www.nationalgeographic.com/environment/article/the-maldives-is-being-swallowed-by-the-sea-can-it-adapt.

MEXICO

1. *Mexico: Migration Tapachula Humanitarian Situation Report No. 1*, UNICEF, March 18, 2022, https://www.unicef.org/media/117641/file/Mexico-(Tapachula)-Humanitarian-SitRep-18-March-2022.pdf.

2. Hillary Klein, "A Spark of Hope: The Ongoing Lessons of the Zapatista Revolution 25 Years On," *NACLA*, January 18, 2019, https://nacla.org/news/2022/12/21/spark-hope-ongoing-lessons-zapatista-revolution-25-years.

3. Elizabeth H. Paris, Roberto López Bravo, and Gabriel Lalo Jacinto, "The Making of a Plaza: Public Spaces and Marketplaces at Tenam Puente, Chiapas, Mexico," *Estudios de Cultura Maya* 58 (June 2021): 45–83, https://doi.org/10.19130/iifl.ecm.2021.58.23862.

4. "Semana Cultural y Semana Santa en San Cristóbal de Las Casas," Chiapas Viajes, last accessed April 27, 2023, https://chiapas.viajes/es/guia/semana-cultural-y-semana-santa-en-san-cristóbal-de-las-casas/42.

5. Mely Martinez, "Bread Soup from Chiapas," *Mexico in My Kitchen*, October 31, 2020, updated November 1, 2020, https://www.mexicoinmykitchen.com/bread-soup-from-chiapas/.

6. Meghdad Abbasi, "History of Raisin," Iran Dried Fruit, May 26, 2019, https://www.irandriedfruit.com/raisin-history/.

NEW ZEALAND

1. Alexander Hare McClintok, "Aotearoa," *An Encyclopaedia of New Zealand*, https://doi.org/https://teara.govt.nz/en/1966/aotearoa; Stacy Morrison and Scotty Morrison, "Why Referring to New Zealand as Aotearoa Is a Meaningful Step for Travelers," *Condé Nast Traveler*, November 15, 2021, https://www.cntraveler.com/story/why-referring-to-new-zealand-as-aotearoa-is-a-meaningful-step-for-travelers.

2. S. Percy Smith, "The Canoes of 'the Fleet,'" in *History and Traditions of the Maoris of the West Coast North Island of New Zealand Prior to 1840* (New Plymouth, NZ: Polynesian Society, 1910), https://nzetc.victoria.ac.nz/tm/scholarly/tei-SmiHist-t1-body1-d5.html#n103.

3. "Māori Potatoes," Museum of New Zealand/Te Papa Tongarewa, last accessed May 19, 2023, https://www.tepapa.govt.nz/discover-collections/read-watch-play/maori/maori-potatoes.

4. "Māori Fishing Techniques," The Fishing Website, accessed May 2016, https://www.fishing.net.nz/fishing-advice/general-articles/maori-fishing-techniques/.

5. Te Ahukaramū Charles Royal and Jenny Kaka-Scott, "Traditional Growing and Gathering," Te Ara: the Encyclopedia of New Zealand, September 5, 2013, http://www.TeAra.govt.nz/en/maori-foods-kai-maori/page-1.

6. Te Ahukaramū Charles Royal, "Papatūānuku: the Land," Te Ara: the Encyclopedia of New Zealand, September 24, 2007, https://teara.govt.nz/en/papatuanuku-the-land.

7. Juliet Levesque, "The Colonial Gaze in Aotearoa New Zealand: Origins, Residue, and Means for Mitigation," *History Honors Papers* 50 (2020), https://digitalcommons.conncoll.edu/cgi/viewcontent.cgi?article=1050&context=histhp.

8. Mike Daniel, "New Zealand's Unique Burrowing Bats Are Endangered," Bat Conservation International, accessed October 30, 2022, https://www.batcon.org/article/new-zealands-unique-burrowing-bats-are-endangered/.

9. "New Zealand's First Sheep Released," New Zealand History, updated January 20, 2021, https://nzhistory.govt.nz/first-sheep-released-in-new-zealand.

10. Te Ahukaramū Charles Royal, "Loss of Land," *Te Ara: The Encyclopedia of New Zealand*, September 24, 2007, https://teara.govt.nz/en/papatuanuku-the-land/page-9.

11. Damien Cave, "With Progressive Politics on March in New Zealand, Māori Minister Blazes New Trails," *The New York Times*, November 15, 2020, updated February 10, 2021, https://www.nytimes.com/2020/11/15/world/asia/new-zealand-progressives-nanaia-mahuta.html.

12. Leone Pihama, et al., *Mana Wahine Reader: A Collection of Writings 1987–1998, Volume I* (Hamilton, Aotearoa/New Zealand: Te Kotahi Research Institute, 2019), http://www.puketeraki.nz/site/puketeraki/Māna%20Wahine%20Volume%201.pdf.

NICARAGUA

1. "Nicaragua and Iran Timeline," *Understanding the Iran-Contra Affairs*, Brown University, last accessed April 27, 2023, https://www.brown.edu/Research/Understanding_the_Iran_Contra_Affair/timeline-n-i.php.

2. "The Counterrevolutionaries ('the Contras')," *Understanding the Iran-Contra Affairs*, Brown University, last accessed April 27, 2023, https://www.brown.edu/Research/Understanding_the_Iran_Contra_Affair/n-contras.php.

3. Sarah Gibbens, "Bodies in Urns Among Artifacts Found in 1,000-Year Old Cemetery," *National Geographic*, June 30, 2017, https://www.nationalgeographic.com/history/article/pre-columbian-cemetery-found-nicaragua-spd.

4. "Nicaraguan Quesillo: Preparation Step by Step," Nicaraguan Recipes & Food, last accessed April 27, 2023, https://recetasdenicaragua.com/recipes/nicaraguan-cuisine/nicaraguan-quesillo/.

5. "Indigenous Peoples in Nicaragua," IWGIA, last accessed April 27, 2023, https://www.iwgia.org/en/nicaragua.html.

6. Clarissa Wei, "Nacatamales Are the Fatty, Meat-Filled Tamales of Nicaragua," *Vice*, October 12, 2015, https://www.vice.com/en/article/mgxpp4/nacatamales-are-the-fatty-meat-filled-tamales-of-nicaragua.

7. "Cuisine in Nicaragua, Food, Recipes, Culture," Nicaragua.com, last accessed April 27, 2023, https://www.nicaragua.com/culture/cuisine/.

NORWAY

1. "Cod," Seafood from Norway, last accessed April 27, 2023, https://fromnorway.com/seafood-from-norway/cod/.

2. Leslie Pariseau, "The Shipwrecked Sailors & the Wandering Cod," *Saveur*, September 19, 2016, https://www.saveur.com/norway-lofoten-dried-cod/.

3. John Lindow, *Norse Mythology: A Guide to Gods, Heroes, Rituals, and Beliefs* (Oxford: Oxford University Press, 2002).

4. Stein R. Mathisen, "Narrated Sámi Sieidis: Heritage and Ownership in Ambiguous Border Zones," *Ethnologia Europaea: Journal of European Ethnology Special Issue Culture and Property* 39 no. 2 (2010), https://www.researchgate.net/publication/292369368_Narrated_Sami_sieidis_Heritage_and_ownership_in_ambiguous_border_zones.

5. "The Rock Art of Alta," Alta Museum, last accessed April 27, 2023, https://www.altamuseum.no/en/the-rock-art-of-alta.

6. "Salmon Fishing in Norway," Visit Norway, last accessed April 27, 2023, https://www.visitnorway.com/things-to-do/outdoor-activities/fishing/salmon/.

7. "About The Salmon Lords," *The Salmon Lords: Brothers of the Rod*, last accessed April 27, 2023, https://www.salmonlords.com/about.

8. Yajie Liu, Jon Olaf Olaussen, and Anders Skonhoft. "Wild and Farmed Salmon in Norway: A Review," *Marine Policy* 35 no. 3 (May 2011): 413–18, https://doi.org/10.1016/j.marpol.2010.11.007.

9. Andrew McKay, "A Guide to Norwegian Salmon," *Life in Norway*, January 9, 2021, https://www.lifeinnorway.net/norwegian-salmon/#Salmon_in_fish_soup.

PORTUGAL

1. "Fado History," Museu do Fado, last accessed April 24, 2023, https://www.museudofado.pt/en/fado-history-en.

2. Lila Ellen Gray, "Memories of Empire, Mythologies of the Soul: Fado Performance and the Shaping of Saudade," *Ethnomusicology* 51 no. 1 (Winter 2007): 106–30, https://www.jstor.org/stable/20174504.

3. "Ulisses," 2022, Universidade de Lisboa, last accessed April 24, 2023, https://www.ulisboa.pt/info/ulisses.

4. "The History of the Spaniards," in *An Universal History, from the Earliest Accounts to the Present Time Volume 16*, George Sale, et al., (London: Osborne and Millar, 1748), https://books.google.ca/books?id=QCwIAAAAQAAJ&pg=PA345&redir_esc=y#v=onepage&q&f=false.

5. "Hidden Lisbon: Where to Find Roman Ruins," *Lisbon Food Blog*, Devour Tours, January 4, 2019, https://devourtours.com/blog/lisbon-roman-ruins/?cnt=CA.

6. MWH, "Lisbon's Ancient Origins," Portugal Travel Guide, March 7, 2022, https://portugaltravelguide.com/history-of-lisbon/.

7. "Oporto, Portugal," Organization of World Heritage Cities, last accessed April 24, 2023, https://www.ovpm.org/city/oporto-portugal/.

8. Przemysław Charzyński, Agnieszka Łyszkiewicz, and Monika Musiał, "Portugal as a Culinary and Wine Tourism Destination," *Geography and Tourism* 5 no. 1 (2017): 87–102, https://www.researchgate.net/publication/318885982_Portugal_as_a_culinary_and_wine_tourism_destination.

9. "Plan Your Visit," Castelo de São Jorge, last accessed April 24, 2023, https://castelodesaojorge.pt/en/plan-your-visit/.

10. Habeeb Salloum, "Azulejos: A Moorish Contribution to the Beautification of Portugal," Arab America, December 2, 2015, https://www.arabamerica.com/azulejos-moorish-contribution-beautification-portugal/.

11. Janet P. Boileau, "A Culinary History of the Portuguese Eurasians: The Origins of Luso-Asian Cuisine in the Sixteenth and Seventeenth Centuries," (PhD diss., University of Adelaide, 2010), https://digital.library.adelaide.edu.au/dspace/bitstream/2440/77948/8/02whole.pdf.

12. Teresa de Castro, "Moorish Heritage in the Cuisines of Spain and Portugal," The LADO Group, July 8, 2007, https://latinodawah.org/moorish-heritage-in-the-cuisines-of-spain-and-portugal/.

13. "Espetada," in *The Oxford Companion to Food*, Alan Davidson (Oxford: Oxford University Press, 2014).

14. "Authentic Espetada Recipe," TasteAtlas, last accessed April 24, 2023, https://www.tasteatlas.com/espetada/recipe.

15. Darlene Abreu-Ferreira, "From Mere Survival to Near Success: Women's Economic Strategies in Early Modern Portugal," *Journal of Women's History* 13 no. 2 (Summer 2001): 58–79, https://doi.org/10.1353/jowh.2001.0040.

SAMOA

1. Helen M. Leach and Roger C. Green, "New Information for the Ferry Berth Site, Mulifanua, Western Samoa," *The Journal of the Polynesian Society* 98 no. 3 (1989): 319–29, https://www.jstor.org/stable/20706295.

2. Mike T. Carson, "Samoan Cultivation Practices in Archaeological Perspective," *People and Culture in Oceania* 22 (2007): 1–29, https://doi.org/10.32174/jsos.22.0_1.

3. Matthew Spriggs, "Taro Cropping Systems in the Southeast Asian-Pacific Region: Archaeological Evidence," *Archaeology in Oceania* 17 no. 1 (April 1982): 7–15, https://www.jstor.org/stable/40386574.

4. Holger Droessler, "Copra World: Coconuts, Plantations and Cooperatives in German Samoa," *The Journal of Pacific History* 53 no. 4 (2018): 417–35, https://doi.org/10.1080/00223344.2018.1538597.

5. "The Rise of the Mau Movement," NZHistory, Ministry for Culture and Heritage, updated September 2, 2014, https://nzhistory.govt.nz/politics/samoa/rise-of-mau.

6. Emily Gove, "As Good as Niu: Food Sovereignty in Samoa," (Honors Thesis, University of Richmond, 2007), https://scholarship.richmond.edu/cgi/viewcontent.cgi?article=1993&context=honors-theses.

SCOTLAND

1. Richard A. Gregory, et al., "Archaeological Evidence for the First Mesolithic Occupation of the Western Isles of Scotland," *The Holocene* 15 no. 7 (2005): 944–50, https://doi.org/10.1191/0959683605h1868ft.

2. "The Outer Hebrides: Archaeology & Pre-History," Taigh Chearsabhagh, last accessed April 24, 2023, https://www.taigh-chearsabhagh.org/heritage/

archaeology/.

3. "A Thumbnail History of the Soay Sheep of St. Kilda," Soay Farms, Southern Oregon Soay Sheep Farms, last accessed April 24, 2023, https://www.soayfarms.com/history.html.

4. "Peatland and Moorland," Comhairle nan Eilean Siar, last accessed April 24, 2023, https://www.cne-siar.gov.uk/strategy-performance-and-research/outer-hebrides-factfile/environment/peatland-and-moorland/.

5. "Hebridean Sheep," Slow Food in the UK, last accessed April 24, 2023, https://www.slowfood.org.uk/ff-products/hebridean-sheep/.

6. Christian Lassure, "The Cleitean of the St. Kilda Archipelago in the Outer Hebrides, Scotland," Architecture de Pierre Seche/Dry Stone Architecture, May 26, 2006, last updated October 14, 2009,https://www.pierreseche.com/cleitean_of_saint-kilda.htm.

7. Ymke Lisette Anna Mulder, "Aspects of Vegetation and Settlement History in the Outer Hebrides, Scotland," (PhD diss, University of Sheffield, 1999), https://etheses.whiterose.ac.uk/10367/1/525010.pdf.

8. Angus Macleod, "The Herring Girls," The Angus Macleod Archive, Angus Macleod papers, Ravenspoint Centre, Isle of Lewis, Series G, File 4, Section 28, http://www.angusmacleodarchive.org.uk/view/index.php?path=%2F8.+The+Fishing+Industry+in+Lewis+and+Scotland%2F1.+Background+and+Overview%2F4.+The+Herring+Girls.pdf.

9. "Peat Formation in Scotland," Hebridean, Hebridean Smokehouse, last accessed April 26, 2023, https://www.hebrideansmokehouse.com/hebweb/webpage/131.

SWITZERLAND

1. Franz Lidz and Tomas van Houtryve, "How (and Where) Did Hannibal Cross the Alps?" *Smithsonian Magazine*, July 2017, https://www.smithsonianmag.com/history/how-hannibal-crossed-the-alps-180963671/.

2. "How the Neutral Swiss Celebrate Their Military Past," SWI, Swiss Broadcasting Corporation, November 12, 2000, https://www.swissinfo.ch/eng/how-the-neutral-swiss-celebrate-their-militarypast/1748380.

3. Evan Andrews, "Why Is Switzerland a Neutral Country?" HISTORY, A&E Television Networks, July 12, 2016, updated August 23, 2018, https://www.history.com/news/why-is-switzerland-a-neutral-country.

4. "Matterhorn: First Ascent in 1865," *Matterhorn Blog*, Zermatt Tourism, last accessed April 24, 2023, https://www.zermatt.ch/en/Media/Article/Matterhorn-First-ascent-in-1865.

5. "Raclette (Swiss) Cheese at the Cheese Society Online," The Cheese Society, accessed January 30, 2023, https://www.thecheesesociety.co.uk/product/raclette-swiss/.

6. "The History of the Raclette," Raclette Grill, last accessed April 24, 2023, https://www.raclettegrill.org.uk/history/.

7. Paul Zinsli, "The Walser: Migrant Farmers Who Settled in High Places," *The UNESCO Courier: A Window Open on the World,* February 1987, UNESCO Digital Library, https://unesdoc.unesco.org/ark:/48223/pf0000072246.

8. Emily Denny, "Glacier Blankets in Switzerland Highlight Global Disparities in *Fighting Climate Change,*" State of the Planet, Columbia Climate School, January 5, 2022, https://news.climate.columbia.edu/2022/01/05/glacier-blankets-in-switzerland-highlight-global-disparities-in-fighting-climate-change/.

TAHITI

1. Jon Bowermaster, "The Fragile Paradise That Tahiti Used to Be," *The New York Times*, February 18, 2007, https://www.nytimes.com/2007/02/18/travel/18explorer.html.

2. Frederic Charles Gray, "Tahiti in French Literature from Bougainville to Pierre Loti," (PhD diss., University of Arizona, 2016), http://hdl.handle.net/10150/287460.

3. Liesl Clark, "Polynesia's Genius Navigators," *PBS*, February 15, 2000, https://www.pbs.org/wgbh/nova/article/polynesia-genius-navigators/.

4. "Discover the Islands of Tahiti," Tahiti.com, last accessed April 24, 2023, https://www.tahiti.com/travel/about-tahiti.

5. "Teahupoo," Aquabumps. March 2, 2018, last accessed April 24, 2023, https://www.aquabumps.com/2018/03/02/teahupoo/.

6. "What Does Teahupoo Mean*?*" Surfer Today, last accessed April 24, 2023, https://www.surfertoday.com/surfing/what-does-teahupoo-mean.

7. Michele Peterson, "Poisson Cru Tahitienne: A Tahitian Fish Ceviche Recipe," *A Taste for Travel*, April 30, 2018, updated January 9, 2023, https://www.atastefortravel.ca/9140-poisson-cru-tahitienne-recipe-tahitian-fish-ceviche/.

8. Gabrielle Page, "Sustainable Development in French Polynesia: Environmental and Cultural Challenges," (Boston: Northeastern University Environmental Justice Resource Center, 2013), https://web.northeastern.edu/nejrc/wp-content/uploads/2017/02/Gabrielle-Page-Research-v3.pdf.

9. Neil Vigdor, "Sprawling Coral Reef Resembling Roses Is Discovered off Tahiti," *The New York Times*, January 20, 2022, https://www.nytimes.com/2022/01/20/science/tahiti-coral-reef.html.

THAILAND

1. "Luang Pu Waen Sujinno Autobiography and His Amulets," *Dhammayut Amulet*, July 17, 2016. http://dhammayut-amulet.blogspot.com/2016/07/luang-pu-waen-sujinno-wat-doi-mae-pang.html.

2. "Thailand Profile: Timeline," *BBC News,* BBC, March 7, 2019, https://www.bbc.com/news/world-asia-15641745.

3. Racha Sachasinh, "Bangkok Rediscovers the Magic of Its Legendary River," National Geographic, March 11, 2022, https://www.nationalgeographic.com/travel/article/bangkok-rediscovers-the-magic-of-its-legendary-river.

4. Parita Nobthai, "What Do You Know about Somtum, Thai Green Papaya Salad?" *Lion Brand Blog*, January 16, 2020, https://www.lionbrand.com.au/blog/what-do-you-know-about-somtum-thai-green-papaya-salad.

5. "Decoding Som Tam, Thailand's Delicious Papaya Salad," *Michelin Guide*, February 17, 2022, https://guide.michelin.com/th/en/article/features/decoding-the-delicious-som-tam.

6. Julia Frances Morton, "Papaya: Origin and Distribution," in *Fruits of Warm Climates* (Miami: Julia F. Morton, 1987), https://hort.purdue.edu/newcrop/morton/index.html.

7. "Western Settlement Along the Chao Phraya River," *Thai PBS World*, March 2, 2022, https://www.thaipbsworld.com/western-settlement-along-the-chao-phraya-river/; "The Curious History of Som Tum (Papaya Salad)," Thai Ginger, August 24, 2020, https://thaiginger.com/the-curious-history-of-som-tum-papaya-salad/; Jolie Liem, "What is the Difference between Laos and Thai Papaya Salad," *Sona Bee,* Sonasia Holiday, June 23, 2023, https://sonasia-holiday.com/sonabee/laos-thai-papaya-salad.

8. "River History," Bangkok River, last accessed April 24, 2023, https://www.bangkokriver.com/river-history/.

9. Racha Sachasinh, "Bangkok Rediscovers the Magic of Its Legendary River," *Travel*, National Geographic. March 11, 2022, https://www.nationalgeographic.com/travel/article/bangkok-rediscovers-the-magic-of-its-legendary-river.

TUNISIA

1. Mansour Arem, "The True Story of Harissa," Zwita: Tunisian Foods, October 19, 2020, https://zwitafoods.com/blogs/news/the-true-story-of-harissa.

2. "Explore the World's Largest Collection of Roman Mosaics," *Smithsonian* Magazine, paid content, last accessed April 24, 2023, https://www.smithsonianmag.com/sponsored/national-bardo-museum-tunisia-worlds-largest-collection-roman-mosaics-180960204/.

3. Ray Harris and Khalid Koser, "History of Tunisia," in *Continuity and Change in the Tunisian Sahel* (London: Routledge, 2004), https://www.taylorfrancis.com/chapters/edit/10.4324/9781351161121-3/history-tunisia-ray-harris-khalid-koser.

4. Massarra Dhahri, "Olive Oil: Tunisia's Gift to the World," *Carthage Magazine*, December 29, 2021, https://carthagemagazine.com/tunisian-olive-oil/.

5. Cain Burdeau, "Tunisia: Land of the Olive Tree," *Olive Oil Times*, February 8, 2018, https://www.oliveoiltimes.com/world/tunisia-land-of-olive-tree/62159.

6. Ahmed Fergiani, "Eating from the African Bowl," Roman Ports, January 17, 2018, https://www.romanports.org/en/articles/human-interest/307-eating-from-the-african-bowl.html.

7. Salem Chaker, "Couscous: Sur l'Étymologie du Mot," Centre de Recherché Berbère, http://www.centrederechercheberbere.fr/tl_files/doc-pdf/couscous.pdf.

8. "Couscous: History, Information, Interesting Facts," WebFoodCulture, last accessed April 24, 2023, https://www.webfoodculture.com/couscous-history-information-interesting-facts/.

9. "Halal Meats," Texas A&M, August 2013, http://animalscience.tamu.edu/wp-content/uploads/sites/14/2016/01/Halal-Foods.pdf.

10. Mohammed Gagaoua and Hiba-Ryma Boudechicha, "Ethnic Meat Products of the North African and Mediterranean Countries: An Overview," Journal of Ethnic Foods 5 no.2 (June 2018): 83–98, https://doi.org/10.1016/j.jef.2018.02.004.

11. "Medina of Tunis," UNESCO World Heritage Convention, last accessed April 24, 2023, https://whc.unesco.org/en/list/36/.

UNITED STATES: ALASKA

1. Maureen P. Hogan and Timothy Pursell, "The 'Real Alaskan': Nostalgia and Rural Masculinity in the 'Last Frontier,'" Men and Masculinities 11 no. 1 (October 2008): 63–85, https://doi.org/10.1177/1097184x06291892.

2. "807th Battalion History, Part 1: Activation and More," National Park Service, February 20, 2021, https://www.nps.gov/articles/aleu-807th-history-pt-1.htm.

3. Douglas Deur, Thomas Thornton, Rachel Lahoff, and Jamie Hebert, Yakutat Tlingit and Wrangell-St. Elias National Park and Preserve: An Ethnographic Overview and Assessment," Anthropology Faculty Publications and Presentations 99 (2015), http://archives.pdx.edu/ds/psu/18157.

4. Zona Spray, "Alaska's Vanishing Arctic Cuisine," Gastronomica 2 no. 1 (February 2002): 30–40, https://doi.org/10.1525/gfc.2002.2.1.30.

5. Frederica de Laguna, "Under Mount Saint Elias: The History and Culture of the Yakutat Tlingit: Part One," Smithsonian Contributions to Anthropology 7 no. 1 (1972), https://doi.org/10.5479/si.00810223.7.1.

6. Bjorn Dihle, "The Tlingit Legend of the Kóoshdaa Káa," Outdoor Life, March 30, 2022, https://www.outdoorlife.com/adventure/tlingit-legend-of-kooshdaa-kaa/.

UNITED STATES: CALIFORNIA

1. L. T. Burcham, "Cattle and Range Forage in California: 1770–1880," Agricultural History 35 no. 3 (July 1961): 140–149, www.jstor.org/stable/3740625.

2. Damian Bacich, "Ranchos in California: The Spanish and Mexican Eras," The California Frontier Project, last accessed April 24, 2023, www.californiafrontier.net/ranchos-in-california/.

3. Nicole Mullen, California Indian Food and Culture (Berkeley: Phoebe A. Hearst Museum of Anthropology and the Regents of the University of California, Berkeley, 2023).

4. Erin Blakemore, "The Illustrious History of the Avocado," JSTOR Daily, May 18, 2017, https://daily.jstor.org/the-illustrious-history-of-the-avocado/.

5. James Bartlett, "The Avocado: A History of the Fruit in California," KCET, September 28, 2018, www.kcet.org/food-living/the-avocado-a-history-of-the-fruit-in-california.

6. Elizabeth Nicholas, "Alice Waters on the Meaning of 'Slow Food,' and Getting Everyone Involved in Regenerative Farming," Vogue, May 26, 2021, www.vogue.com/article/alice-waters-on-the-meaning-of-slow-food-regenerative-farming.

UNITED STATES: HAWAII

1. Emma Kauana Osorio, "Struggle for Hawaiian Cultural Survival," Ballard Brief, March 2021, https://ballardbrief.byu.edu/issue-briefs/struggle-for-hawaiian-cultural-survival.

2. "What Is Māna?" Mānoa Heritage Center, last accessed April 24, 2023, https://www.manoaheritagecenter.org/moolelo/kuka%CA%BBo%CA%BBo-hciau/what-is-mana/.

3. Dore Minatodani, "Chronicling America: Historic Newspapers from Hawai'i and the U.S.: Surfing," University of Hawai'i at Mānoa Library, March 17, 2022, https://guides.library.manoa.hawaii.edu/c.php?g=105252&p=687128.

4. Robin Helene Connors, "Gender, Status and Shellfish in Precontact Hawaii," (MA Thesis, San Jose State University, 2009), https://scholarworks.sjsu.edu/cgi/viewcontent.cgi?article=4662&context=etd_theses.

5. Rachel Laudan, The Food of Paradise: Exploring Hawaii's Culinary Heritage (Honolulu: University of Hawai'i Press, 1996).

6. Jess Larson, "Hawaiian-style Kalbi (Grilled Korean Short Ribs)," Plays Well with Butter, July 28, 2021, https://playswellwithbutter.com/kalbi-short-ribs/.

7. Alexis Cheung, "Hawaiian Mac Salad Isn't Mainland Mac Salad," TASTE, February 25, 2019, https://tastecooking.com/hawaiian-mac-salad-isnt-mainland-mac-salad/.

8. Nanea Kalani, "Friend or Foam: Hawaii's Plate Lunch History," Honolulu Civil Beat, October 14, 2011, https://www.civilbeat.org/2011/10/13267-friend-or-foam-hawaiis-plate-lunch-history/.

UNITED STATES: NEW JERSEY

1. Catherine DeAngelis, Italian Immigration to New Jersey, 1890 in Italian Heritage Curriculum (NJ: New Jersey Italian and Italian American Heritage Commission, 2010), https://www.njitalianheritage.org/wp-content/uploads/2015/12/Italian-Immigration-to-New-Jersey-1890.pdf.

2. Hasia R. Diner, Hungering for America: Italian, Irish, and Jewish Foodways in the Age of Migration (Cambridge, MA: Harvard University Press, 2003).

3. Luca Cesari, "Carbonara: History, Origins, and Anecdotes of a Legendary Recipe," Gambero Rosso, November 29, 2021, updated April 6, 2023, https://www.gamberorossointernational.com/news/carbonara-history-origins-and-anecdotes-of-a-legendary-recipe-2/.

4. Francine Segan, "Carbonara: Origins and Anecdotes of the Beloved Italian Pasta Dish," La Cucina Italiana, April 5, 2021, updated April 5, 2022, https://www.lacucinaitaliana.com/italian-food/italian-dishes/carbonara-origins-and-anecdotes-of-the-beloved-italian-pasta-dish?refresh_ce=.

5. John F. Mariani and Galina Mariani, The Italian-American Cookbook: A Feast of Food from a Great American Cooking Tradition (Boston: Harvard Common Press, 2000).

6. Mari Uyehara, "Carbonara, Always Controversial," TASTE, updated August 22, 2017, https://tastecooking.com/the-murky-history-of-roman-carbonara/.

UNITED STATES: NEW YORK

1. Evan Kleiman, "'I'll Have What She's Having': New Exhibit Follows History of Jewish Deli," Good Food, podcast, KCRW, updated April 29, 2022, https://www.kcrw.com/culture/shows/good-food/jewish-delis-edibles-biden-agriculture-policy/skirball-delicatessen-history-exhibit.

2. harry g. levine, "Pastrami Land: The Jewish Deli in New York City," Contexts 6 no. 3 (2007): 67–69, https://www.jstor.org/stable/41801065.

3. Patricia Volk, "Deli," American Heritage, February/March 2002, https://www.americanheritage.com/deli.

4. Kenny Sokan and Rachel Gotbaum, "Pastrami on Rye: A Full-Length History of the Jewish Deli," The World, PRX and WGBH, March 31, 2016, https://theworld.org/stories/2016-03-31/pastrami-rye-full-length-history-new-york-jewish-deli.

5. Charley Lanyon, "Is NYC's Most Iconic Sandwich—Dying?" BBC Travel, BBC, February 24, 2016, https://www.bbc.com/travel/article/20160218-is-nycs-most-iconic-sandwich-dying.

Ode To Tavel
Photographs © 2023 Patrick Trefz

All rights reserved. No part of this book may be reproduced in any manner in any media,
or transmitted by any means whatsoever, electronic or mechanical (including photocopy,
film or video recording, Internet posting, or any other information storage and retrieval system),
without the prior written permission of the publisher.
Published in the United States by powerHouse Books,
a division of powerHouse Cultural Entertainment, Inc.
32 Adams Street, Brooklyn, NY 11201
www.powerHouseBooks.com

First edition, 2023

Library of Congress Control Number: 2022935352
ISBN 9781648230134

Cover Design: Borja Garmendia (Pensando en Blanco)

Book Design: Brooklyn Taylor, www.brookisawesome.com

Managing Editor: Emma Peters

Travel Story text: Patrick Trefz with Vicky Brown Varela

Copy Editor: Laurie Prendergast

Editorial Assistant: Mia Berger

Photo Editor: Lauren Frentz

Photo Archivist: Mark Gordon / G10 Capture

Basque Editors: Maialen Sarasua, Inigo Gaiton

Food Editors: John Osborne, Erin Dresser, Lo Frentz

Food and Beverage Consultants: Galli El-sherif, David Kinch, John Locke,
Juan Lucca, Sarah Margaux, David Morgan

Printed by Artron Art (Group) Co., Ltd.
10 9 8 7 6 5 4 3 2 1
Printed and bound in China